D1448767

MAINE STATE LIBRARY

WITHDRAWN

WAYNE STATE LIBRARY

PERSPECTIVE DRAWINGS BY PROGRAMMABLE CALCULATOR

PERSPECTIVE DRAWINGS BY PROGRAMMABLE CALCULATOR
A Method with Graphic Aids

David Yue

VNR VAN NOSTRAND REINHOLD COMPANY
NEW YORK CINCINNATI TORONTO LONDON MELBOURNE

Gift
1-24-90

742 Y94p 1984

Yue, David.

Perspective drawings by
 programmable calculator.

To Charlotte

Copyright © 1984 by Van Nostrand Reinhold Company Inc.

Library of Congress Catalog Card Number: 82-23845
ISBN: 0-442-29035-7

All rights reserved. No part of this work covered by the copyright hereon may
be reproduced or used in any form or by any means—graphic, electronic, or
mechanical, including photocopying, recording, taping, or information storage
and retrieval systems—without permission of the publisher.

Manufactured in the United States of America

Published by Van Nostrand Reinhold Company Inc.
135 West 50th Street
New York, New York 10020

Van Nostrand Reinhold Company Limited
Molly Millars Lane
Wokingham, Berkshire RG11 2PY, England

Van Nostrand Reinhold
480 Latrobe Street
Melbourne, Victoria 3000, Australia

Macmillan of Canada
Division of Gage Publishing Limited
164 Commander Boulevard
Agincourt, Ontario MIS 3C7, Canada

15 14 13 12 11 10 9 8 7 6 5 4 3 2 1

Library of Congress Cataloging in Publication Data

Yue, David.

 Perspective drawings by programmable calculator.

 Includes index.
 1. Perspective—Data processing. 2. Computer
graphics. 3. Programmable calculators. I. Title.
T369.Y83 742'.028'54 82-23845
ISBN 0-442-29035-7

PREFACE

I once found a fascinating drawing—a three-point perspective of an airplane in flight making a banking turn. This drawing was much more complicated than any perspective drawing I had encountered in art classes and architecture school. I studied it for a long time trying to interpret the intricate web of construction lines. I never completely figured out what the artist was doing.

After five centuries, perspective drawing still remains a baffling and intriguing subject. New methods and tools are constantly being devised to assist in accurately portraying the visual world on a two-dimensional picture plane. With the onset of the electronic age, new technologies offer new possibilities for reexamining old problems. To use these new tools, it is necessary to set aside any previously learned perspective methods, and to rethink perspective drawing in terms of geometry and trigonometry that can be computed by the programmable calculator. One-point, two-point, and three-point perspectives are not separate topics, but aspects of a single system, and most construction lines and measuring points have been eliminated. Information once derived arduously can be found quickly, and very complicated drawings can be constructed easily.

DAVID YUE

v

CONTENTS

1 INTRODUCTION

Beyond the mechanical use of the eyes, the ability to see is an acquired skill. To see is to understand, to grasp with the mind. Training the mind to interpret the constant flood of visual experience has always necessitated the use of the eye-brain-hand loop—to actively look, analyze, and record. The study of a single drawing can reveal significant clues about the artist's state of mind; the study of the drawings produced by a culture can reveal how a group of people perceives the world.

Perspective is important to a particular attitude. The frame of the picture is a window on the world. It is used to convince the eye that the view is authentic, regardless of whether the picture attempts to reproduce the real world or attempts to materialize an imaginary one. The continuous record of commentaries and the use of perspective in pictures can be traced to the Renaissance. Prior to that time, attitudes were different and the rigorous use of perspective scant.

The high achievements of Brunelleschi and Alberti have been reduced in our time to teaching children to draw telephone poles and railroad tracks receding to the horizon. One might speculate that the impact of perspective is most intensely felt when it embraces technology. In the primeval forest, distance is governed by the relative size of trees (a vague measurement owing to natural variation) and by aerial perspective (the density of the air obscuring distance). In this environment, there is no linear perspective. But driving down a two-lane blacktop in Kansas with a center yellow stripe and Burma Shave signs along the roadside, the sense of perspective is powerful.

The formal rules of perspective developed since the Renaissance reflect the manner in which the eye sees our world; pictures correctly drawn along these lines can communicate the illusion of reality. As this method of visualization has become so much a part of our culture, even those who are visually unsophisticated can readily understand the abstract two-dimensional representation of three-dimensional space.

Although easily understood by the untrained observer, there is something intimidating about the construction of a complicated perspective drawing. Most people would no more attempt it than they would sing in public—feeling that both art forms are the prerogative of professionals. But even architects, who ought to construct perspectives in the normal course of their work, are frequently hesitant about making them. There are always technical headaches in constructing traditional perspectives. The frustrations may stem from preconceptions about the size of the finished drawings and from what point of view the subject should be seen. The existing plans from which the drawing is to be made, unless by the queerest luck, are always at the wrong scale. An image projected from these drawings

1

would be either too small to be informative or too large to be manageable. Once the plans are redrawn to the appropriate scale, the angle from which the subject is best viewed may result in a vanishing point that is farther away than the longest straightedge. If there are many different planes, there must be a vanishing point for each one. If there is a tilt, as in the Leaning Tower of Pisa, an additional set of plans and points will be needed. The result is a blur of construction lines. An enormous amount of time, effort, and consequently money is expended to find a few precious points; and the embellishment of the finished drawing has yet to be done.

But clearly the need exists to explain three-dimensional ideas by some means. Some people have the ability to assemble in their minds a three-dimensional whole from fragments; but for many people, even complete plans, sections, and elevations are just pieces of a mystifying puzzle. In part to avoid the nuisance of constructing a traditional perspective, the modern practice of architecture frequently resorts to other means of visualization: freehand sketches, axonometric drawings, scale models, photographs of models and even drawings of photographs of models.

Freehand drawings are only limited by the evocative skill of the draftsman; yet in this artfulness exists the potential for exaggeration and deceit.

Axonometric drawings are floor plans to scale with the vertical elements at the same scale. This approximates a bird's-eye view if seen from above or a worm's-eye view if seen from below. They are easy to draw from existing plans, but the larger they are, the more distorted they look at the periphery, as the eye has the tendency to see in perspective.

Models have the virtue of showing horizontal and vertical planes as three-dimensional solids, thus allowing the eye to rove about freely and look from any angle or distance. Their disadvantages are that they are not easily portable, they tend to emphasize the building's roof, and even the simplest sketch model takes a long time and a lot of money to build.

Photographs of models require additional technique, equipment, time, and money.

Drawings taken from photographs of models seem to have the sincerity of a prostitute's kiss.

There would be definite advantages in being able to economically produce accurately constructed perspectives. If a drawing could be constructed in minutes instead of hours, ideas could be examined quickly and developed if they looked promising or discarded if they did not. Consider the flexibility of a method that uses readily accessible technology.

Up in the attic you find an old lute. You take it downstairs, dust it off, and decide that a drawing of it might look very nice in your study. You prop up the lute, find a pen and paper and the right place to sit. To make the drawing, however, requires some skill, some subtlety in the method of observing, and some elusive quality often called talent. It takes

training to rid yourself of preconceptions of what a lute looks like and to draw exactly what you see. The sound hole is known to be round, but when viewed obliquely, it appears oval. The neck when viewed from any angle is foreshortened. If you take all distortions into account and faithfully reproduce what you see, the drawing will be correct in perspective, and the illusion that it is real will be complete.

Perspective drawing has a strict definition: *An observation from a fixed point of an image on a fixed plane of objects fixed in space.* From where you sit, your eye level establishes the local horizon. The image that you see is the image on your retina as cast by the lens of your eye. The lute is at a fixed orientation and distance from you. The image that you draw on your pad is the translation, subject to mental editing and cropping, of the image that enters your eye.

If you find you have difficulty drawing what your eye sees, you could construct a device similar to the one depicted in the Albrecht

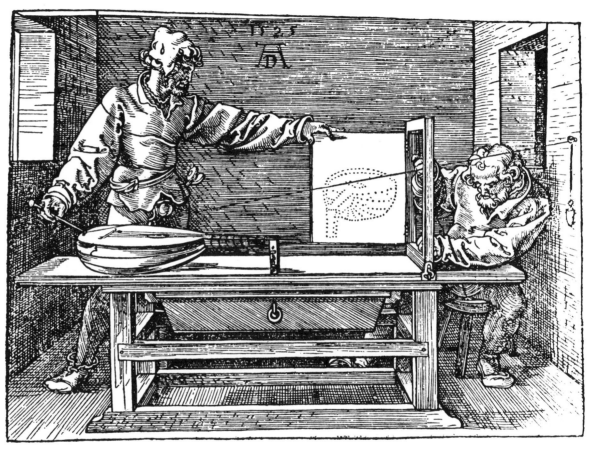

Figure 1.1

Dürer woodcut (Figure 1-1). A string is passed through a screw eye on the wall, with a pointer at one end and a weight to keep the line taut at the other. A piece of paper is taped to a door that is hung in a frame. With the door open, you pull the pointer and the string through the frame to a spot on the lute, while your assis-

tant locates the point at which the string passes through the frame. Then you shut the door and mark that point on the paper. The process is repeated for as many points as needed to give a clear picture of the lute. Obviously, even for something as small as a lute, this method is ridiculously difficult and would rely on at least

Photograph Courtesy The Minneapolis Institute of Arts.

Figure 1.2

4

one friend who was generous to your eccentricities. Anything larger than the lute would be nearly impossible to draw with this method.

Artists have often toyed with the idea of being able in some way to put a frame around what one sees (Figure 1–2). Even if such a simple solution were possible, you might not have the opportunity to see what you want to draw. What you want to draw might not yet exist, or might no longer exist, or the point of view might be inaccessible.

You have received in the mail the plans for what might be the sailboat of your dreams; but before you decide whether you want to buy it, you would like to see what it would look like through your picture window as it glides past your house on the ocean. You would like to see how closely this particular boat fulfills your fantasy.

If exactly the same boat were to happen by, you could take a picture of it with a camera and have a photograph to contemplate. Or if

the boat happened to stop dead in the water, you might quickly trace the outline on the glass with a grease pencil and have another tangible record. But as you only have the plans, and there is no similar boat in sight, you will have to construct a drawing from the dimensions on the plans and a few other pertinent facts supplied by your imagination.

First, you must determine the distance of the boat from your picture window and whether it is hugging the coast or on the horizon. And you must decide from what point you could best view the boat, whether standing at the glass or sitting across the room. This information will establish how large the image will appear on the glass.

Second, you must determine the boat's location in your field of vision. You might think of the window as a periscope with crosshairs dividing your view into quadrants. Is the boat just coming into view or just passing? How far above or below the horizontal crosshair does it appear?

And third, you must determine the attitude of the boat, whether it is bearing out to sea or parallel to the coast. What is the degree of roll? Is it heeling over in a brisk wind or becalmed? What is the pitch? Is the bow raised by the crest of a wave or lowered in its trough?

Given some method of organizing this information so that numbers could be applied to all these dimensions, it should be possible with Euclid's help to calculate where any point on the sailboat would appear on the window. This simply involves taking a specific point in a three-dimensional system and translating it into a specific point in a two-dimensional system. (Figure 1–3)

The thought of working out such long, tedious, and repetitive calculations is an odious task even for the most facile mathematicians. But we have an advantage over Dürer. We have inexpensive machines that do long, tedious, and repetitive calculations for us.

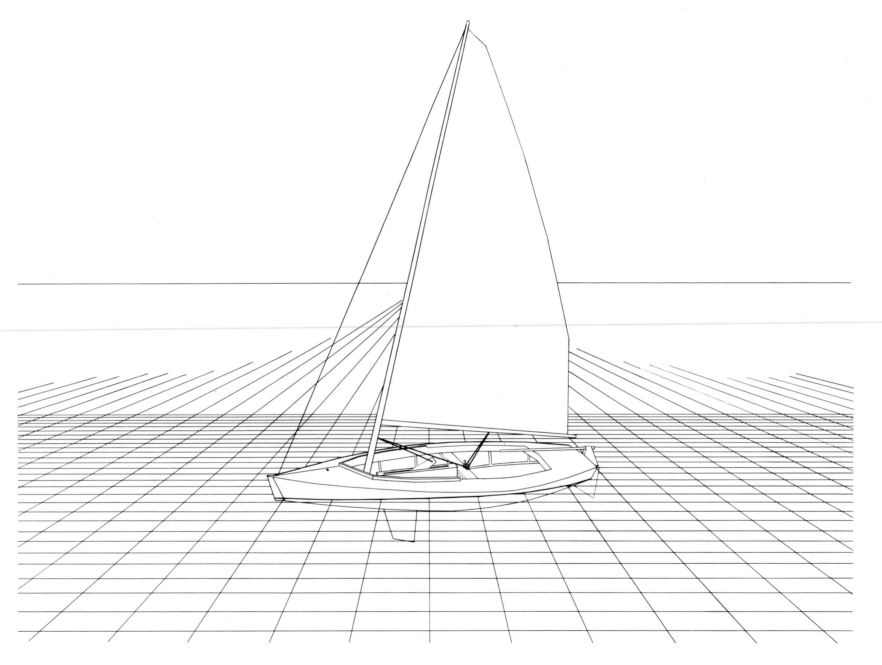

Figure 1.3

2 CALCULATORS

The programs contained in this book have been written to be used on both Hewlett-Packard (HP) and Texas Instrument (TI) calculators. The basic perspective program, BASIC P, can be run on all HP scientific programmable calculators and on the TI 58 and TI 59 calculators.

Very little mathematics is required to use these programs. The programs do require specific information in order to operate. The text will try to give both a mental image and a graphic representation of the information required by the program as well as an interpretation of the results.

A program for a programmable calculator consists of nothing more than the order in which the keys on the keyboard must be pressed to solve a problem. The program is entered into the program memory by pressing the keys in the prescribed order. Each time the program is run the calculator internally mimics an operator pressing the keys. The calculator, of course, can do this much faster than a person, and it can do it repeatedly and tirelessly.

Calculators differ in the number of program steps that can be stored and the number of memory registers. In general, the greater the capacity of a calculator, the greater the cost. It is also true that the greater the capacity, the more automated the computation; and, therefore, the faster the computation and the less chance for error. Some programs have been written to be used in conjunction with BASIC P that facilitate, for example, the calculation of such common shapes as rectangles and circles. In all but the smallest calculators, these separate programs may be assembled in the program memory and can be called on as required. In the smallest capacity calculators, intermediate results of computation can usually be tabulated by hand, and problems can be solved in parts. If the program is too long for the capacity of the calculator or infrequently used, it is possible to manually follow the steps of any program on the keyboard.

The HP and the TI calculators operate in essentially the same way, and have essentially the same capabilities. There is a display and a keyboard. A number is entered into the display by means of keys on the keyboard. Certain mathematical operations, represented by other keys on the keyboard, can be performed on this number. This number may also be used with other numbers following the rules of mathematics.

While the HP and the TI calculators operate in a similar manner, their logic systems are different. The HP system is Reverse Polish Notation (RPN) and the TI system is Algebraic Operating System (AOS). The RPN method evaluates an equation from the innermost parenthesis outward, while AOS evaluates an equation from left to right. When working in RPN, you calculate in the same way you would with pencil and paper. RPN forces the user to think of a problem in a particular way but rewards the user in solutions that are quick and elegant. The AOS follows standard mathematical procedure and consequently can solve an equation as it appears in a book, but the user must be careful to close all open parentheses. Both systems have their adher-

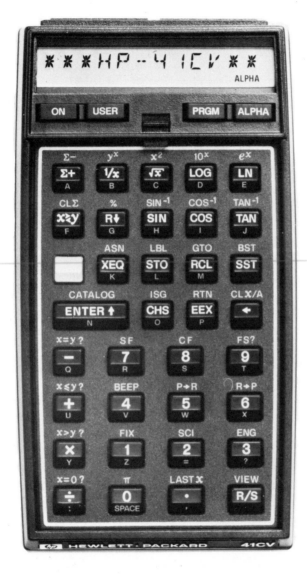

Photograph Courtesy the Hewlett-Packard Company

Figure 2.1

ents. The choice of one system over the other is more a reflection of personality than of logic; HP people tend to lock their calculators in their rooms, while TI people tend to wear them on their belts.

HEWLETT-PACKARD CALCULATORS

The basic perspective program was originally written on an HP 25, which was the smallest capacity of the programmable calculators made by HP with a mere 49 program steps and 8 memory registers. All subsequent HP calculators have a larger capacity and many additional features, though the logic system remains the same. The programs in this book are written for the format of the HP 41CV (Figure 2–1). This calculator in addition to handling numbers can also present words. Some programs ask for specific information for their

operation. The advantage of this is that the program may be used, once the intent and the procedure have been learned, without reference to the book. The programs can be used in other HP programmable calculators by ignoring those steps which contain requests for information and manually entering the required information into the appropriate memory registers. The requests for information are generally preambles to the program proper and are easily isolated.

The HP 41CV has a continuous memory—everything that is stored in the memory will be retained even if the calculator is shut off. The calculator has a large memory, and programs and data can reside in the memory until they are called up. The HP 41CV is part of a system that has a number of peripheral devices which include a card reader and printer. The card reader is useful for storing a program in a permanent form—once the program is keyed into the calculator, it need never be keyed in

again. The printer is useful for obtaining a hard copy of the information generated by the program.

TEXAS INSTRUMENT CALCULATORS

The two principal programmable calculators are the TI 58C and the TI 59. The TI 58C has a continuous memory and the TI 59 (Figure 2–2) has a built-in card reader. The TI 58C will retain any program that is entered into the calculator even when shut off, but there is no way to permanently store a program. As a result, when the program is erased, it must be re-keyed in. The TI 59 erases its memory every time it is shut off, but programs can be stored on magnetic cards which can be quickly processed through the machine. The TI 58C and the TI 59 also differ in their respective capabilities—the memory of the TI 59 is twice as large as that of the TI 58C. A printer is also available for both.

Photograph Courtesy Texas Instruments Incorporated

Figure 2.2

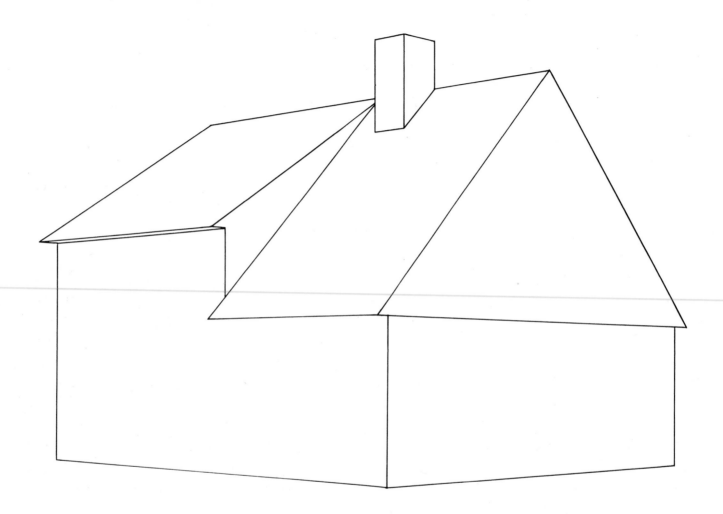

Figure 3–1

3 BASIC PERSPECTIVE PROGRAM

Drawing a single image that implies something three-dimensional as seen from a particular point involves the amalgamation of many complex pieces of information. Imagine holding a grid in front of an object and being able to draw that image in terms of connecting points on a graph. With this method, it is just that easy. The calculator processes three components through a system of four lengths and three angles and translates all the bits of information into a two-component answer. Drawing an image in perspective by this method simply involves punching in numbers on the calculator and plotting points. To make a specific perspective picture, it is necessary to know what dimensions go into making that view; and for the system to be completely flexible, every variable must be taken into account.

You are standing on an ice floe looking out at a white world so brilliant that there are neither shadows nor forms. A frosty mirage appears before you: A Levittown house! Could this be the beginning of a subarctic-urban development (Figure 3–1)? What observations can be made about this house? Even in a landscape where there are no reference points and nothing to give scale, there are still a number of pieces of information that can be ascertained. You can tell whether the house is above you or below you. You know this by the way the lines of the house are sloped. If you draw an eye-level line (Figure 3–2), you can see that part of the house is below you and part of the house is above you. This line also establishes the horizon. If you look in the direction exactly parallel to the ice, you will see the horizon line. It is one of the facts of geometry in the observed world that parallel planes appear to converge. The horizon line is always established by your eye level. All parts of the house that are above you seem to slope downward to the horizon, and all the parts below you seem to slope upward.

You can further define your relationship to the house by establishing a vertical line. This line represents the exact center of your field of view, or more simply what direction your nose is pointing (Figure 3–3). This point moves across the horizon as you turn your head. If you hold your head steady, you can imagine this line. This establishes where the house is in your field of view and the perpendicular plane—or picture window—through which the house is observed. This picture plane could be anywhere between you and the house.

Another thing that can be observed is that the lines of the house intersect (Figure 3–4). These intersections form points. A point is formed by the intersection of at least two lines. A particular point has a unique relationship to both your eye level and the direction you are looking. Consequently, every point can be located as a combination of two dimensions (Figure 3–5), one along the eye level X and one along the vertical Y.

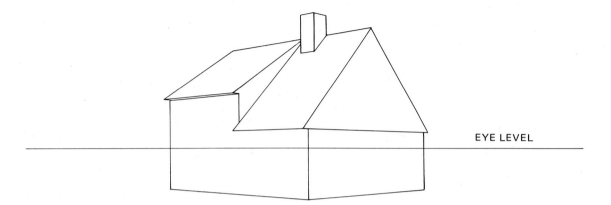

EYE LEVEL

Figure 3–2

12

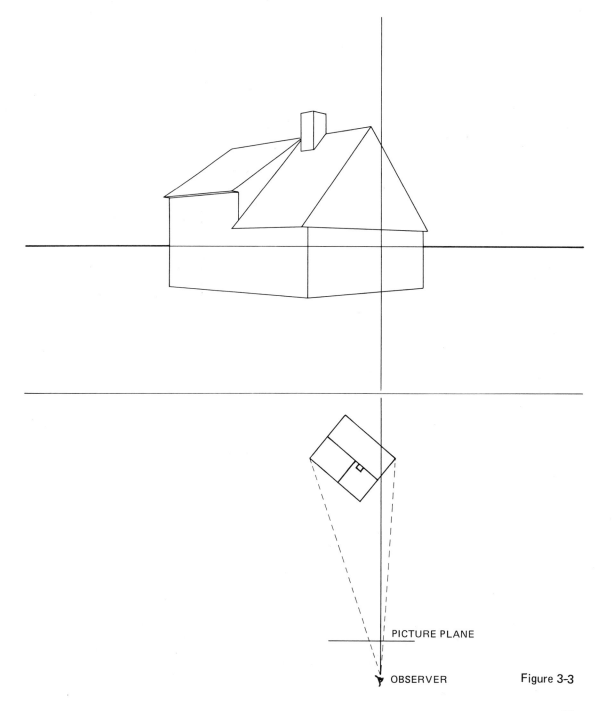

PICTURE PLANE

OBSERVER

Figure 3-3

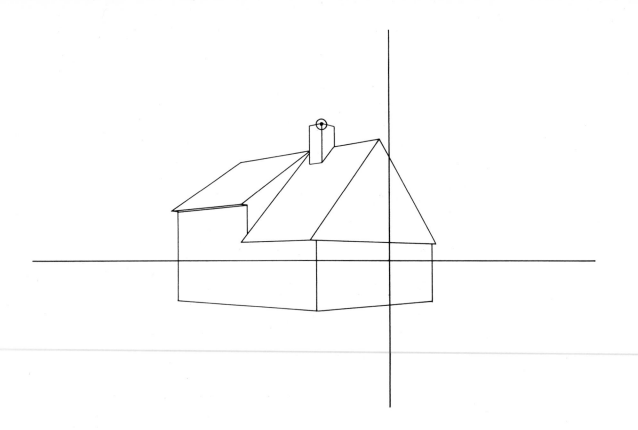

Figure 3-4

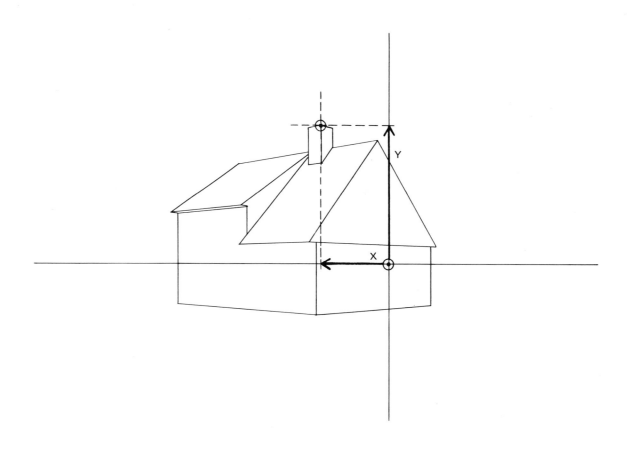

Figure 3–5

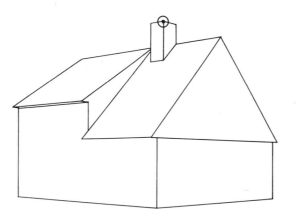

Further, if two or more lines define a point, it is also true that two points define a line. If we knew where all the points were in the house, and how all the lines of the house intersected, we could connect those points and have a perspective picture of the house.

We know that in the real world points are defined by three dimensions. If we pick a particular point on the chimney of the house (Figure 3–6), that point can be located by measuring it from a particular bench mark— its height (z), length (y), and breadth (x).

The bench mark may even be a point outside the house. It is only a reference point from which all points on the surface of the house can be measured (Figure 3–7). Any particular point on the house can be thought of as a combination of measurements along the z, y, x lines or axes. If a convenient bench mark is picked, all the points of the house easily and systematically fall into place.

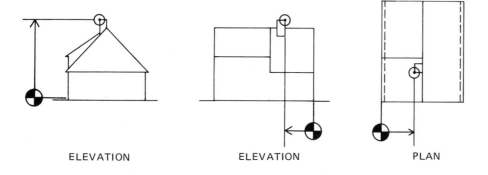

ELEVATION ELEVATION PLAN

Figure 3–6

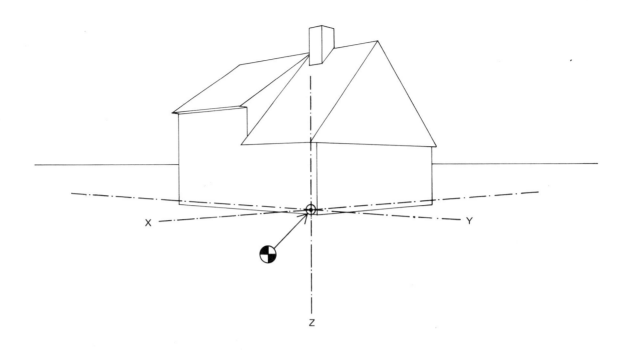

Figure 3-7

ENTERING COORDINATES FOR HP CALCULATOR

The (z', y', x') coordinates for a point will be entered into the operational stack of the Hewlett-Packard calculator. Up to four separate items may be entered into the stack, and the stack may be represented by the graphic:

0.00
0.00
0.00
0.00

A number punched into the calculator may be thought of as appearing at the bottom of the stack. *Example,* 12.34:

0.00
0.00
0.00
12.34

Certain manipulations can be done to the numbers in the stack. For example, numbers can be pushed up in the stack by pressing the button Enter↑ . *Example,* 12.34 Enter↑ :

0.00
0.00
12.34
12.34

They can be pushed down by pressing the button R↓ . The stack is cyclical—any number item falling below the bottom appears at the top. *Example:*

0.00		12.34
0.00	R↓	0.00
12.34		0.00
12.34		12.34

All numbers in the stack can be cleared by pressing f STK . *Example:*

12.34		0.00
0.00	f STK	0.00
0.00		0.00
12.34		0.00

If you make an error entering a number, you can change it by bringing that number to the bottom of the operational stack, clearing it by pressing CLR x , and entering the correct number.

When we enter the location of a point on the house, we must do so in the following order: z'

Enter↑ *y'* Enter↑ *x'*:

0.00
z'
y'
x'

Be careful not to press Enter↑ after x' or the following will result:

z'
y'
x'
x'

The calculator will process the dimensions as y', x', x' instead of z', y', x'.

When we take a point z', y', x' from Figure 3–6 and process this point through the program and the memory registers, we arrive at a point X, Y in Figure 3–5 *Example: z'* Enter↑ *y'* Enter↑ *x'* Xeq BASIC The number that appears on the display is X. Press R↓ to retrieve Y.

ENTERING COORDINATES
FOR TI CALCULATORS

The TI calculators do not have an operational stack. The TI calculators have a series of letter labels that can be used to execute specific functions. These labels may be represented by the graphic:

A′	B′	C′	D′	E′
A	B	C	D	E

When pressed, the buttons A – E execute certain functions as specified by the program. Letters A′–E′ may be reached by pressing 2nd and then the corresponding A – E button. This format may also be used in HP calculators that have similar letter labels and do not have alphanumeric capabilities. The letters can be relabeled for the BASIC Perspective Program as follows:

A′	B′	C′	D′	E′
z′	y′	x′	BASIC	E

The coordinates of a point z', y', x' (Figure 3–6) may be entered in the calculator by the following procedure:

Enter *z'*	Press A	Display *z'*
Enter *y'*	Press B	Display *y'*
Enter *x'*	Press C	Display *x'*

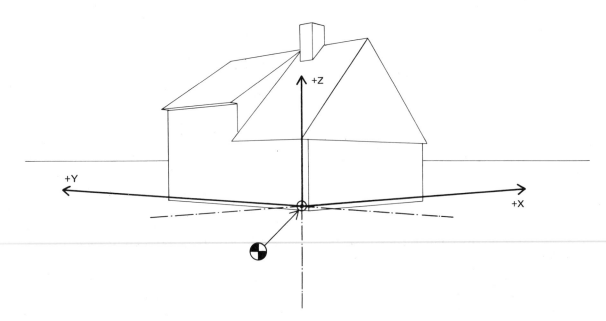

+Z

+Y

+X

In the BASIC Program, once a number has been entered into a particular letter label, it will be sustained in that label. This is not always true for all other programs. If, for example, only one number of the three is changed for the next coordinate point, then only that number need be entered:

Enter y_2' Press B Display y_2'

The BASIC Perspective Program may be executed by the following:

Press D

The calculator computes the values of X and Y on the picture plane:

Display X

Press R/S Display Y

as illustrated in Figure 3–5.

Figure 3–7a

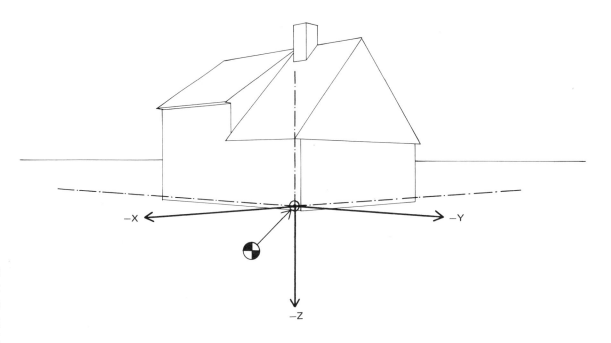

SELECTION OF BENCH MARK FOR BOTH HP AND TI CALCULATORS

The selection of a particular bench mark is only a matter of convenience. The bench mark may be thought of as the origin point of three axes (x, y, z), with the axes having direction and therefore positive (Figure 3–7a) and negative (Figure 3–7b) value. A point in the house could be anywhere around the bench mark and could be represented as a combination of $\pm x'$, $\pm y'$, $\pm z'$. The corresponding X, Y could similarly be $\pm X$, $\pm Y$.

USING THE MEMORY REGISTERS TO STORE DIMENSIONS FOR BOTH HP AND TI CALCULATORS

When a bench mark has been selected and has established a relationship between it and every point of the house, it is then necessary to establish the observer's relationship to the

Figure 3–7b

bench mark, and consequently the observer's relationship to every point on the house. Once established, the bench mark becomes a fixed reference point. Since the relationship between the house and the observer must remain constant for a particular family of points, this information is stored in the memory registers. The memory registers may be represented by the graphic:

R-00	0.00
R-01	0.00
R-02	0.00
R-03	0.00
R-04	0.00
R-05	0.00
R-06	0.00
R-07	0.00

When the registers are cleared, each window contains 0.00. Each box has an address, and once the number has been inscribed into a register, it remains there until it is cleared or until another number replaces it. Numbers can be recalled from the registers without altering the content of the register. A number is stored into the memory register by punching in the dimension, pressing STO and the number which represents the address of that memory register box. *Example,* 12.34 STO 00:

R-00	12.34
R-01	0.00
R-02	0.00
R-03	0.00
R-04	0.00
R-05	0.00
R-06	0.00
R-07	0.00

Certain specific dimensions must be entered into the memory registers that define the relationship of the observer to the house (Figure 3–8). There is the distance from the observer to the picture plane STO 00, the picture plane to the plane of the bench mark STO 01, the displacement of the bench mark to the left or right of the center line STO 02, and the height above or below the eye-level line STO 03. The following rule must be obeyed: *all dimensions must be measured in the same units.*

The dimension entered into the operational stack or letter label and the memory registers must have the same base for the final dimensions to be meaningful. If the dimensions of the house are in meters, the distance from the observer must be in meters. If foot-inch dimensions are used, the inches must be in decimal feet—one inch, for example, must be entered in the calculator as 0.0833 feet.

R-00	
R-01	
R-02	
R-03	
R-04	
R-05	
R-06	

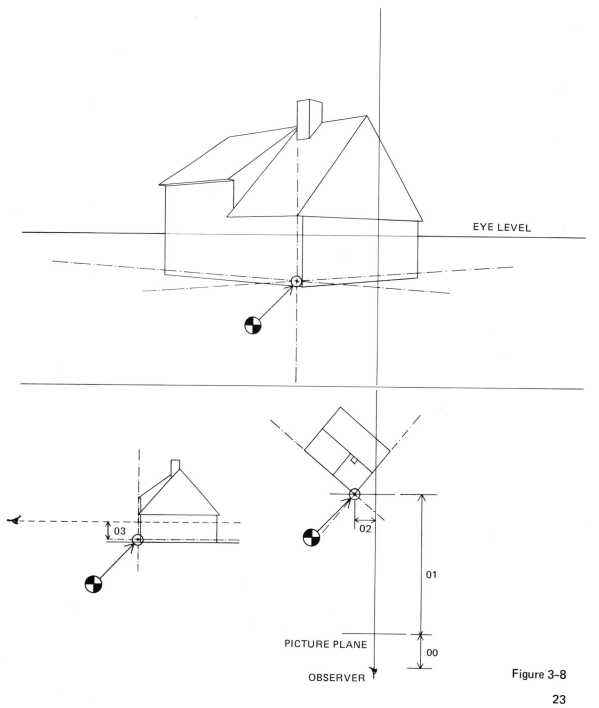

EYE LEVEL

03

01

02

PICTURE PLANE

00

OBSERVER

Figure 3–8

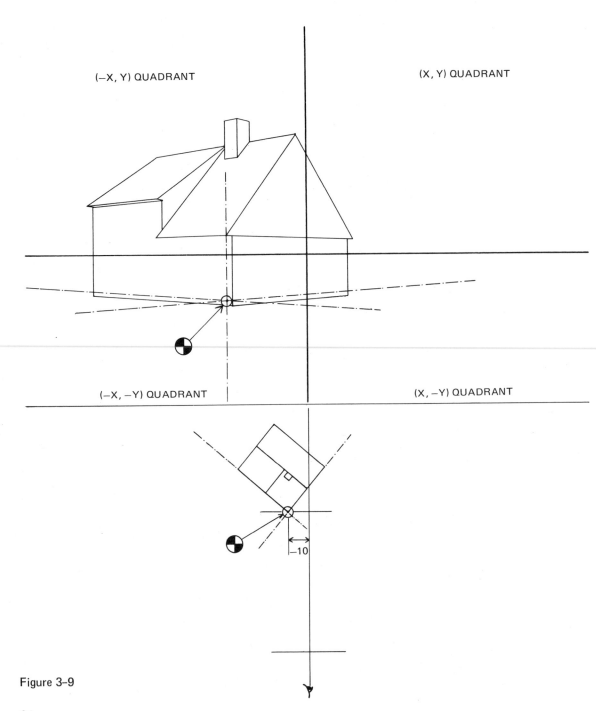

R–00	
R–01	
R–02	−10
R–03	−5.5
R–04	
R–05	
R–06	

(−X, Y) QUADRANT

(X, Y) QUADRANT

(−X, −Y) QUADRANT

(X, −Y) QUADRANT

−10

To further clarify the location of the bench mark, two additional qualifications are required (Figure 3–9):

1. A bench mark to the left of the vertical center line is defined as negative, on the vertical as 0, and to the right of the vertical as positive.
2. A bench mark if above eye level is defined as positive, if at eye level as 0, and if below eye level as negative.

It is important to note that where a house appears in your field of view affects what it looks like. If the bench mark is above eye level (Figure 3–10), the house would appear to be on a hill. If the bench mark is to the right of the vertical and positive (Figure 3–11), it would be the same as if you had adjusted your position a little by turning to the left.

Although the bench mark has been located, we do not yet know definitively every point of

Figure 3–9

R-00	
R-01	
R-02	0
R-03	+5.5
R-04	
R-05	
R-06	

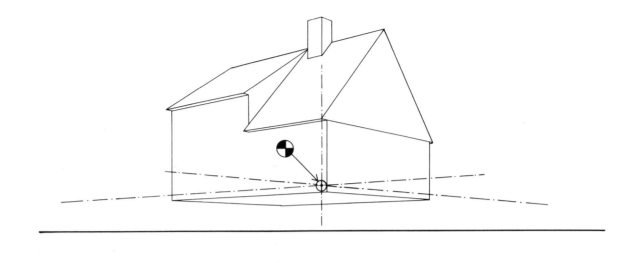

the house relative to the observer. A point on the house could still be anywhere around the bench mark because the three axes about the bench mark may be rotated to some degree. It is necessary therefore to set the amount and direction of each rotation.

To set a standard for the rotation, which in three dimensions can be quite confusing, the rule is as follows: *as viewed from the positive pole, counterclockwise rotation is defined as positive.*

With this rule in mind, obviously all the converses are also true (Figures 3–12, 3–13, and 3–14). The signs and the amount of rotation must be entered into the appropriate boxes of the memory register.

Houses in their normal postures exhibit rotation only about the y–axis (Figure 3–15). If, however, there were a sudden break in the ice, and a corner of the house were to sink, it might be in a different posture (Figure 3–16).

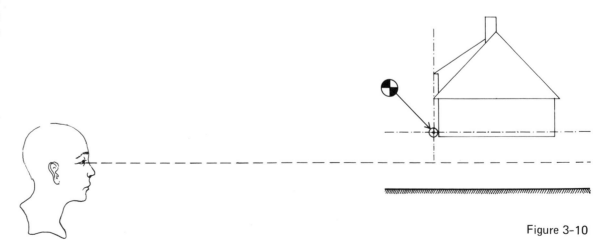

Figure 3-10

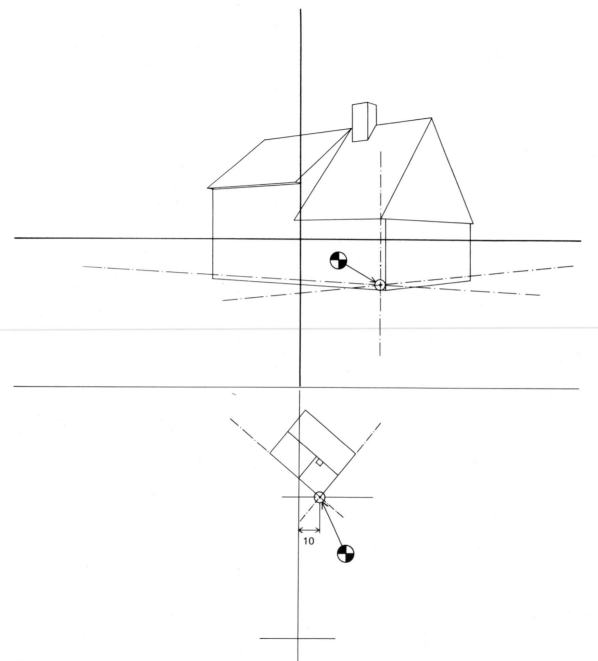

R-00	
R-01	
R-02	10
R-03	-5.5
R-04	
R-05	
R-06	

Figure 3-11

R-00	
R-01	
R-02	
R-03	
R-04	
R-05	/////
R-06	

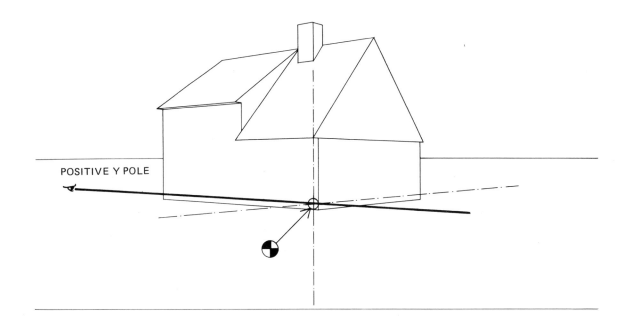

POSITIVE Y POLE

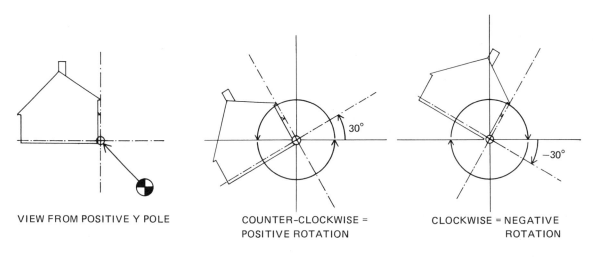

VIEW FROM POSITIVE Y POLE

COUNTER-CLOCKWISE =
POSITIVE ROTATION

CLOCKWISE = NEGATIVE
ROTATION

Figure 3–12

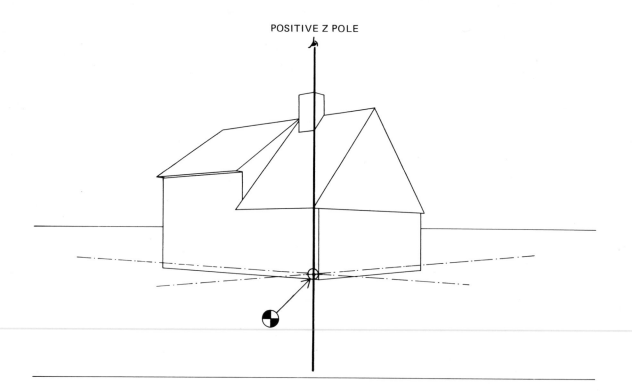

POSITIVE Z POLE

R-00	
R-01	
R-02	
R-03	
R-04	
R-05	
R-06	/////////

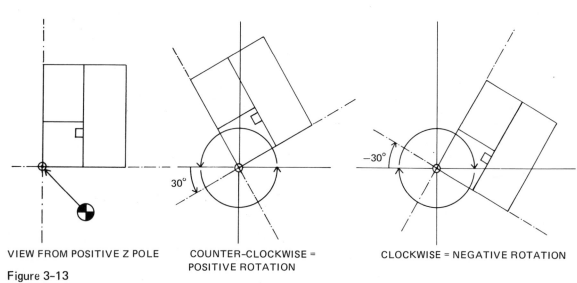

VIEW FROM POSITIVE Z POLE COUNTER-CLOCKWISE = CLOCKWISE = NEGATIVE ROTATION
 POSITIVE ROTATION

30° −30°

Figure 3-13

R-00	
R-01	
R-02	
R-03	
R-04	/////
R-05	
R-06	

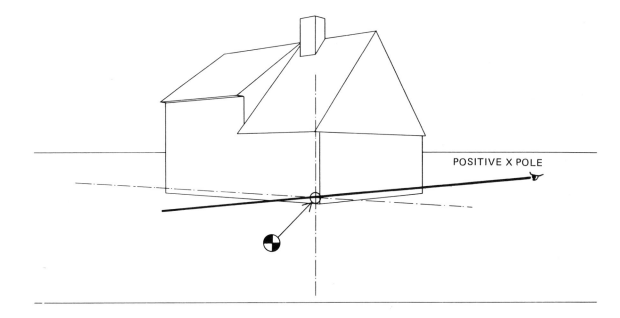

POSITIVE X POLE

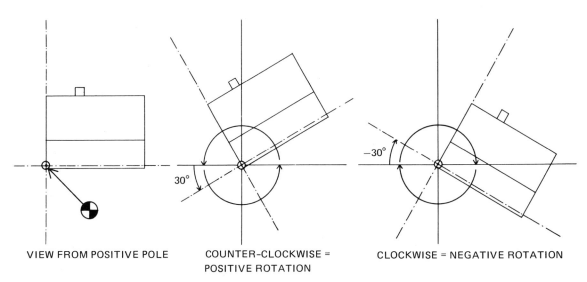

VIEW FROM POSITIVE POLE

COUNTER-CLOCKWISE =
POSITIVE ROTATION

CLOCKWISE = NEGATIVE ROTATION

Figure 3-14

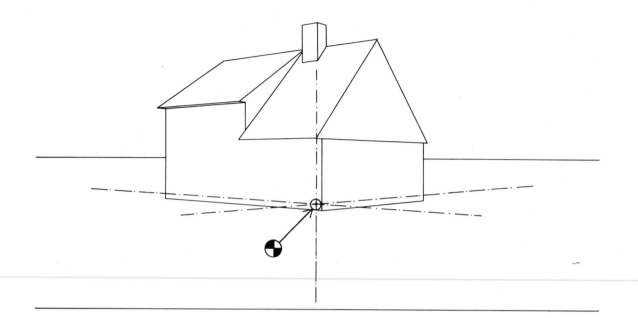

R-00	
R-01	
R-02	
R-03	
R-04	0
R-05	0
R-06	50

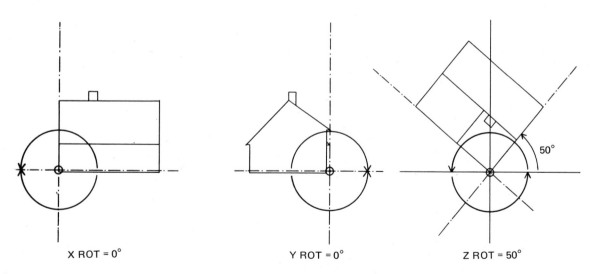

X ROT = 0° Y ROT = 0° Z ROT = 50°

Figure 3–15

R-00	
R-01	
R-02	
R-03	
R-04	−12
R-05	15
R-06	50

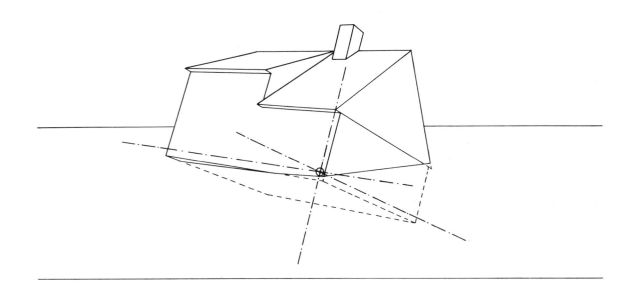

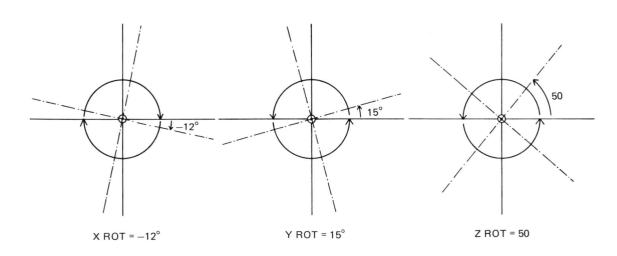

X ROT = −12° Y ROT = 15° Z ROT = 50

Figure 3–16

After the program has been entered into the calculator, the data base (Figure 3-17) which establishes the relationship of the observer to the house must be punched into the memory registers. (Determining the location of the picture plane has to do with the scale of the drawing and will be discussed later. The last memory register R-07 must be kept open to store intermediate calculations.)

If we then take plans of the house (Figure 3-18), we see that along each axis there are relatively few dimensions. In the actual production of perspective drawings, it is usually not necessary to list the points; it is easier to simply work from point to point, plotting the lines as you go. It may, however, be necessary to alter the dimensions on the plans to reflect the fact that all points must be measured from the bench mark.

Set up your drawing by constructing an eye-level line (a horizontal line drawn on your paper) and a vertical-center line (a vertical line drawn somewhere near the middle of the sheet). The program is entered, memory registers charged, coordinates loaded, and the program executed. Six seconds later (on the HP, a bit longer on the TI) you are ready to begin plotting points with none of the traditional vanishing points, projection lines, and rescaled plans and elevations (Figure 3-19). Plot as many points as desired or as few as needed. When the points are connected, the result is a perspective drawing (Figure 3-20).

R-00	16
R-01	60
R-02	0
R-03	−5.5
R-04	0
R-05	0
R-06	50

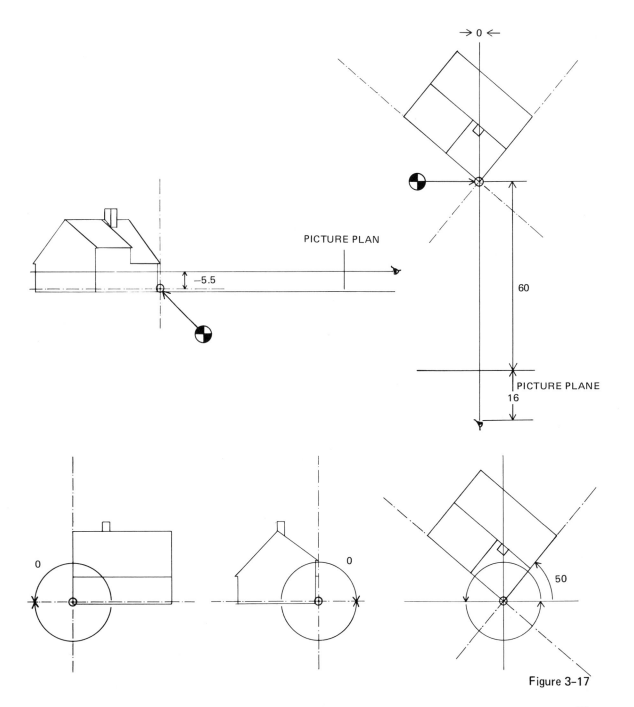

Figure 3–17

33

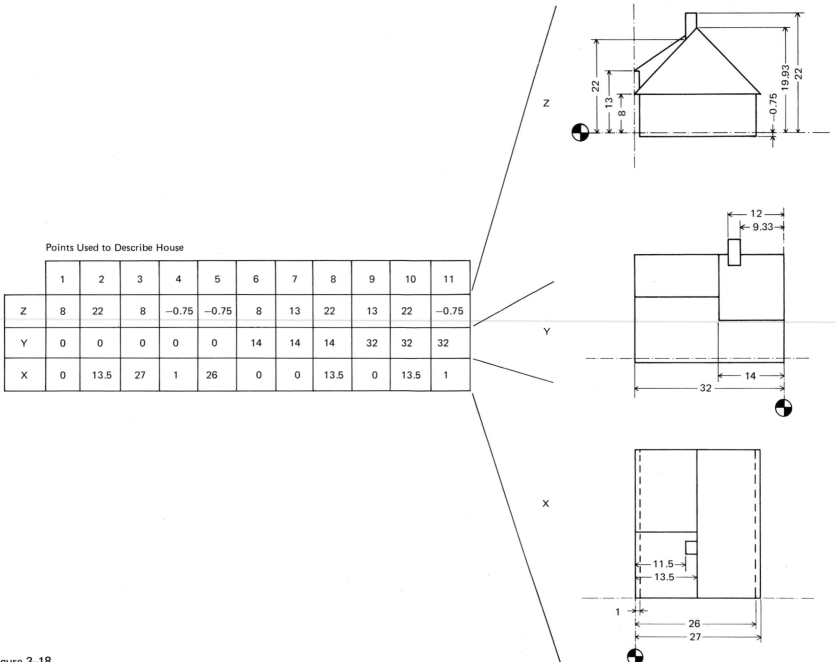

Points Used to Describe House

	1	2	3	4	5	6	7	8	9	10	11
Z	8	22	8	−0.75	−0.75	8	13	22	13	22	−0.75
Y	0	0	0	0	0	14	14	14	32	32	32
X	0	13.5	27	1	26	0	0	13.5	0	13.5	1

Figure 3–18

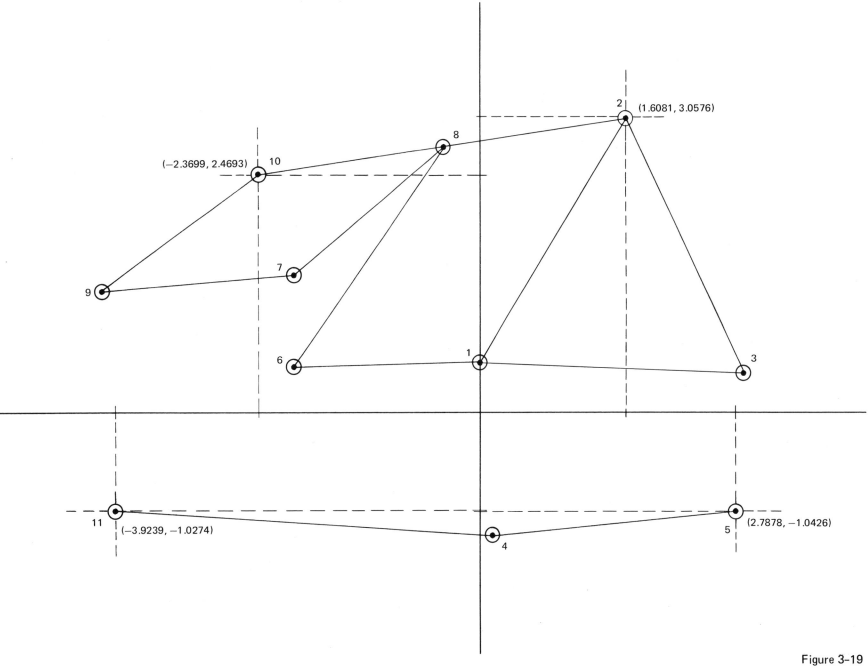

Figure 3-19

35

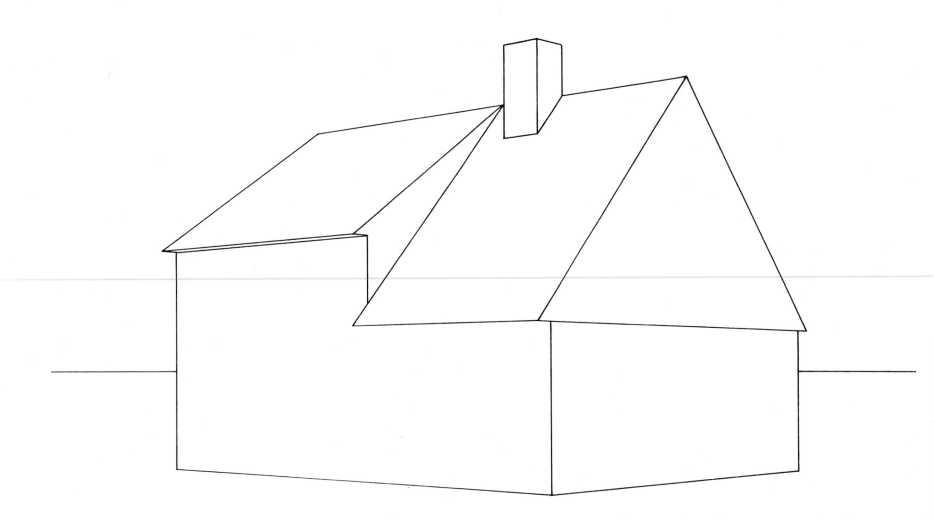

Figure 3-20

4 SCALING

There are two basic rules of perspective drawing. The first is that you cannot see around a corner, and the second is that an object looks smaller from farther away. Both rules are obvious from our everyday experience. The second rule is illustrated in Figure 4-1. The simple geometry of the relationship shows that as an object is moved away from the observer, the angle becomes smaller. If a cross section through the cube is thought of as the base of an isosceles triangle, and the distance from the observer to the cube is thought of as being the height of the triangle, as the cube moves farther away, the height of the triangle increases while the base remains the same. The angle at the apex must become smaller. The view above each position of the cube shows how the cube would appear to the observer. The smaller the angle, the smaller the amount of the field of view the object occupies, and the smaller the object appears.

If we set a position for the cube in Figure 4-2, a cross section through the cube establishes the base of a particular isosceles triangle and the distance of the cube establishes the height of that triangle. It is possible to introduce a picture plane anywhere between the cube and the observer. This may be thought of as a piece of glass through which the observer sees the cube (Figure 4-3). Regardless of the position of the glass picture plane, the observer sees the cube as the same size. If we were to draw the image of the cube on pieces of glass in the three positions in Figure 4-3, then take the three pieces of glass and stack them together, we would see Figure 4-4. The glass nearest the cube has the largest image while the glass nearest the observer has the smallest image. In terms of simple geometry, each piece of glass cuts a similar triangle (Figure 4-5). While the base and the height of the triangle may change, the angle at the

apex—the observer's eye—does not change, and the observer's perception of the object does not change.

If we want to replace the pieces of glass between the cube and the observer, they must be placed at exactly the same positions at which they were drawn for the lines of the drawing to align with the edges of the cube from the observer's point of view. The size of the image fixes a proportional relation between the observer and the glass, and the glass and the cube. Therefore, the position of each piece of glass is uniquely determined. Only when a piece of glass is in its proper position, will it carry an image that precisely describes the position of the cube in relation to the observer. There is only one position to view the drawing so that the angle subtended by the drawing at the eye will be equal to the angle subtended by the object at the eye.

Moving closer to the drawing of the cube is

not analogous to moving closer to the cube since now the angle subtended at the eye by the drawing will not be the same as the angle subtended by the object (Figure 4–6). There is only one position to view the drawing in which the drawing of the object appears precisely the same as the observer's view of the object itself. If we stray too far from the correct position, the perspective will look distorted. This is true for all linear perspective.

The distance and size of an object determine the amount of the field of view the object occupies. A brick at twenty feet occupies only a small percentage of the field of view while a brick at four inches will dominate the field of view. Again imagine a glass plate placed between the brick and the eye with the perspective view of the brick drawn on the glass as viewed by the eye. The observer will continue to see the outline as a synthetic view of the brick if the brick is removed. But this synthetic

view will be correct only if the observer maintains that exact position with regard to the glass plate. If the observer walks closer or backs away, the drawing on the glass plate will no longer be correct. The correct perspective view from one vantage point may look exaggerated at another vantage point.

The picture plane is the surface of the drawing. The distance at which the draftsman intends the drawing to be seen must be the distance at which the imaginary glass plate is inserted between the eye and the object to be drawn. Fiddling with that distance leads to the consequences illustrated in the following examples.

In Figure 4–7, we are looking down at a common brick on the sidewalk 5 feet in front of us, from the height of 5.25 feet. The numbers that describe the position of the brick with regard to the observer are:

R-00	16.0000
R-01	71.0000
R-02	0.0000
R-03	0.0000
R-04	46.3972
R-05	0.0000
R-06	50.0000

The picture plane is sliced through the axis of vision at a distance of 16 inches and the brick is a further 71 inches beyond the picture plane. These two numbers are entered into the memory registers R-00 and R-01 respectively. There is no horizontal or vertical displacement and 0.0000 have been entered into R-02 and R-03. Since we are looking down at the brick, the number 46.3972 is entered into R-04 (an explanation of the effect of a downward view will be given in the next chapter). The brick is also rotated 50.0000° about the z-axis, and this number is entered into R-06.

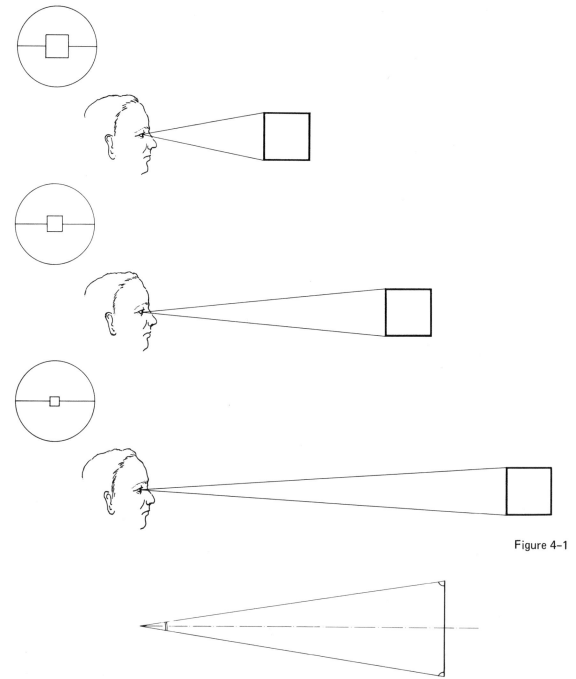

Figure 4-1

Figure 4-2

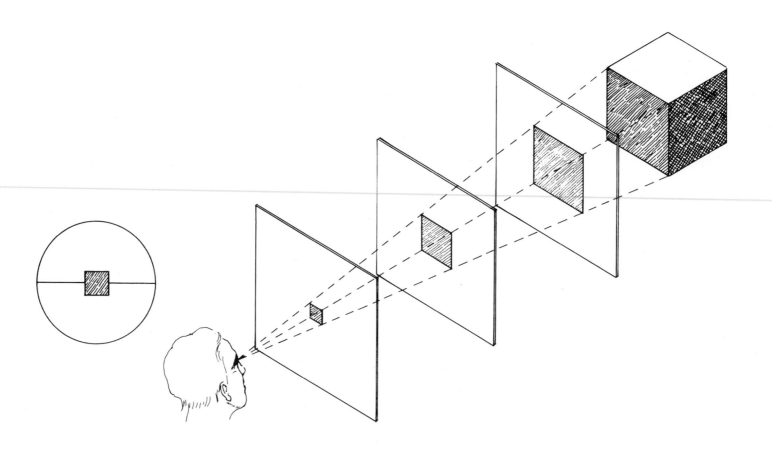

Figure 4–3

Figure 4-4

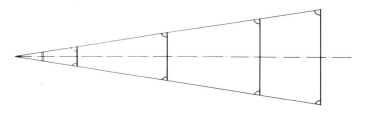

Figure 4-5

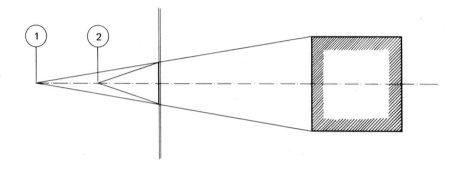

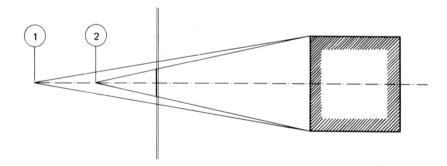

Figure 4-6

42

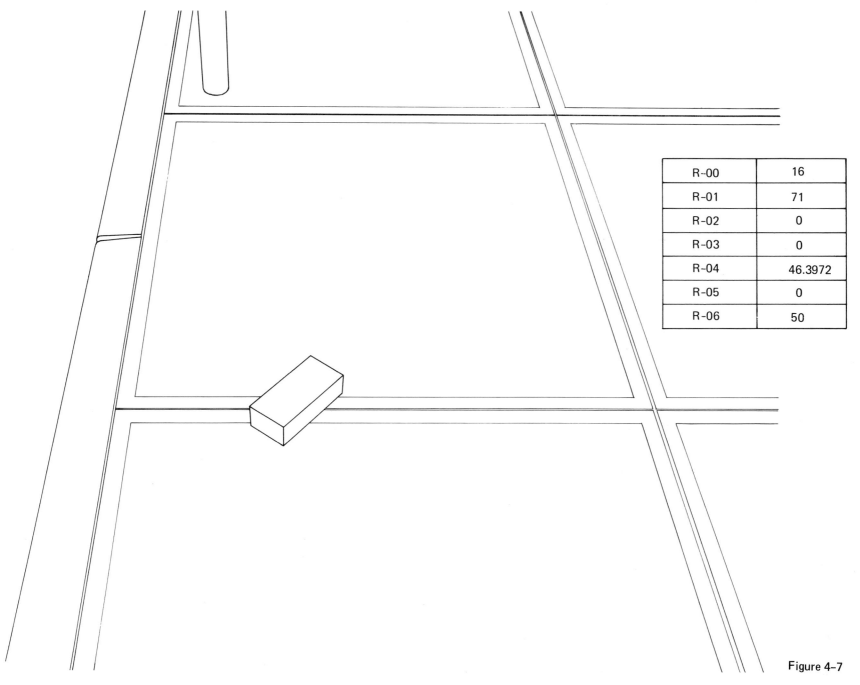

R-00	16
R-01	71
R-02	0
R-03	0
R-04	46.3972
R-05	0
R-06	50

Figure 4–7

43

In Figure 4–8, we take a view of the brick at the same orientation, but with an eye-to-picture-plane distance of 4 inches and a picture-plane-to-origin distance of 6 inches. The numbers that describe the position of the brick with regard to the observer are:

R-00	4.0000
R-01	6.0000
R-02	0.0000
R-03	0.0000
R-04	46.3972
R-05	0.0000
R-06	50.0000

If we look at this second drawing in comparison with the first, when the perspective looks all right in the first, the perspective in the second looks exaggerated. Both drawings are correct in perspective, but the second drawing was intended to be viewed at a distance of 4 inches. If you close one eye and look at the

Figure 4-8 Look at the black spot from a distance of 4 inches.

drawing at that distance for a second, you will see that the perspective is all right. The image may be blurry because it is difficult for many people to see a sharp image at such a short focal distance. An extraordinarily close view of Figure 4-7 would reveal the converse distortion.

In Figure 4-9, the orientation and distance is the same as in Figure 4-8, but in this case, the center of the brick is moved to the right of the axis of vision. The numbers that describe the position of the brick with regard to the observer are:

R-00	4.0000
R-01	6.0000
R-02	6.0000
R-03	0.0000
R-04	46.3972
R-05	0.0000
R-06	50.0000

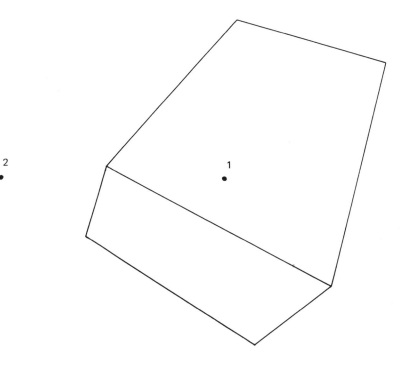

Figure 4-9 Look at the black spot to the left of the brick at a distance of 4 inches.

If we look at this picture and assume that the axis of vision passes through the center of the brick (black spot number 1), the brick from this point of view looks contorted. This drawing is also correct in perspective. The eye position is 4 inches from the surface of the drawing and the axis of vision is to the left of the brick (black spot number 2). Close one eye, position the other 4 inches from the surface of the drawing at black spot number 2. Viewing the brick from this position, the perspective again will look all right.

Careful placement of the picture plane and the center of vision will help convey the most accurate visual information to translate three dimensions into a two-dimensional form. Perspective drawing is in essence the mapping, on a plane, of points in three dimensions as they appear at a particular vantage point. A comfortable working distance might be 16 inches; a larger drawing may be viewed from 4 or 5 feet, and a mural size drawing may be seen at more than 20 feet.

ENLARGEMENTS AND REDUCTIONS

Imagine we have a glass plate at a fixed distance in front of an observer, and we intend to draw the image of a building on this glass plate; the only method to make the image larger is to move the observer and the glass plate closer to the building, and the only method to make the image smaller is to move the observer and the glass plate away from the building. The building itself cannot inflate or shrink. It should now be clear that it is not possible to enlarge or diminish a drawing by moving the picture plane back and forth on the line between the eye and the origin. The movement of the picture plane does not truly make the image bigger or smaller since the observer must move correspondingly closer or farther away to see the correct perspective. If you understand the proportional relationships involved, it is possible to manipulate them to facilitate your calculations for your drawings.

Drawings are often made to be reproduced. But factors such as the ease of drawing, the fineness of the pen, and the quality of line often create difficulties making a drawing at the exact size intended to be seen. Accommodations in size can easily be made on the calculator by adding to or subtracting from the eye-to-picture-plane distance in relation to the overall eye-to-origin distance. If the drawing is intended to be seen at a distance of 16 inches, it may be easier to draw it larger in the original and have it reduced. If it is drawn 50 percent larger, the eye-to-picture-plane dimension must also be 50 percent longer or in this case 24 inches. The overall distance must remain the same, otherwise the perspective will change. Thus, the addition of 8 inches to the

eye-to-picture-plane distance will be at the expense of the picture-plane-to-origin distance. If the original drawing is then reduced by 1/3, the reproduction is the proper size to be seen at a distance of 16 inches.

SELECTING A SCALE

The basic measuring tools are the architect's scale, the engineer's scale, and the metric scale. The latter two are the most convenient to use in plotting points because the decimal form of the coordinates can be measured directly by the decimal divisions marked on the scales. The different magnitudes marked on the engineer's scale—10, 20, 30, etc.—permit some latitude in selecting a comfortable unit. The actual scale to be used is to some degree a matter of taste, as the numbers can be easily altered in the calculator to match the preferred scale. I like to have the coordinates in such a form as to be measured in whole numbers (and

their associated decimal fractions) less than 10. This gives a healthy distribution of numbers without having to look at too many decimal places.

There are two situations that are frequently encountered in making perspective drawings—making a drawing from a specific place and making a drawing to fit a specific size. The following is one method to make accurate perspective drawings to satisfy each condition.

Fixed Point of View

This is the case where the position from which the perspective will be taken is fixed, and the drawing is allowed to be as large as necessary to accurately show the view from that point. There are always certain conspicuous places from which a building will be viewed— through an entrance gate, at the corner of a street, or any other such circumstance of site that regulates vantage points. The following is

a procedure for making the drawing and for selecting a scale.

1. Find the distance from the observer to the origin, and the orientation of the origin. This information can be culled from a sketch of the site, or a likely position may be hypothesized. All the dimensions must be in the same units and in decimal form. The specifics of distance, displacement, and rotation are stored into the appropriate memory registers as explained in the previous chapter.

In the example (Figure 4–10) the origin is taken to be at the center of the bell tower and the building is turned 35 degrees about that point. The observer is 166 feet away.

2. Select the distance from which the drawing will be seen. The distance will be 16 inches.

3. Locate the position of the picture plane. As we have discussed before, the surface of the

drawing and the picture plane are the same. But if we take 16 inches to be 1.33 feet, the resulting numbers for the coordinates of a point would be very small fractions of a foot, which do not neatly match any of the proportions on our scales. If we convert the overall dimensions to inches, 166 feet would be 1992 inches, which would be no problem for the calculator, but it would mean that all the dimensions of the building would have to be translated into inches. A simple solution is found by manipulating the position of the picture plane. If we imagine that the picture plane were located at 16 feet, then if this were drawn, it would produce an enormous picture that could only be correctly viewed at a distance of 16 feet. If we then plot the resulting coordinate points of this huge drawing using a 10 scale as one inch = one foot, a coordinate dimension of 3.6907 feet can be plotted as 3.6907 inches as seen from a distance of 16 inches. The

numbers that describe the position of the building with regard to the observer are:

R-00	16.0000
R-01	150.0000
R-02	0.0000
R-03	-8.0000
R-04	0.0000
R-05	0.0000
R-06	35.0000

4. Plot the points. The points of the building may be taken from the two elevations in Figure 4–10. When Figure 4–11 is viewed at a distance of 16 inches, the picture is the perspective view of the building 166 feet away.

PICTURE PLANE

PLAN OBSERVER

ELEVATION ELEVATION

Figure 4–10

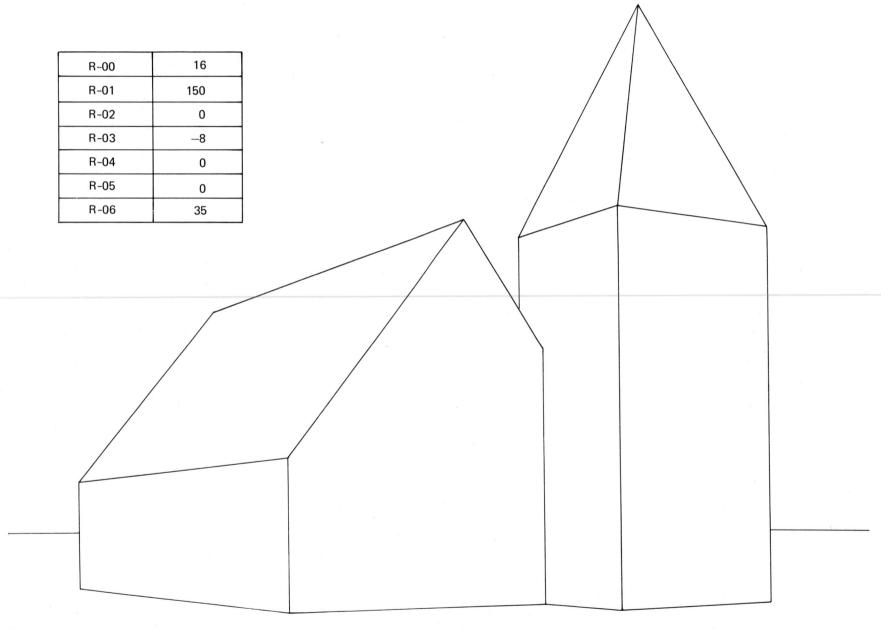

R–00	16
R–01	150
R–02	0
R–03	–8
R–04	0
R–05	0
R–06	35

Figure 4–11

Fixed Drawing Size

In this case, the boundary of the drawing is established. It often happens that drawings must be submitted within a prescribed size, whether to conform to the rules of a competition or to be squeezed into the format of a brochure or some other limiting factor. Since the dimensions of the building cannot be expanded or contracted easily, the only way to make the image larger is by moving the observer closer or to make the image smaller by moving the observer farther away. The following is a procedure for making this drawing.

1. Determine the limiting dimension of the drawing. Since the effects of foreshortening will change the width dimension as the overall distance changes, the most convenient bench mark dimension is the vertical height of the bell tower at the origin.

The height limit for the drawing will be 4 inches.

2. Determine the position of the picture plane. As in the previous section, the location of the picture plane is determined by the distance that the drawing is to be seen. In this case, let's say that it will be seen at 24 inches, and the drawing will be made at 10 scale.

3. Calculate the distance. Since the image size is 4 inches and the drawing is to be viewed at a distance of 24 inches, and we know that the height of the bell tower is 65 feet, the distance at which the building must be set can be computed as a proportion. The overall distance must be 390 feet. The eye-to-picture-plane distance relates to the image size as the overall distance relates to the height of the bell tower. The numbers that describe the position of the building with regard to the observer are:

R-00	24.0000
R-01	366.0000
R-02	0.0000
R-03	-8.0000
R-04	0.0000
R-05	0.0000
R-06	35.0000

4. Calculate the points. The height of the bell tower at the origin will be exactly 4 inches, though anything that is nearer the observer may be somewhat larger because of the effects of foreshortening (Figure 4–12). The overall distance can be finely adjusted to create virtually any image size.

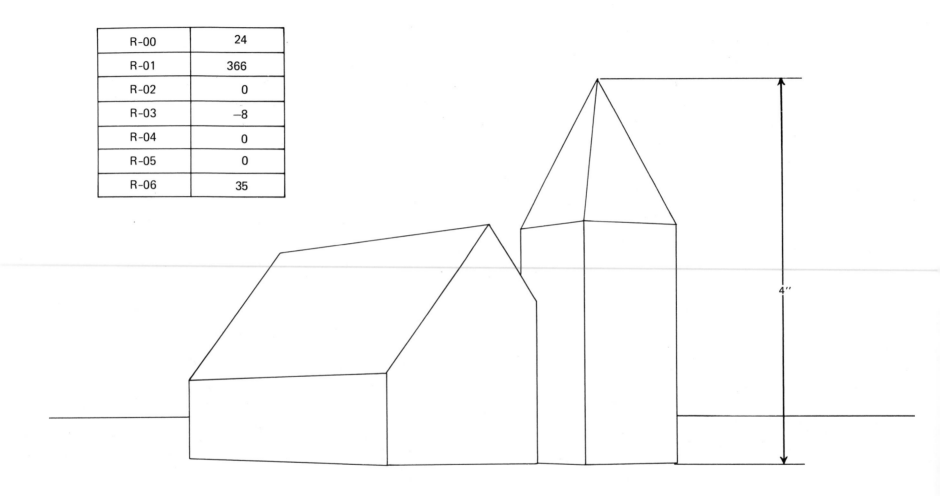

R–00	24
R–01	366
R–02	0
R–03	–8
R–04	0
R–05	0
R–06	35

4"

Figure 4–12

SHRINKING DRAWINGS

The perspective effect is most dramatic when there is a clear comparison between near and far. The limiting case is when there are two things that are both infinitely far away. In this case there is no perspective—the farther object does not appear smaller than the nearer object, and the drawing of the two objects would be an isometric. We see the lessening of the perspective effect at even relatively short distances. We see this effect when a center field television camera frames a pitcher on the mound and a batter at the plate. The pitcher and the batter appear to be the same size even though we know that they are 60 feet 6 inches apart. This is an example of the telescopic lens effect—compared with the overall distance between the camera in the outfield and the players, the distance between the mound and the plate is not significant.

Figure 4–13 is the same view as in Figure 4–11 but seen three times as far away. The numbers that describe this view are:

R-00	16.0000
R-01	482.0000
R-02	0.0000
R-03	− 8.0000
R-04	0.0000
R-05	0.0000
R-06	35.0000

While the overall distance in Figure 4–11 is 166 feet, the overall distance in Figure 4–13 is 498 feet. If we look at the near corner of the bell tower as compared to the corner at the right, there is little effect of foreshortening because the distance between the near and the far corner is insignificant compared to the overall distance. The building as a whole seems flatter and more stretched out.

Figure 4–14 is Figure 4–11 reduced to 1/3 the original size. This can easily be done by using the 30th scale instead of the 10th scale. The drawing is immediately 1/3 the original size. This drawing retains the rake of the roof line, which is not how the building would appear as seen from three times as far away as in Figure 4–13. While the correct distance to view Figure 4–13 is 16 inches, the correct distance to view the reduced drawing is now 5 $\frac{1}{3}$ inches. The 16 inches, which was the correct distance to view the original drawing must also be reduced to 1/3 the original distance. The eye has no trouble accommodating this change of scale, reading it as a drawing reduced in size rather than a building seen at a great distance.

R-00	16
R-01	482
R-02	0
R-03	−8
R-04	0
R-05	0
R-06	35

Our eyes are constantly bombarded with visual information in many different forms, and our ability to interpret this information is quite keen. We can easily see that a building on a postage stamp, no matter what distance we look at the drawing, is still recognizably a building. This is in part the result of our ability to make deductions from visual clues. Since we know the approximate size of a brick, or a tree, or a window, we can guess at the size of the building. We make analogous assessments of what the building looks like, which conforms to what we know about the building in

Figure 4-13

R-00	16
R-01	150
R-02	0
R-03	−8
R-04	0
R-05	0
R-06	35

general. We may be surprised when we see the actual building that it is larger or smaller than we expected.

As we have seen, with the proper selection of distance and the location of the picture plane, we can accurately reproduce what the eye would see. The numerical precision produced by the calculator far exceeds the draftsman's accuracy of drawing. We can make a drawing of something that does not yet exist and see how it will appear. It is in a sense a numerical camera obscura.

Figure 4-14

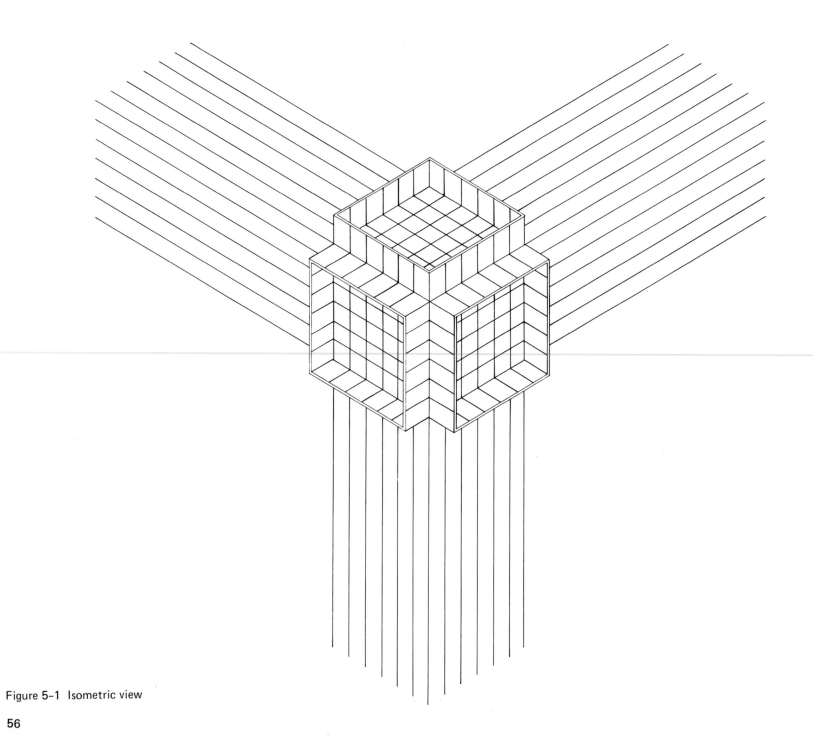

Figure 5-1 Isometric view

5 BIRD'S-EYE WORM'S-EYE DIFFERENT PERSPECTIVE VIEWS

When we look at the world, the eye discerns certain facts of distance and angle. If we look at an object in our field of view from a particular position, we see in effect a set of facts. Movement forward or backward changes the set of facts. Turning or nodding the head also changes the set of facts. It is our ability to instantaneously perceive and interpret this information that enables us to navigate in our world. If we analyze the changes that occur with regard to distance and angle when we change our viewing position, we can easily use this system to draw different perspective views.

Perspective drawing has been generally taught as three separate, unrelated methods: *one-point, two-point, and three-point perspective.* The procedures for constructing each different type of drawing is quite specialized. A three-point perspective cannot be constructed using a one-point perspective method.

Yet these are not really unrelated topics. They only represent different states of rotation of one coordinate system.

Consider the three-axis coordinate system as made up of bundles of parallel lines, one bundle each for the x-, y-, and z-axes. There are enough parallel lines in each bundle so that every point in space can be accounted for as the intersection of one line from each bundle (Figure 5–1, an isometric view). The bundles are also linked by these intersections—when one bundle is rotated about its axis, the other two must rotate with it. We will see that these three bundles can generate three kinds of images on the picture plane.

ONE-POINT PERSPECTIVE

If two axes are parallel to the picture plane, the view is a one-point perspective.

In this case (Figure 5–2) the coordinate system is not rotated with respect to the observer. The lines parallel to the z-axis are vertical. The lines parallel to the x-axis are horizontal. Both bundles are parallel to the picture plane. But only two of the three mutually orthogonal axes can be in the same plane, and consequently no more than two axes can be parallel to the picture plane. The y-axis is thus perpendicular to the picture plane, and the image of this bundle of parallel lines will appear to converge.

TWO-POINT PERSPECTIVE

If only one axis is parallel to the picture plane, the view is a two-point perspective.

In two-point perspective, all the bundles are rotated about the z-, or vertical, axis. If we assume that the rotation is not some multiple of 90° (case number 1 again), neither the x-axis nor the y-axis are now parallel to the picture plane. Only the z-axis is now parallel to the picture plane (Figure 5–3). Each of the other

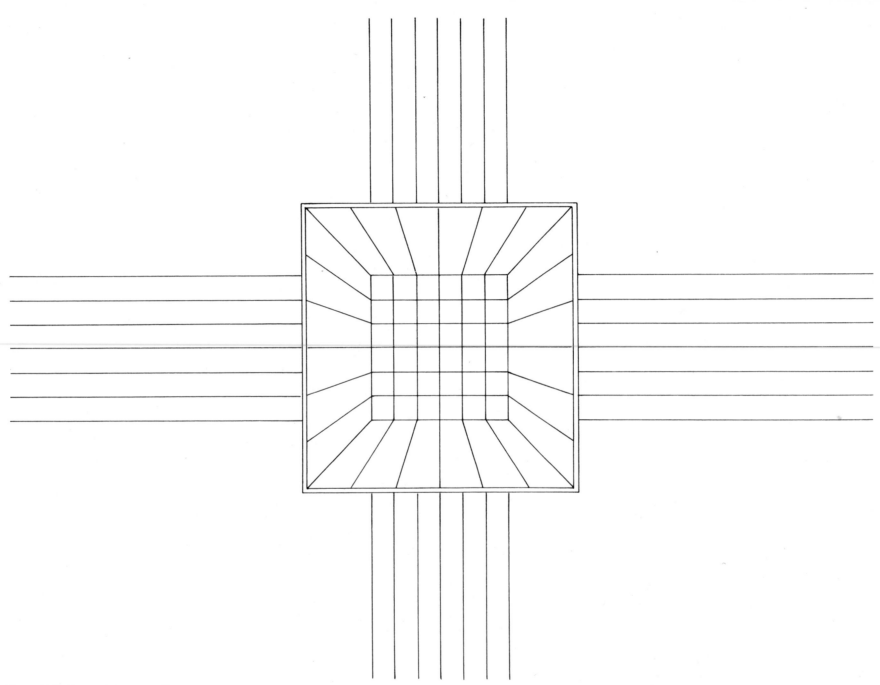

Figure 5-2 One-point perspective

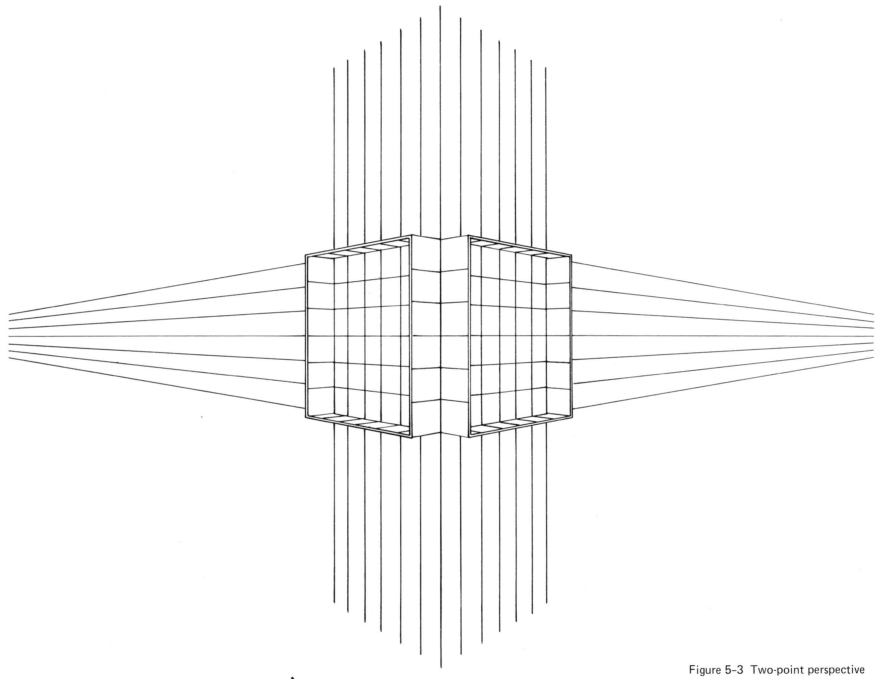

Figure 5-3 Two-point perspective

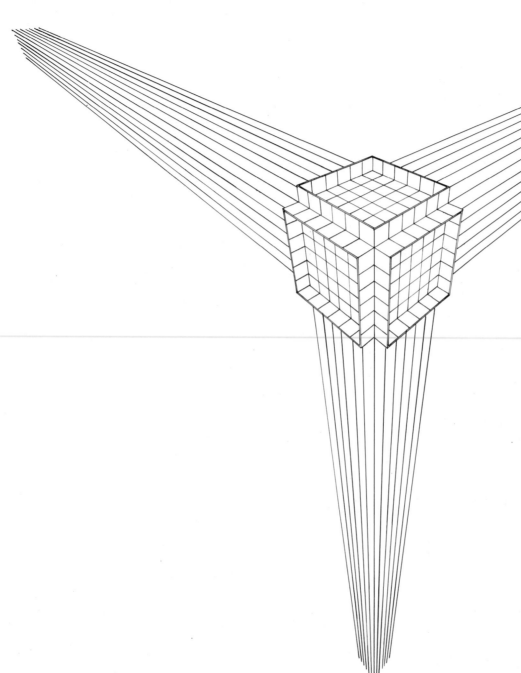

bundles of parallel lines will appear to converge at its own point on the horizon. It is possible to rotate all the bundles about the x-axis. In this case, neither the z-axis nor the y-axis are parallel to the picture plane. Only the x-axis is now parallel to the picture plane. Each of the other bundles of parallel lines will appear to converge at its own point on the vertical line.

THREE-POINT PERSPECTIVE

If no axes are parallel to the picture plane, the view is a three-point perspective.

In the third case, all the bundles are now rotated about both the x- and z-axes (but not by a multiple of 90°). (See Figure 5–4.) Now there are no axes parallel to the picture plane. On the picture plane, the image of each bundle will appear to converge at its own point. Rotation about only the x- and y-axes or the z- and

Figure 5-4 Three-point perspective

y-axes will not result in a three-point perspective. Since the *y*-axis is perpendicular to the picture plane (Figure 5–2), if we rotate the coordinate system about this axis, the other axes will still be parallel to the picture plane. If we rotate the coordinate system about either the *z*- and *y*-axes or the *x*- and *y*-axes, the result will be a listing two-point perspective. This would be the same as the view of the horizon from a banking airplane.

These definitions can be put into practical use immediately. Three of the seven numbers entered into the memory registers of a projection describe the state of rotation of the coordinate system. The *x*-rot, *y*-rot, and *z*-rot registers receive numbers that represent the amount of rotation in degrees, with the qualification that positive numbers mean counterclockwise rotation as seen from the positive pole.

Assuming that the four linear components have been entered into the memory registers, the following shows how the three different perspective views are produced merely by introducing rotation to the appropriate registers (the angle must not be a multiple of 90°).

ONE-POINT PERSPECTIVE

When 0.0000 has been entered into R-04 (*x*-rot), R-05 (*y*-rot), and R-06 (*z*-rot) a one-point perspective results.

The lines parallel to the *x*-axis will be horizontal, the lines parallel to the *z*-axis will be vertical, and the lines parallel to the *y*-axis will seem to converge when the image is projected on the picture plane. The intersection of the horizontal line (which is the observer's horizon) and the vertical line (which is the direction the observer's nose is pointing) is the point on the picture plane where the lines parallel to the *y*-axis appear to converge.

TWO-POINT PERSPECTIVE

When an angle has been entered into either the R-04 (*x*-rot) or the R-06 (*z*-rot) registers, a two-point perspective results.

When the coordinate system is rotated about the *z*-axis (or *x*-axis) the bundle of lines parallel to this axis will still be parallel after the rotation. A number entered into R-06 (*z*-rot) —the frequent case—will result in two vanishing points on the horizon line. A number entered into R-04 (*x*-rot)—the rare case—will result in two vanishing points on the vertical line of the picture plane. A number entered into the R-05 (*y*-rot) will result in a one-point perspective because both the *z*- and *x*-axes will still be parallel to the picture plane.

THREE-POINT PERSPECTIVE

When angles are entered into both R-04 (*x*-rot) and R-06 (*z*-rot), the result will be a three-point perspective.

Now there are no bundles parallel to the picture plane. If a number is entered into R-05 (y-rot) in addition, the three-point perspective will appear rotated on the picture plane.

If a number is entered into R-05 (y-rot) and either of the other two registers, a two-point perspective will result and the horizon line will be on a diagonal.

Thus, any perspective view, even eccentric views such as bird's-eye and worm's-eye, can be easily drawn using this system if we understand the nature of the rotation involved and enter the proper numbers in the proper registers.

For convenience, rotation about the z-axis will be called *turning,* and rotation about the x-axis will be called *tilting.* If we imagine a pizza sitting on the xy-plane of the coordinate system, we can turn the pizza about the vertical axis. As the pizza turns, all the pepperoni

change position relative to the observer though they are fixed relative to each other.

The pizza may be rotated about the x-axis by holding the pan in both hands and tilting the pizza toward or away from the observer. If we assume that the pizzeria is too dark to act as a frame of reference and the only thing we can see is the pie itself, there would be no difference in the image of the pizza on the picture plane if we tilted it toward the observer—a risky proposition since it might slip on to his lap—or if the observer stood up and looked down at the pizza from the same distance.

This can be extended to any case in which the observer is looking down from above or up from below (Figure 5-5). A bird's-eye perspective is usually taken to mean a false perspective where near things are at the bottom of the drawing and far things are at the top of the drawing, but everything is drawn at the same

size. When we tilt the view by rotating the axis, we create a true perspective as seen from above (Figure 5-6) or below (Figure 5-7). This view, as we have seen, will be a three-point perspective.

Three-point perspectives are usually illustrated by views that are the converse of the bird's-eye view, which are called here the worm's-eye view. This is a view of a tall building, with one vertical vanishing point and two horizontal vanishing points.

If we walk down Park Avenue and look straight ahead, all the vertical lines of the buildings will appear to be parallel. Since the buildings are tall, they extend far beyond our field of view; to see their cornices, we must tilt the head upward. It is only as we raise our eyes that the vertical lines begin to appear to converge, and we see a third vanishing point. Looking upward also has the effect of lower-

ing the horizon, and conversely, looking downward has the effect of raising the horizon. Not only does the horizon position change proportionally as we tilt the head, but also the position of the other two vanishing points on the horizon change. A single view looking both down the avenue and up at the building cornices cannot be drawn without introducing an element of distortion.

A single, fully integrated perspective system can replace three graphic methods and more accurately reflect how we see the world.

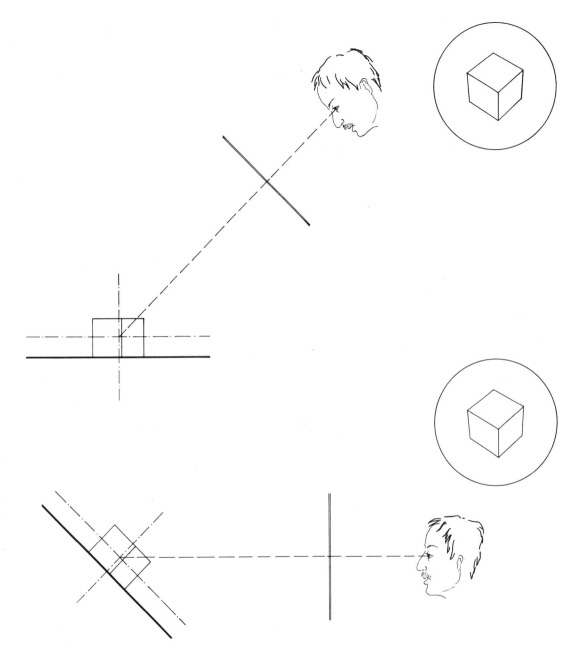

Figure 5-5

Figure 5-6 A bird's-eye view or in this case a buzzard's-eye view.

Figure 5–7 A worm's-eye view or in this case a maggot's-eye view.

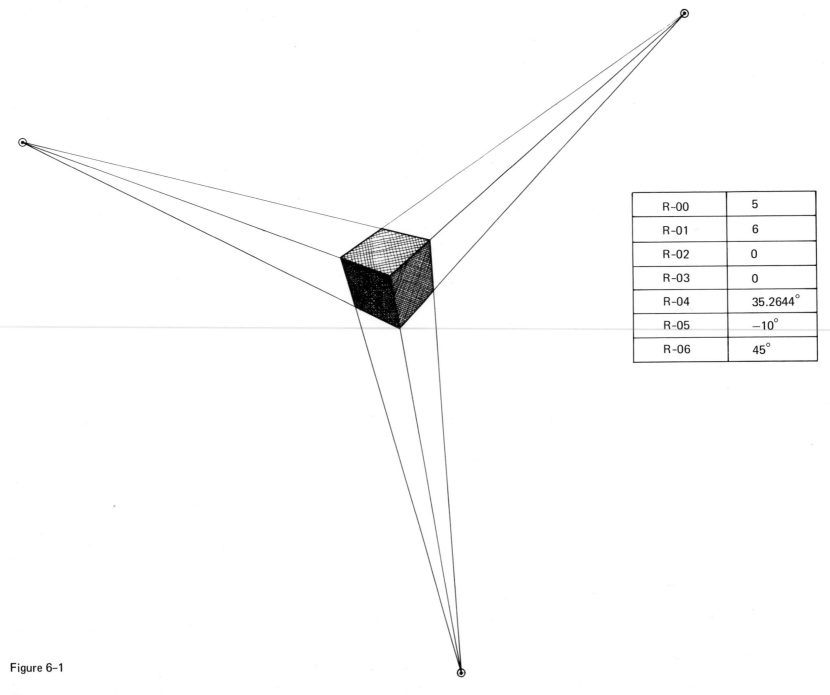

R–00	5
R–01	6
R–02	0
R–03	0
R–04	35.2644°
R–05	−10°
R–06	45°

Figure 6–1

6 AUTOMATIC COMPUTATION OF VANISHING POINTS

In traditional perspective methods, establishing the vanishing point is crucial to the construction of the drawing; a drawing cannot be made without the vanishing point. This inherently limits perspective views to a narrow range of angles. Using the programmable calculator frees perspective drawing from these restrictions. It is not necessary to find the vanishing point since a drawing can be made from a series of points that are independent of the vanishing point. However, locating a vanishing point is often very helpful. If the vanishing points are near at hand, they can reduce the number of measurements that have to be made. They also can act as an arbiter to help align two points.

The traditional definition of the vanishing point—a point where two parallel lines meet—does not offer much guidance toward finding a means of calculating vanishing points. There is nothing in our experience that proves that two parallel lines meet at a point. If we look at railroad tracks that appear to meet at the horizon and walk toward that point, we will never find it. We know that railroad tracks are always about the same distance apart. Even in Euclidean geometry, there is no proof that two parallel lines meet at a point. Consistent geometries, the non-Euclidean geometries, can be constructed using the assumption that parallel lines meet at no points or at two points.

To find a useful definition of vanishing points, it is necessary to think about them in a different way.

The great elliptical piazza in front of St. Peter's Cathedral in Rome is defined by a colonnade designed by Bernini. Walking in the piazza, two double-rows of columns create the feeling of being embraced by the long arms of the church. There is also a sense of being contained within a structure that is clearly open.

The illusion of containment is created by the alignment of the columns—from almost every point within the ellipse we see the first row of columns and a partial view of the columns beyond. There are, however, two points within the ellipse where the view is startlingly different: standing at the focus of the ellipse, on either side of the central obelisk, we see only the first row of columns and can see through the colonnade to the secular world beyond.

Let us imagine that we see by means of magical rays emanating from the eye. These rays travel in straight lines and stop when they strike something. These rays are of course symmetrical to the physical reality of a wave or a particle of light entering the eye. When we see something, we have a straight line of sight. Thus, when we look at the colonnade from the focus, these rays strike only the first row of columns. This obstructs any rays from striking any of the columns beyond.

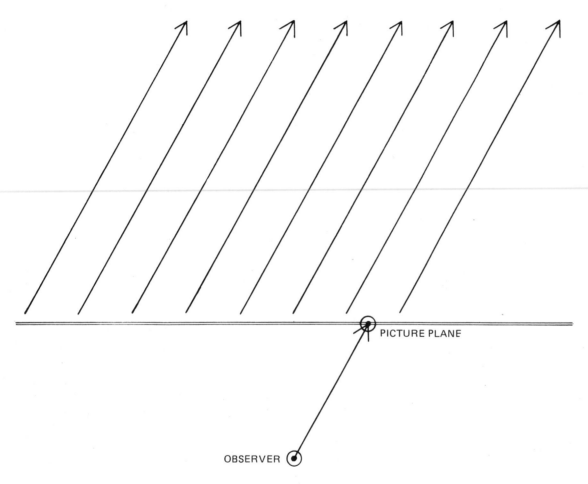

PICTURE PLANE

OBSERVER

There are several things we can conclude from this which may seem obvious but which can help lead toward a definition of the vanishing point. First, no matter where in the field of view something may be, there is a straight line that relates it to the eye. Second, no matter how many things are on the same line, the observer will see only one. One of the rules of perspective is that you cannot see around a corner.

This straight ray that emanates from the eye is akin to looking through the length of a soda straw. If you move the straw throughout the field of view, there is always a way of turning the straw so that it is possible to look through it. Now imagine that you have a large bunch of very long straws. They are stacked together in the bunch and tightly packed; thus, they are also parallel to each other. If we look at the ends of the straws, they form a wall of circles. Among all these circles, there will be one circle

Figure 6-2

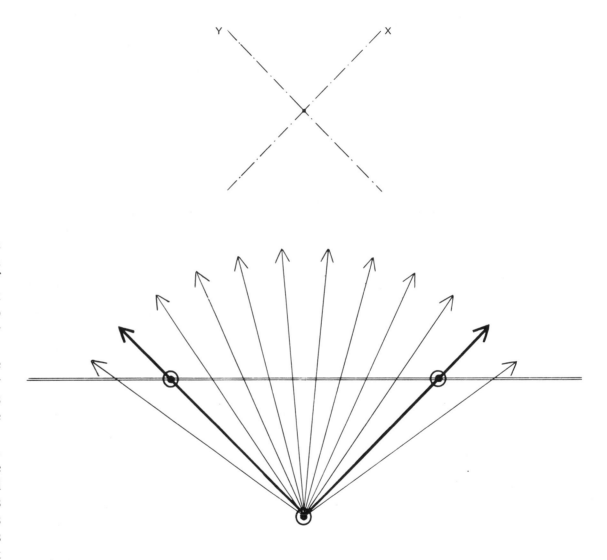

which the observer will be able to look through and see the world beyond. All that will be seen by looking down the others is the inside wall of the straw. The one straw that we can look through is the one that allows the visual ray to pass through. That is the visual ray exactly parallel to the bundle of straws.

If we insert a glass plate between the bundle of straws and the observer and mark the straw we can see through on the glass, this mark is the vanishing point for that particular bundle of parallel lines.

The observer's location is a single point. There is only one line that passes through the point that is parallel to that bundle of parallel lines. There is only one line that passes through the point that is parallel to each axis of the coordinate system. This line intersects the picture plane at only one point. This point is the vanishing point (Figure 6-2).

Using this definition, it is always possible to

Figure 6-3

	b	c
R-00	5	5
R-01	6	6
R-02	0	0
R-03	−3	−3
R-04	0	0
R-05	0	0
R-06	30	60

a

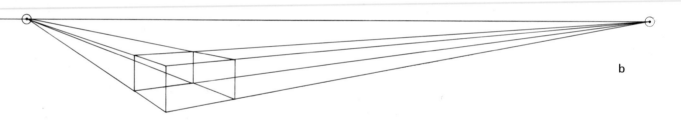

b

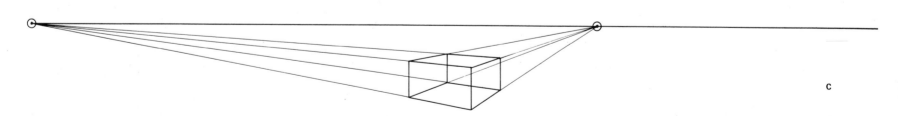

c

Figure 6–4

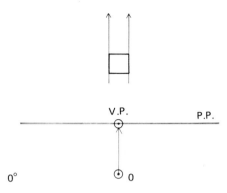

0°

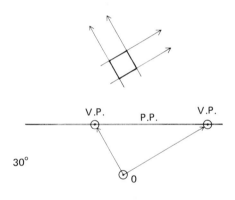

30°

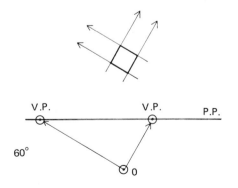

60°

Figure 6-5

calculate the position of the vanishing point on the picture plane given the angular relationship of the bundle to the observer—the x-rot, y-rot, and z-rot—and the distance of the observer to the picture plane. When parallel lines are rotated about the x-, y-, and z-axes, it is convenient to think of the eye as the apex of a visual cone (Figure 6-3).

MOVEMENT OF VANISHING POINTS WITH ROTATION OF COORDINATE SYSTEM

Rotation about the z-, or vertical, axis, results in the vanishing point moving along the horizon or eye level (Figure 6-4). The vanishing point is located at the point where the line of sight becomes parallel to the parallel lines (Figure 6-5).

Another way of describing this is that the parallel lines form an angle with the normal to the picture plane. When the line of sight forms an equal angle, that is said to be the vanishing point (Figure 6-6).

The position of this point in the picture plane may be found by the relationship:

$$a = \frac{L}{\tan \ominus}$$

where a is the distance along the horizon from the origin, L is the distance from the apex of the visual cone to the picture plane, and \ominus is equal to z-rot (Figure 6-7). No matter how the z-axis rotates, the vanishing point will be on the horizon.

Rotation about the y- and z-axes results in the vanishing point describing a circle. The radius of a circle is defined:

$$r = \frac{L}{\tan \ominus}$$

71

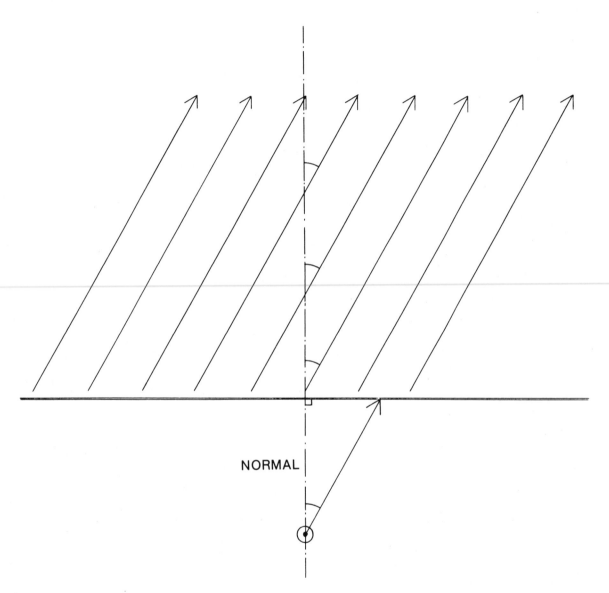

In the special case when y-rot $= 0$, it can be seen that the vanishing point is on the horizon line and $r = a$. The position of the vanishing point satisfies the equation:

$$r^2 = x^2 + y^2$$

The y-axis is normal to the picture plane. Since the line of sight forms an angle with the normal, as the normal rotates, the line of sight rotates, cutting a circle on the picture plane (Figure 6–8).

NORMAL

Figure 6–6

72

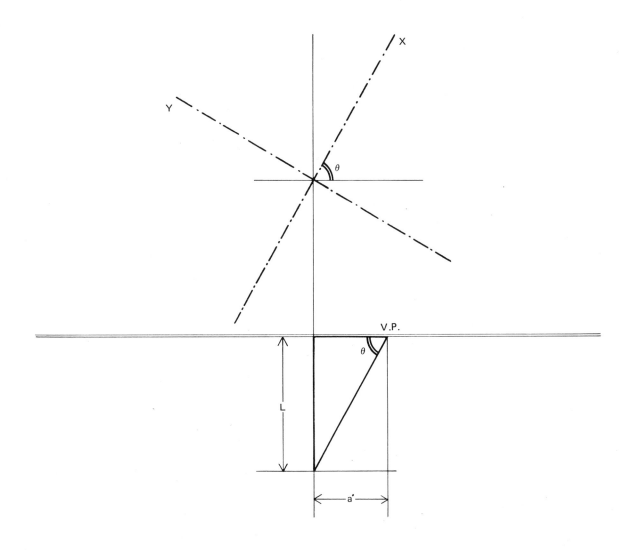

Figure 6–7

73

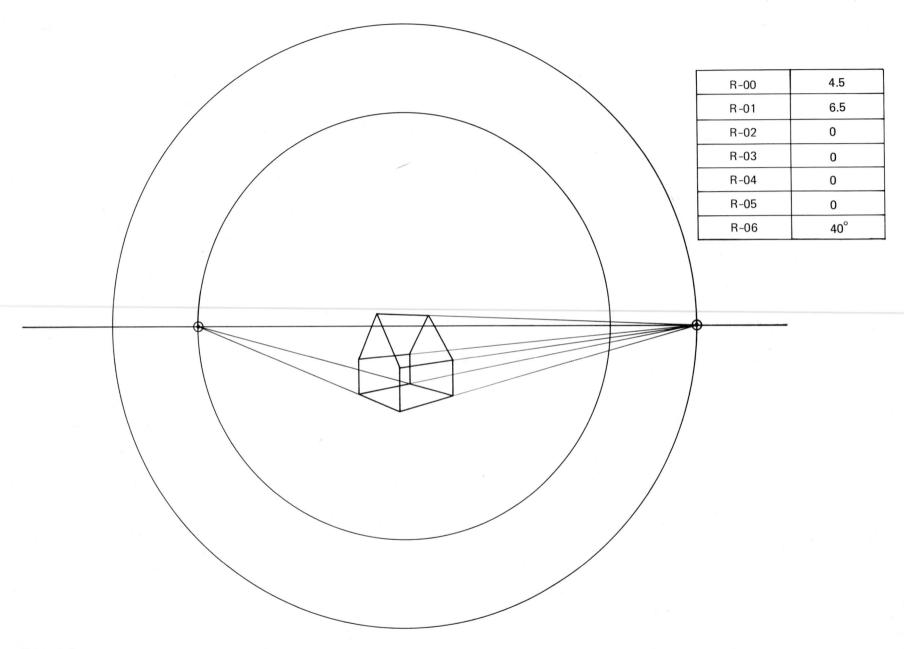

R-00	4.5
R-01	6.5
R-02	0
R-03	0
R-04	0
R-05	0
R-06	40°

Figure 6-8a

R-00	4.5
R-01	5.6
R-02	0
R-03	0
R-04	0
R-05	$-120°$
R-06	$40°$

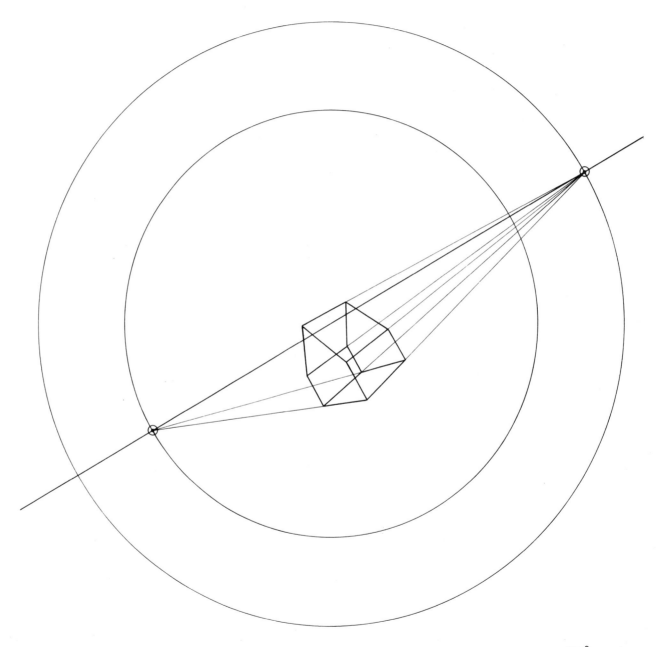

Figure 6-8b $-120°$ rotation.

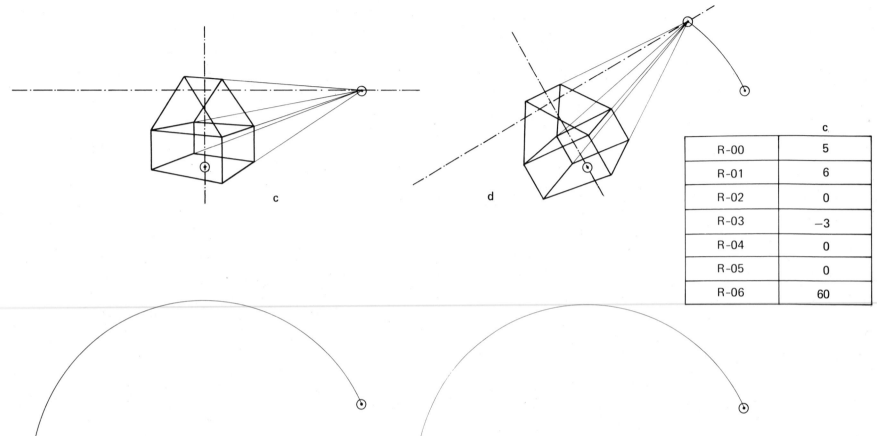

	c
R-00	5
R-01	6
R-02	0
R-03	−3
R-04	0
R-05	0
R-06	60

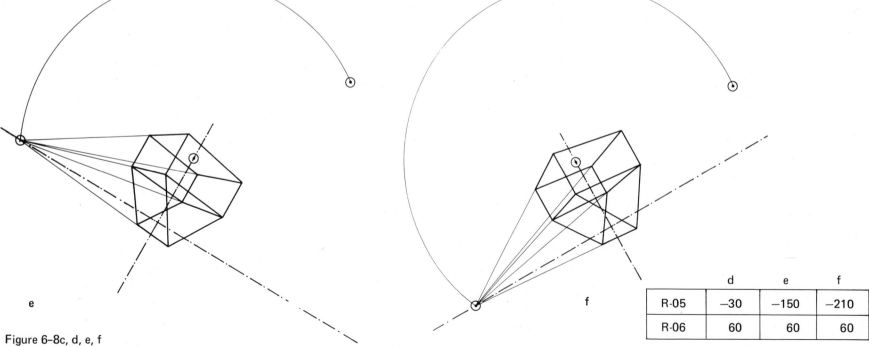

	d	e	f
R-05	−30	−150	−210
R-06	60	60	60

Figure 6–8c, d, e, f

76

Rotation about x- and z-axes results in the vanishing point describing a hyperbola. Figure 6–9 illustrates how the vanishing points would appear in different states of rotation. The horizon lines become progressively higher as the x-axis is tilted toward the observer. Figure 6–10 illustrates the curve that a single vanishing point would describe in a 360° rotation. It may be observed that as the horizon line moves progressively higher, the vanishing point moves farther from the vertical line, as the x-axis rotates from 0°–90°. From 90°–180°, the horizon line starts from the distant bottom of the picture plane and moves upward. As the coordinate system tumbles forward, the vanishing point traces the two hyperbolas, until it returns to the original position after a 360° rotation.

The coordinates of the vanishing point satisfies the equation:

$$\frac{x^2}{a^2} - \frac{y^2}{L^2} = 1$$

L is the distance from the apex of the visual cone to the picture plane and a is defined:

$$a = \frac{L}{tan\ \Theta}$$

This is easy to see if you imagine two cases, x-rot $= 0$ and x-rot $= 90°$. In the first case it is the same as having only rotation about the z-, or vertical, axis, and the vanishing point is on the horizon. In the second case, the xy-plane is parallel to the picture plane, thus the parallel lines in that plane appear as parallel lines in the picture plane. As the rotation of the x-axis approaches the vertical, the parallel lines approach being projected as parallel, with the vanishing points very far away.

Rotation about only the y-axis results in no movement of the vanishing point. The vanishing point is located at the intersection of the horizon line and the vertical line on the picture plane.

Rotation about only the x-axis results in two vanishing points on the vertical line. The position is defined by the following equation:

$$y = L(tan\ \Theta)$$

where y is the distance from the origin along the vertical line, L is the distance from the apex of the visual cone to the picture plane, and Θ is the amount of rotation about the x-axis (Figure 6–11).

Rotation about the x- and y-axes has the same result as rotation about the z- and y-axes.

Rotation about all three axes results in three vanishing points describing three concentric circles.

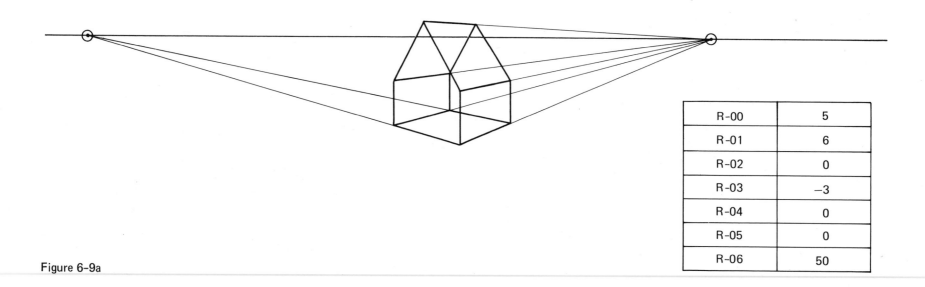

Figure 6-9a

R-00	5
R-01	6
R-02	0
R-03	-3
R-04	0
R-05	0
R-06	50

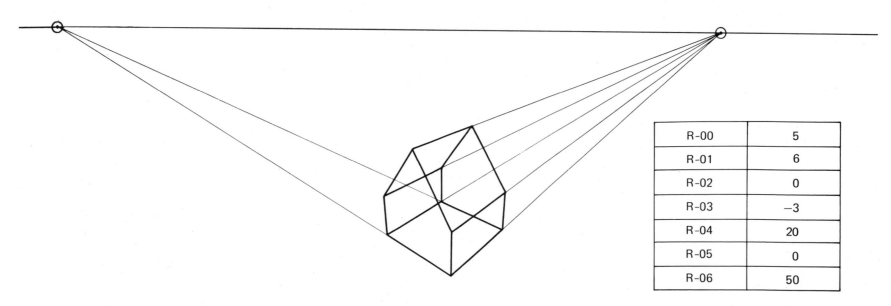

Figure 6-9b

R-00	5
R-01	6
R-02	0
R-03	-3
R-04	20
R-05	0
R-06	50

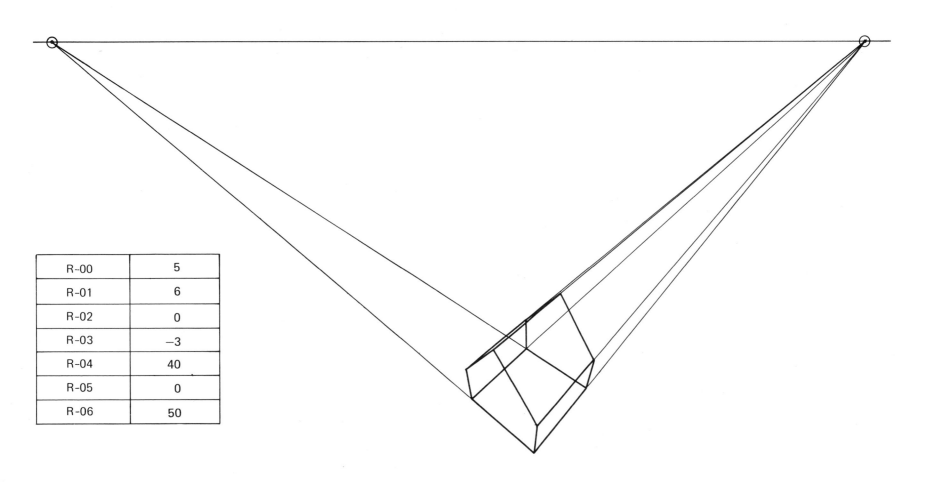

R-00	5
R-01	6
R-02	0
R-03	−3
R-04	40
R-05	0
R-06	50

Figure 6-9c

79

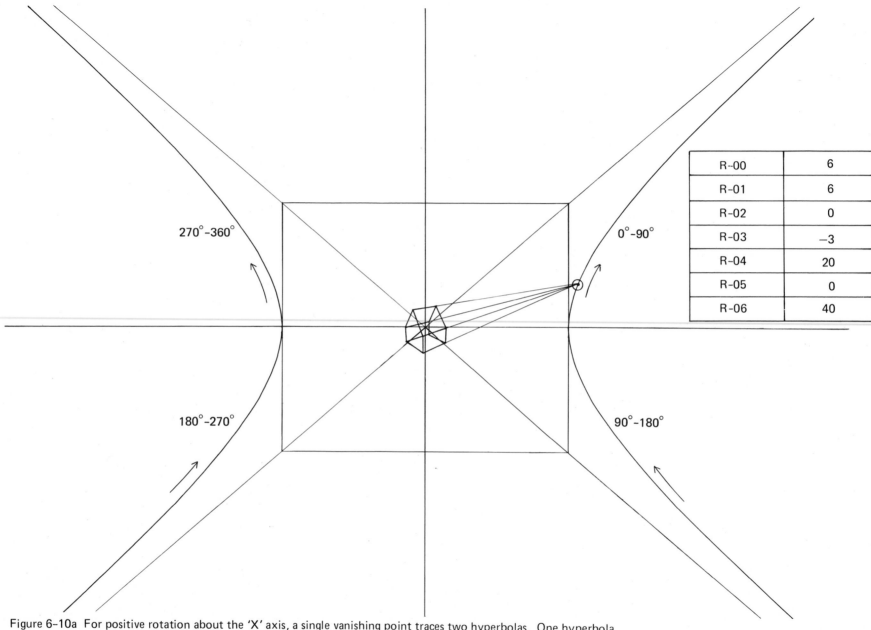

R–00	6
R–01	6
R–02	0
R–03	–3
R–04	20
R–05	0
R–06	40

270°-360°

0°-90°

180°-270°

90°-180°

Figure 6-10a For positive rotation about the 'X' axis, a single vanishing point traces two hyperbolas. One hyperbola is generated as the coordinate system rotates from 0°-180°, the other is generated from 180°-360°, in the direction as noted by the arrows.

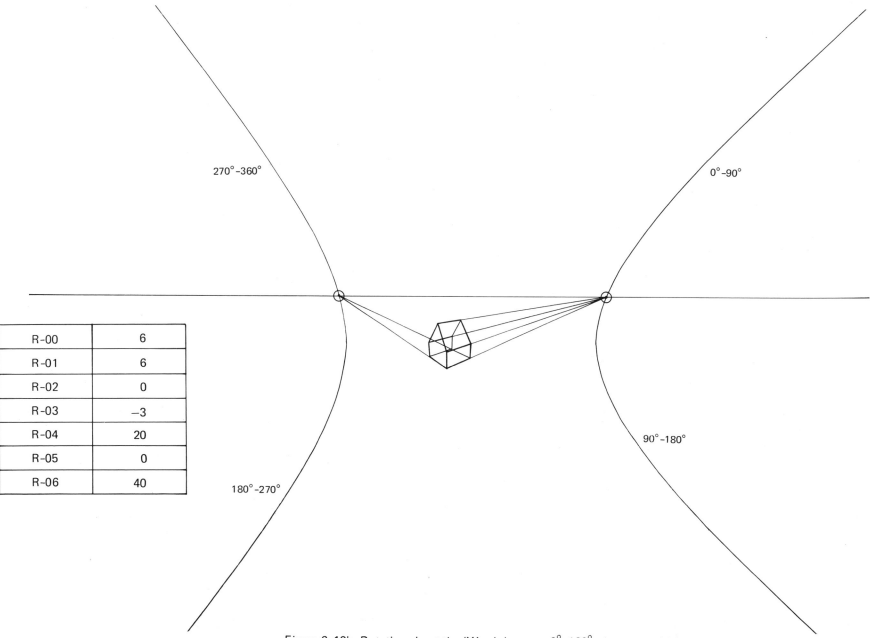

R-00	6
R-01	6
R-02	0
R-03	−3
R-04	20
R-05	0
R-06	40

270°-360°

0°-90°

90°-180°

180°-270°

Figure 6-10b Rotation about the 'X' axis between 0°-180°, the two vanishing points describes two hyperbolas. As the 'X' axis rotates from 0°-90°, the horizon line connecting the two vanishing point moves upward and the vanishing point moves farther apart.

81

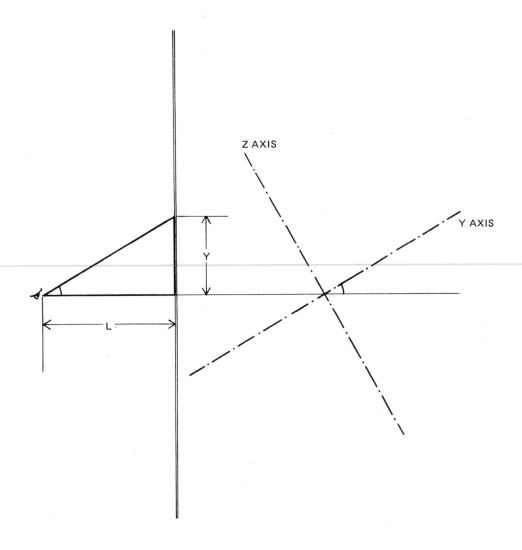

Figure 6-11

82

VP PROGRAM

For those who own calculators with small program capacity, it will be necessary to sort through these equations to compute the vanishing points for a particular situation. The mathematical expressions for the vanishing points can be consolidated into a single program. This allows the vanishing points to be calculated without having to remember the formulas. The program also takes into account the possibility that a two-point or three-point perspective may also be rotated about the y-axis. The program computes the vanishing points by taking the eye-to-picture-plane distance, and the rotations about the x-, y-, and z-axes from the memory registers. The program needs no other information, and it produces the coordinates of the vanishing points that would appear on the picture plane.

VAN PT PROGRAM

The vanishing point may be found by a second method. There may be a plane that is not parallel to the coordinate planes such as a gable roof. Without having to calculate the equivalent amount of rotation of the plane, which in some cases may be difficult, the second method allows you to compute the position of the vanishing point given four points—any two points on two parallel lines.

This method of finding the vanishing point is designated the VAN PT Program. The program requires four points—any two points on two parallel lines each defined by its coordinates (x,y,z). The first line will be defined by points 1 and 2. The second line will be defined by points 3 and 4. The order of the points within a line is not important, but the pairing of the points is important. A square with the vertices $a\ b\ c\ d$ (Figure 6–12) might have two vanishing points. In the first case a–b must be entered as points 1 and 2, and c–d must be entered as points 3 and 4. In the second case there is also a vanishing point for lines a–d and b–c; a–d must be entered as points 1 and 2 and b–c must be entered as points 3 and 4. Again the order of the points is not important, but the pairing is important. The program produces the coordinates of the vanishing point in the form $X = \ldots, Y = \ldots.$

A word of warning about interpreting the results of the vanishing point calculation. Extremely small numbers such as 8.0000×10^{-9} should be interpreted as 0.0000; extremely large numbers can be interpreted for all practical purposes as infinitely far away, and lines leading to such a vanishing point would be parallel. It also sometimes happens that a number is the limiting case, and approaching

the limit would require the illegal computation of dividing by zero. This will produce a DATA ERROR in the display. This problem may be overcome by picking another point closely adjacent but having a dimension that is computable by the calculator.

CONCLUSION

Vanishing points are useful if they are near at hand, but frequently they are very far away. A one-degree rotation of the coordinate system, with the eye-to-picture-plane distance of 24″ means that one vanishing point is relatively near at hand, 0.4189″ in the positive direction on the horizon line with the coordinates (0.4189, 0.0000), while the other is 1,374.9591″ away in the negative direction on the horizon line with the coordinates

(-1,374.9591, 0.0000). Even with relatively large rotation, the vanishing point may be inconveniently far away:

Rot.	V.P. No. 1	V.P. No. 2
10°	(136.1108, 0.0000)	(-4.2318, 0.0000)
20°	(65.9395, 0.0000)	(-8.7353, 0.0000)
30°	(41.5692, 0.0000)	(-13.8564, 0.0000)

There will usually be at least one vanishing point relatively nearby. The maximum distance for the nearest vanishing point is reached when the coordinate system is rotated 45° about the vertical axis, and the two vanishing points are equally far away and equal to the eye-to-picture-plane distance. In any other case, there is one vanishing point that is nearer.

Dependence on the vanishing points makes perspective drawing, in all but a narrow range of angles, physically very difficult. With the programmable calculator it is possible to lay out the perspective without any vanishing points or with one or more when convenient. Since the positions of all the vanishing points are easily calculated, they can be used to facilitate drawing, but they need never be a hindrance.

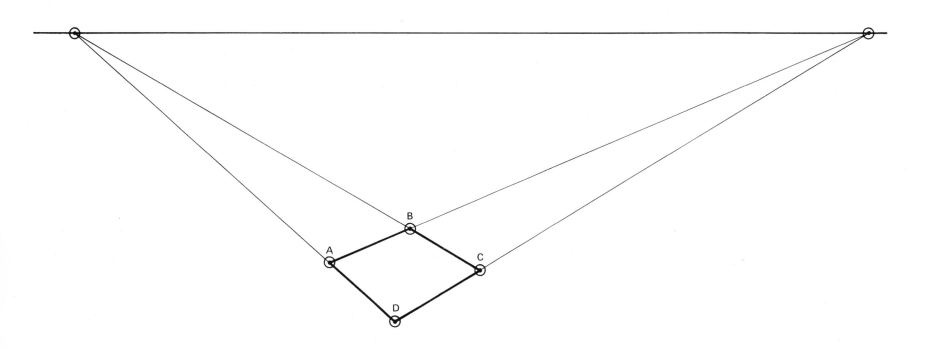

Figure 6–12a

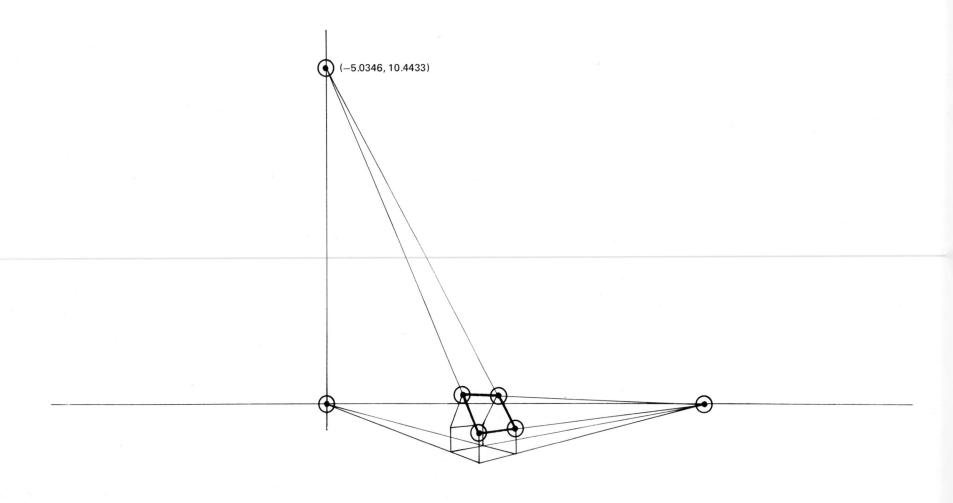

(−5.0346, 10.4433)

Figure 6-12b The van PT program may be used to calculate the vanishing point of a gable roof. This point is on a vertical line with the V.P. on the horizon line.

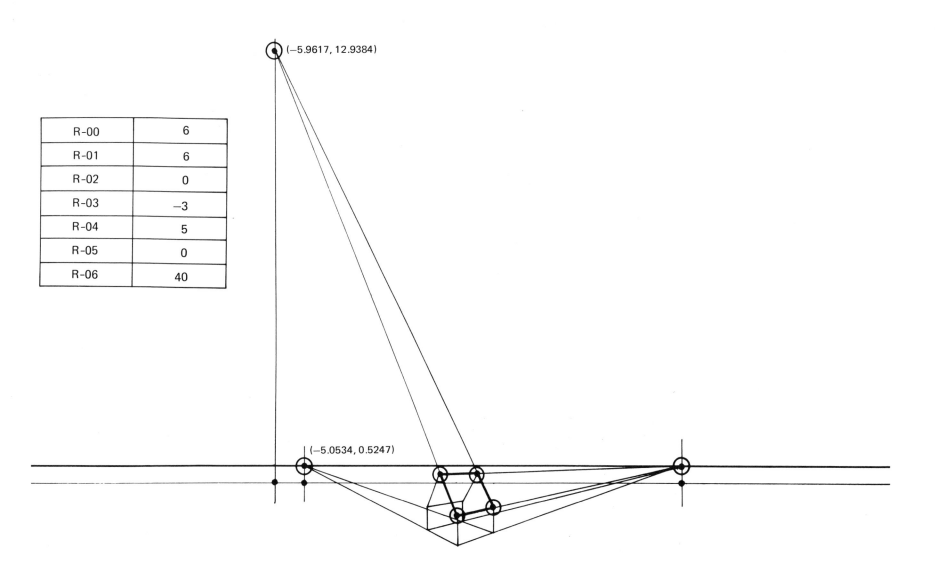

R-00	6
R-01	6
R-02	0
R-03	−3
R-04	5
R-05	0
R-06	40

(−5.9617, 12.9384)

(−5.0534, 0.5247)

Figure 6-12c When the coordinate system is rotated about the 'X' axis, the gable roof V.P. is no longer on a vertical line with the V.P. on the horizon line.

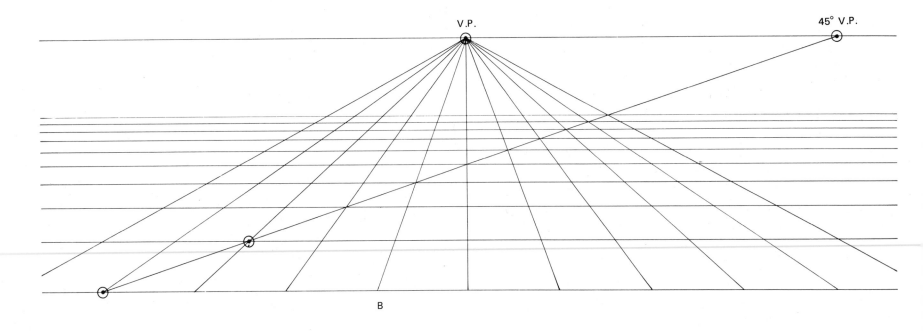

V.P.

45° V.P.

B

A

Figure 7-1

7 GRIDS AND MAPS

In linear perspective, there are a number of factors that contribute to the illusion of space and distance: the convergence of parallel lines, the reduction of size with distance, and the narrowing of lines that apparently are equally spaced. The pattern of square floor tiles has long been a device to suggest space and distance, and finding the spacing of the tiles will lead to an understanding of how distance is gauged in perspective.

The convergence of lines is easiest to demonstrate graphically, and it can be done with a scale and straightedge. If we take convergence as an abstract idea without reference to any particular space, we can draw a horizon line and mark a point near the center of that line. We can then draw a second line below it and on this line mark off equal distances with the scale. When we connect the points of the second line with the point on the first line, all the lines will seem to meet at a vanishing point. This completes the convergence component.

This in itself, however, does not create a very effective illusion of space. There are no milestones, no indication of scale. It appears as if we were looking down an infinitely long bowling alley.

If we want to show floor tiles, we must draw in the orthogonal lines. The narrowing of these lines will create the sense of distance. We now run into the problem of graphics: How do we determine the spacing between the first and second line, and how do we determine the rate that subsequent lines narrow? This problem puzzled people in the Renaissance who spent time staring at the pattern of square floor tiles. With their instruments, it was difficult enough to gauge the amount of change between rows of tiles, let alone deduce the numerical relationship. One early attempt was to say that each subsequent line was diminished by one-third from the preceding length. This was wrong.

A correct method found in the Renaissance was ingenious. We must keep in mind that each equal division of the second line represents one side of a square on a row of equal squares. If we imagine the diagonals of these squares, all the diagonals would be parallel. If they are parallel, they must converge at a vanishing point. As we have seen in the chapter on vanishing points, when we have a rotation of 45°, which would be the angle of the diagonal to the picture plane, the distance of the observer to the picture plane must be equal to the distance from the central vanishing point to the 45° vanishing point. After we plot this new vanishing point, we can connect it to any point on the line marked with equal divisions. This would be the diagonal of the squares (Figure 7–1). The square becomes defined when the diagonal intersects the adjacent side, the next line converging at the central vanishing point. The square becomes complete when a line parallel to the horizon is drawn through this intersection. As we con-

tinue drawing the diagonal, it intersects additional lines that are converging toward the central vanishing point. Each intersection defines a new square. If parallel lines are drawn through all these intersections, the result will appear to be equally spaced lines as the floor tiles recede toward the horizon. With a single line, the spacing of all narrowing parallel lines is determined.

This solution works well for a one-point perspective grid of squares, but for anything more intricate, it becomes difficult to apply. There is a numerical method that remains invariant throughout rotation. The rate at which parallel lines of equal spacing narrow in perspective is not a direct ratio, such as diminishing by one-third for each new line. It is a *cross ratio,* the ratio of two ratios. Given the coordinates of three points which indicate two equal lengths, the fourth point, or next line, and subsequent points can always be found.

The points could be found using the basic perspective program; but since there is a direct numerical relationship between points, the CR program (which calculates new points by means of the cross ratio) is much simpler and consequently operates much faster. The following is the procedure for using the CR program:

CR Program

1. Enter the seven numbers into the memory registers for the basic perspective program.
2. Set flag 01 if X dimension is desired or clear flag 01 if Y dimension is desired.
3. Enter the number of additional points desired.
4. Enter the coordinates in three dimensions in the form *zyx* of point 1, point 2, and point 3. The distance from point 1 to point 2 must be equal to the distance from point 2 to point 3.

The result will be the X- and Y-coordinates on the picture plane of the first three points and the X- or Y-coordinate (as specified in item 2) of the additional number of points (as specified in item 3).

ONE-POINT PERSPECTIVE

Use the basic perspective program to plot the first two equidistant points. Subsequent points can be located with a scale and straightedge. Connect all the points to the vanishing point—the intersection of the vertical and horizontal axes of the grid (Figure 7–2).

Use the CR program procedure to compute the points of the grid along the x- or y-axis (y in this case). (See Figure 7–3.) Draw in the parallel lines, and they will narrow correctly (Figure 7–4).

R-00	24
R-01	24
R-02	0
R-03	−8
R-04	0
R-05	0
R-06	0

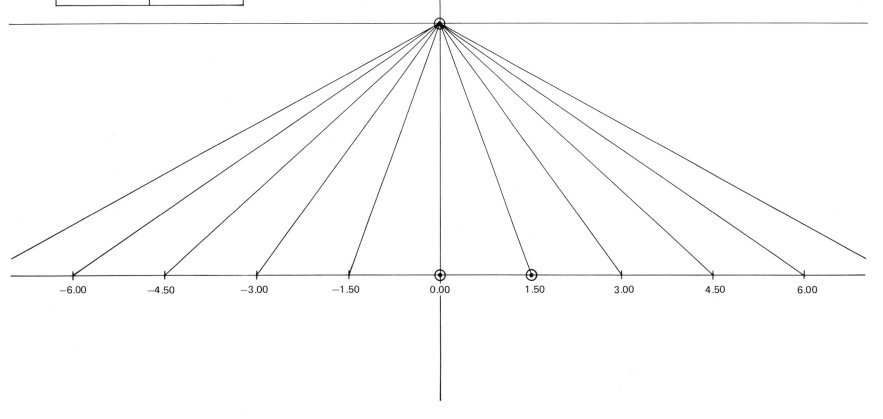

Figure 7-2

R-00	24
R-01	24
R-02	0
R-03	−8
R-04	0
R-05	0
R-06	0

Figure 7–3

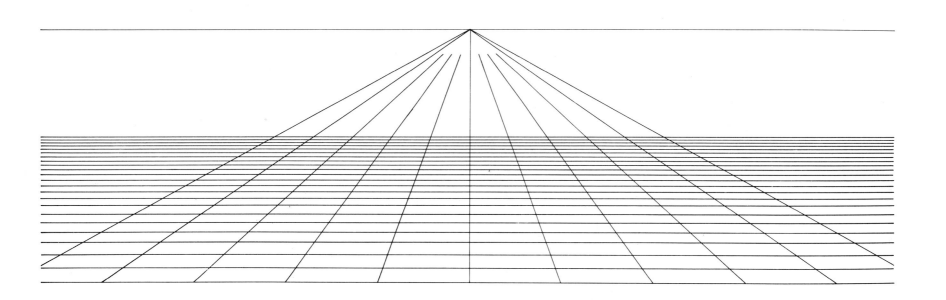

Figure 7-4

Calculate the vanishing points. Follow the procedure for the CR program. Draw a line through the first three points to the vanishing point. Mark off where the additional Y values intersect this line (Figure 7–5). Then connect these positions to the opposite vanishing point. To find the orthogonal grid, repeat this entire procedure (Figure 7–6). The resulting grid will be in correct perspective (Figure 7–7). If the vanishing point is too far to reach with a straightedge, repeat the program for another parallel line a comfortable distance away. Connecting the points along these parallel lines will be the same as connecting directly to the vanishing point, as illustrated by the three-point perspective grid (Figures 7–8, 7–9, and 7–10).

PRACTICAL EXAMPLE

Using this method, grids can be drawn on any plane, not just the horizontal plane and can be drawn even when the vanishing points are very far away. It is only a matter of finding three equally spaced points on a line. All other points on that line result from the CR program. It is sometimes useful to plot a grid on the facade of a building as the guide lines for drawing details. Grids drawn on vertical planes give a quick and direct sense of three dimensions.

The office building in the example can be drawn easily using the programmable calculator. When we have specified the seven numbers of the basic perspective program, we can calculate the position of the near vanishing point by using the VP program or by using the relationship:

$$\frac{24''}{\tan 75°} = 6.4308''$$

24″ is the distance from the observer to the picture plane. 75° is the angle that the building is turned toward the observer. Since the result is positive, the vanishing point is to the right of the intersection of the vertical and the horizon lines on the horizon line.

We take the origin to be the near corner of the building, and we take the grid to be 10 feet in the vertical direction and 6 feet in the horizontal direction (Figure 7–11).

We first mark the positions of the vertical dimensions since the coordinate system is only rotated about the z-axis and all the floor heights will be equal. Therefore, it is only necessary to calculate the top and bottom of the vertical line and to divide the line into twenty equal parts. We find that the 200 feet of the building translates to 10 inches on the

drawing, and that the 10 feet of the grid is 0.5 inches on the drawing.

The face of the building on the right of this edge can be drawn by connecting each point on the line to the near vanishing point which we have already found (Figure 7–12). Each horizontal element of the right face will now be correct in perspective.

The face of the building on the left of the edge could be found by connecting all the floors to the left vanishing point:

$$\frac{24''}{\tan 15°} = 89.5692''$$

Again, 24″ is the distance from the observer to the picture plane, and 15° is the angle that the face is turned toward the observer. Since this vanishing point is nearly 7.5 feet away from the center of the drawing, it is too cumbersome to use. Instead we can compute the position of the top and bottom points of the line representing the left edge of the building using the basic perspective program. This line can be divided into twenty equal segments and the spacing between each division will be found to be 0.4843 inches. Corresponding points between the two lines can be connected, and the floors on this face of the building have been described (Figure 7–13).

The vertical lines for the building can be found by using the CR program once for each face. For the left face we must use the following three points:

$$(0, 0, 0)$$
$$(0, 6, 0)$$
$$(0, 12, 0)$$

The program will produce a list of dimensions which will be marked on the x-axis to the left of center.

For the right face of the building, the following dimensions must be used:

$$(0, 0, 0)$$
$$(6, 0, 0)$$
$$(12, 0, 0)$$

The program will produce a list of dimensions which will be marked on the x-axis to the right of center. The vertical lines drawn through these points will be equally spaced as they will appear in perspective (Figures 7–14 and 7–15).

It is possible to buy predrawn grids to make perspective drawings, but with this method it is possible to design any special grid, for any purpose, at any size. It takes so little computing time that the length of time it takes to produce a grid is determined by the speed with which a draftsman can plot points and draw lines.

R–00	24
R–01	16
R–02	0
R–03	−8
R–04	0
R–05	0
R–06	−15

−6.95 −4.92 −3.34 −1.70

(6.4308, 0)

(1.77, 4.8) (3.61, 4.44) (5.53, 5.09)

Figure 7-5

(5.53, 5.09)

Figure 7-6

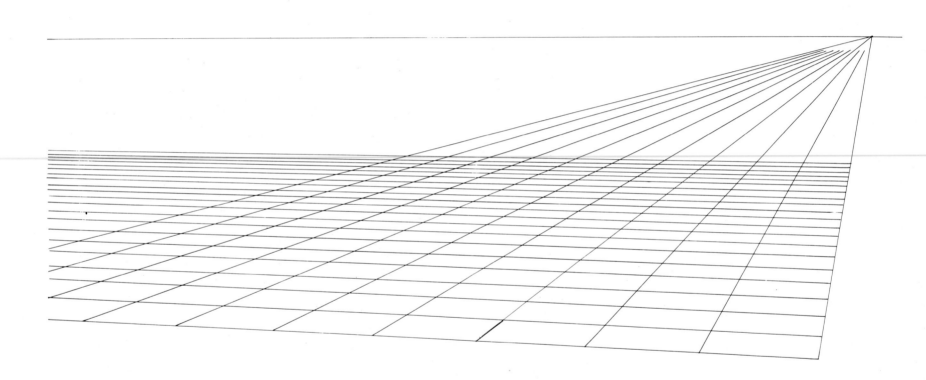

Figure 7-7

98

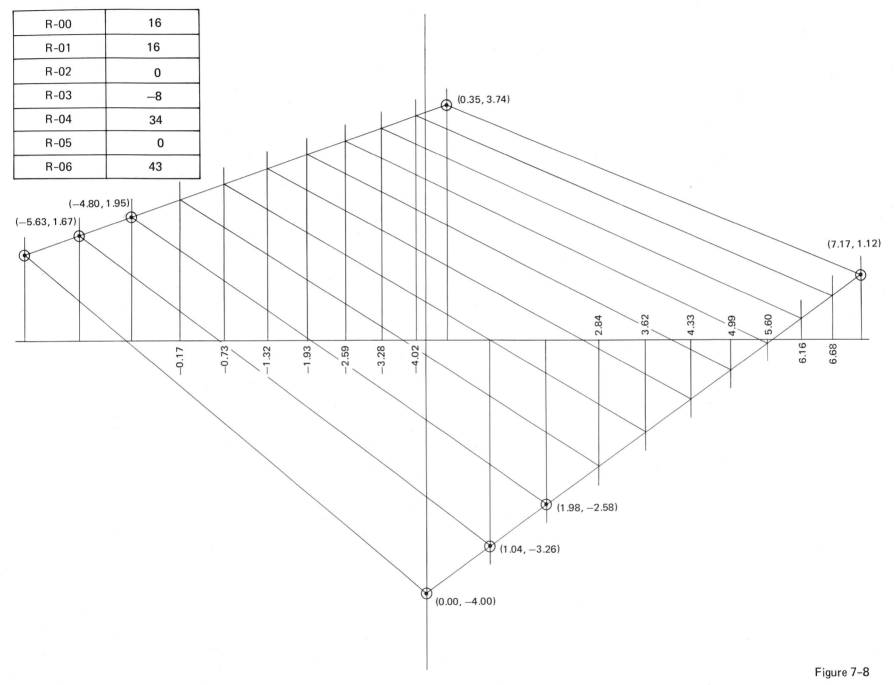

R-00	16
R-01	16
R-02	0
R-03	−8
R-04	34
R-05	0
R-06	43

(0.35, 3.74)

(−4.80, 1.95)

(−5.63, 1.67)

(7.17, 1.12)

2.84

3.62

4.33

4.99

5.60

6.16

6.68

−0.17

−0.73

−1.32

−1.93

−2.59

−3.28

−4.02

(1.98, −2.58)

(1.04, −3.26)

(0.00, −4.00)

Figure 7-8

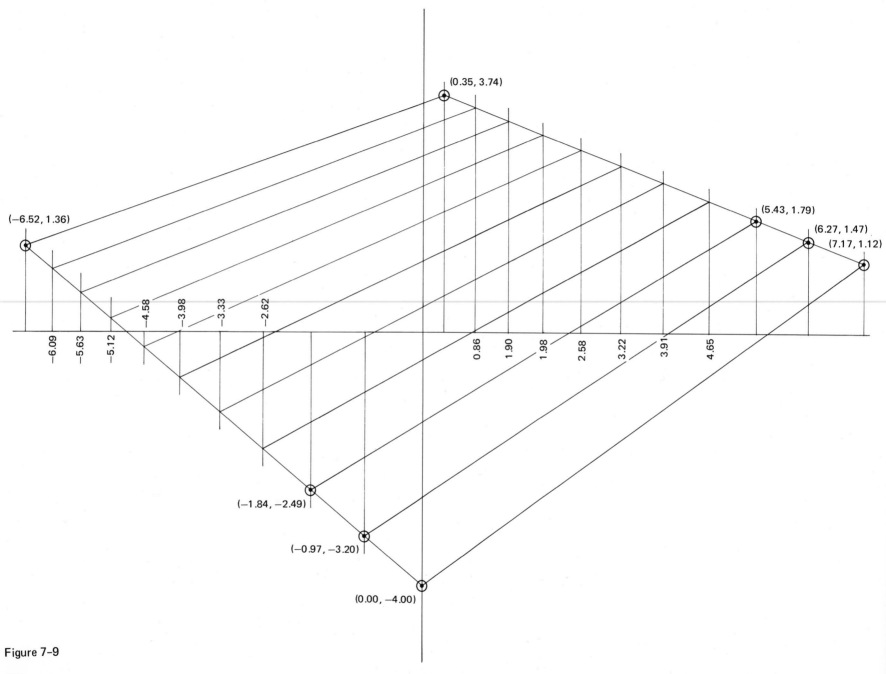

Figure 7–9

100

Figure 7-10

200

ELEVATION

R-00	24
R-01	456
R-02	0
R-03	−50
R-04	0
R-05	0
R-06	75

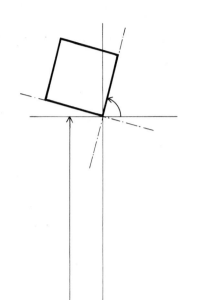

456

PICTURE PLANE

24

PLAN

10

6

GRID PANEL

Figure 7-11

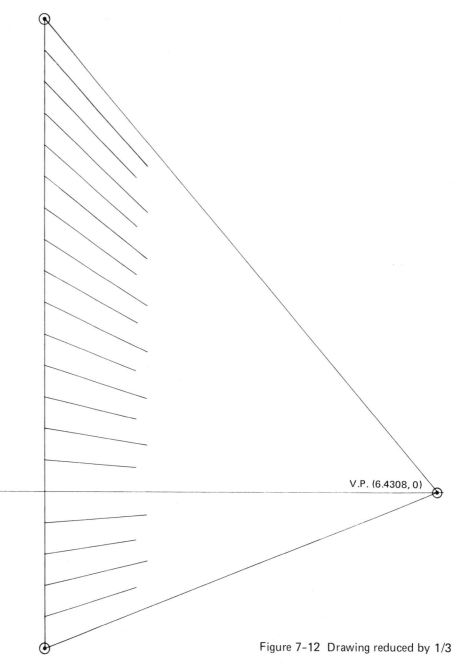

V.P. (6.4308, 0)

Figure 7-12 Drawing reduced by 1/3

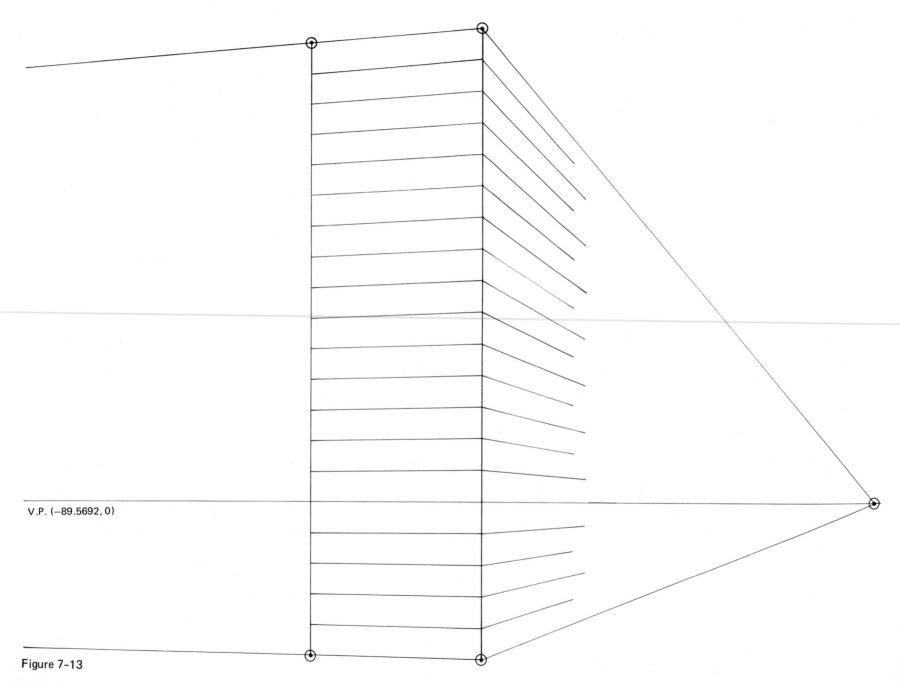

V.P. (−89.5692, 0)

Figure 7-13

Figure 7-14

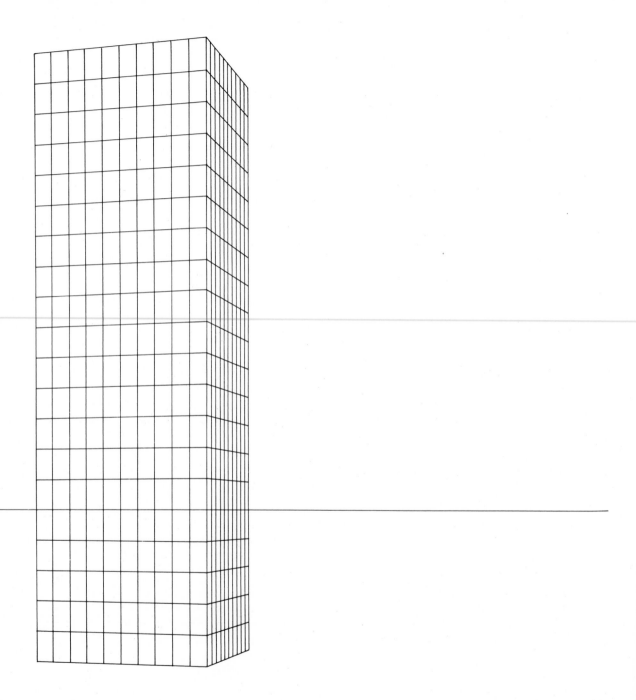

Figure 7-15

106

TOPOGRAPHY IN PERSPECTIVE

The grids described so far have been essentially in one plane. It is possible to think of this grid as a surface, a kind of skin that can be stretched or deformed. If we have an equal grid spacing in two dimensions but allow the vertical dimension to change, we come up with a grid that expresses the qualities of a varying surface. We will then be able to see topographical features in perspective, as if wire mesh was molded to conform to the earth's surface.

The information to plot such a drawing is readily available. A topographic map contains information on all three dimensions. The map coordinates define a plane and the contour lines add the third dimension. If we establish a grid system on the map and a central reference point, we merely have to read off the ground elevation and grid coordinates (Figure 7–16), enter them into the basic perspective program, and we will have that point as seen in perspective.

There are three basic approaches to making perspective views of topography. The drawings can all be derived from information on the topographical map. They differ in their visual effect, in the information they contain, and in their ease of execution.

The first method is to maintain the square grid in the horizontal plane and vary the vertical distances. If there is no change in elevation, the drawing will be the same as that of square floor tiles. As there are slight changes in the elevation, the shape of the squares will deform and the length of the sides will increase. When the changes in elevation are dramatic, the sides of the quadrilateral will be exaggerated, giving weight to such deformations (Figure 7–17). The ground forms will assume a cubist quality. The disadvantage of doing this is that the sensuousness of the surface is directly proportional to the number of points that are plotted, and even a relatively simple topography may require an enormous number of points. Also, the visual quality of the surface may dominate anything that is placed on it, and a great deal of finesse is required to balance the drawing so that the observer's attention will not be led astray.

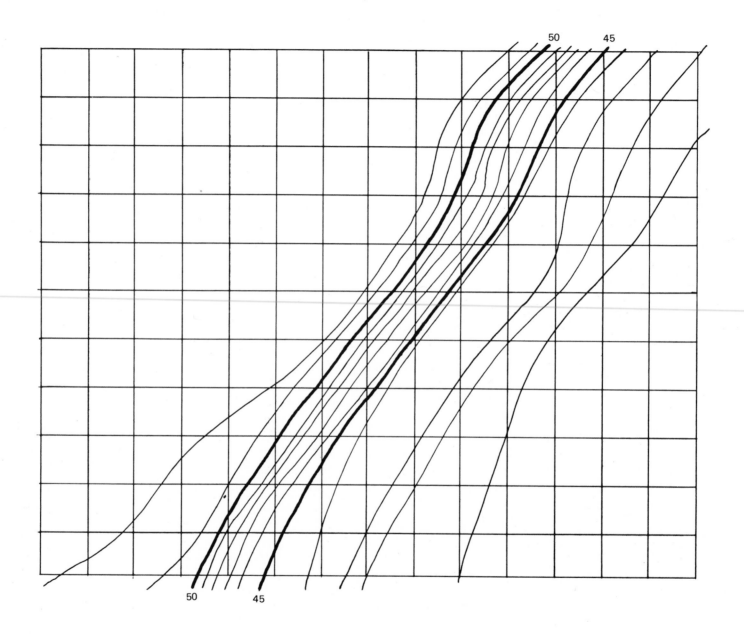

Figure 7-16 Topographical map

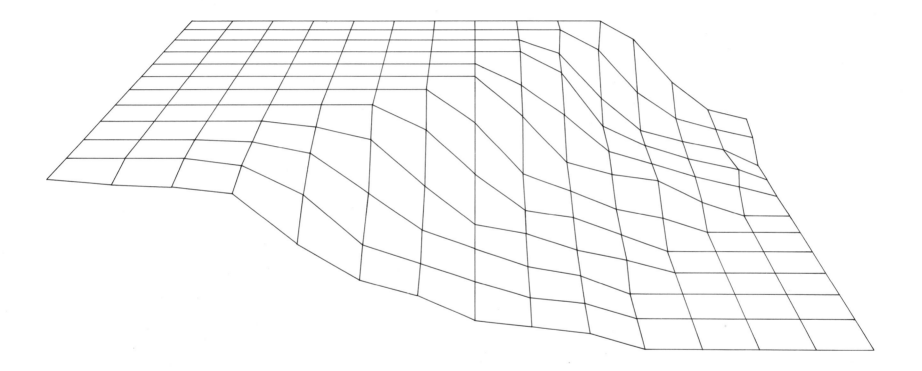

Figure 7-17

109

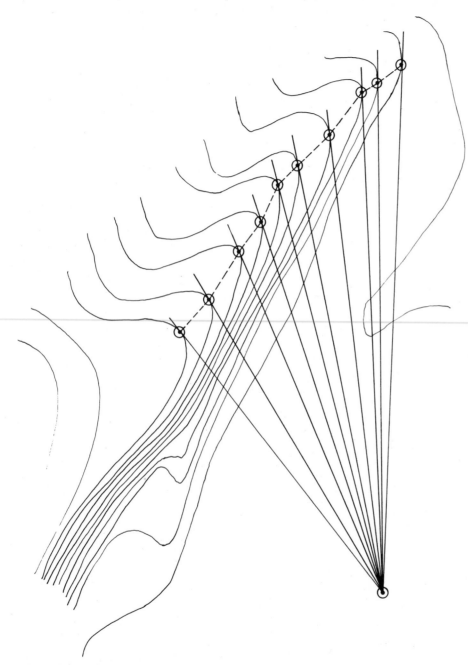

The second method is to follow a particular contour line, reading the map coordinates for points on the contour line. The effect of the drawing will be similar to looking at a chipboard contour model. If the contour lines are relatively straight, few points will have to be calculated. It is advisable to mark the position of the observer on the map and to draw lines of sight to the tangents of the contours. The crest of a ridge is an example of such a tangent point. A contour line might disappear behind a ridge, but might appear again. It is a good idea to plot the nearest contour lines and their tangents first because a point on a lower, near contour line might obscure a point on a higher, farther contour line. If enough contour lines are used, the drawing will have a geologic

Figure 7-18 Tangent to the contour line forms the ridge.

strata effect. The sinuousness of the lines may also draw the attention of the eye more than anything placed on it.

The third method is the most economical and the least obtrusive. The method is to draw only the ridges of the edges of the contour lines (Figure 7-18). The topography is only suggested by these lines. The position of the observer is marked on the map, and following the precautions of the second method, the edges of the ground forms can be accurately located and the feeling of the topography can be conveyed.

Figures 7-19 and 7-20 illustrate how the addition of the ground forms can supplement a drawing.

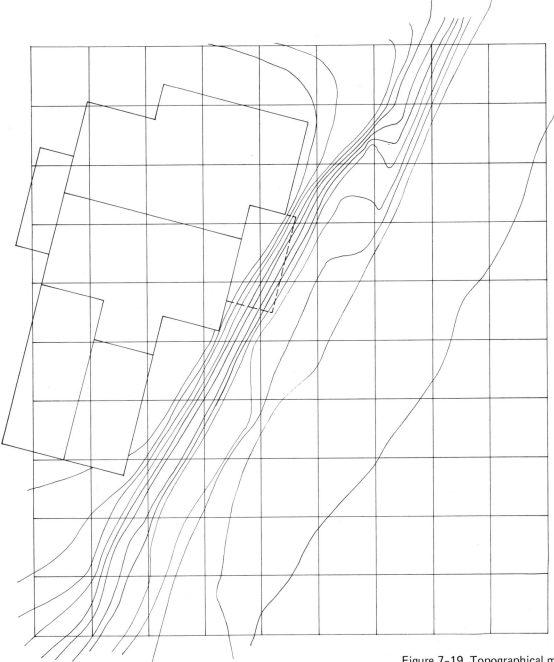

Figure 7-19 Topographical map.

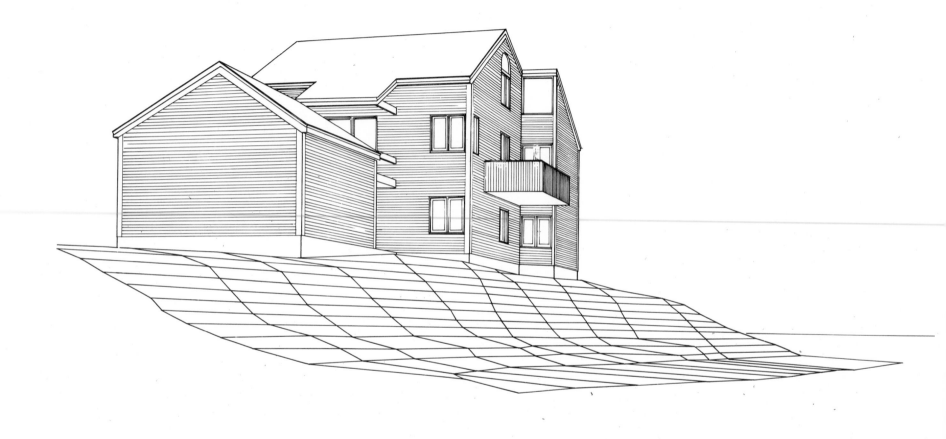

Figure 7-20

8 SQUARES

The square is such an essential and frequently used element in perspective drawing, it is worthwhile to automate the procedure for making squares. The SQUARE program is a handy subroutine that computes the four vertices of the square given one point. It actually finds these points for any rectilinear quadrilateral, but for the sake of simplification, it is called SQUARE. In addition to saving time, this program also facilitates using the center of an object as the numerical center or origin. This becomes even more significant when we are dealing with turning and shifting and with manipulating multiple objects.

The selection of the position of the origin with respect to the object being drawn is often determined by the convenience of the dimensioning. In some cases it is easiest to place all the dimensions in the positive quadrant so that all numbers are measured as positive numbers. Since rotation is always about the origin, the effect of rotation in such orientation is that the object is swung around the origin. This can be imagined as a person being swung around a revolving door. The origin is the axis about which the revolving door rotates (Figure 8–1). This may not be the intended effect. It is often more natural to think of the rotation as being about the central axis of the object. This is analogous to the way in which records on a turntable turn about their holes. From a numerical point of view, however, if the origin is at the center, the pattern of positive and negative values can easily result in confusion (Figure 8–2).

The SQUARE program merely changes the appropriate signs for each quadrant so that there can be no error caused by an incorrect sign. The point entered is the z-, y-, x-coordinates of the vertex in the positive quadrant (Figure 8–3). The program generates four points on the picture plane, the first being the one in the $-x,-y$ quadrant and proceeding counter-clockwise for successive points. The reason for this is that in the most frequent cases, we are starting with the point that is nearest the observer. The result is four pairs of numbers representing the perspective view of the four vertices of the square.

Incorporated in the program are two flags which, when set, indicate that the program must execute the TURN and SHIFT subroutine. This will be discussed later and can be ignored for the present.

A practical example demonstrating the convenience of using the SQUARE program would be drawing an abstract view of the Empire State Building. The Empire State Building may be thought of as a stack of rectilinear components. As we have said before, the SQUARE program will calculate the four points for any positive x and y value. Using the SQUARE program, with relatively few points we can easily compute all the points that would describe the building as it would be seen in perspective, in any orientation, from any position (Figure 8–4).

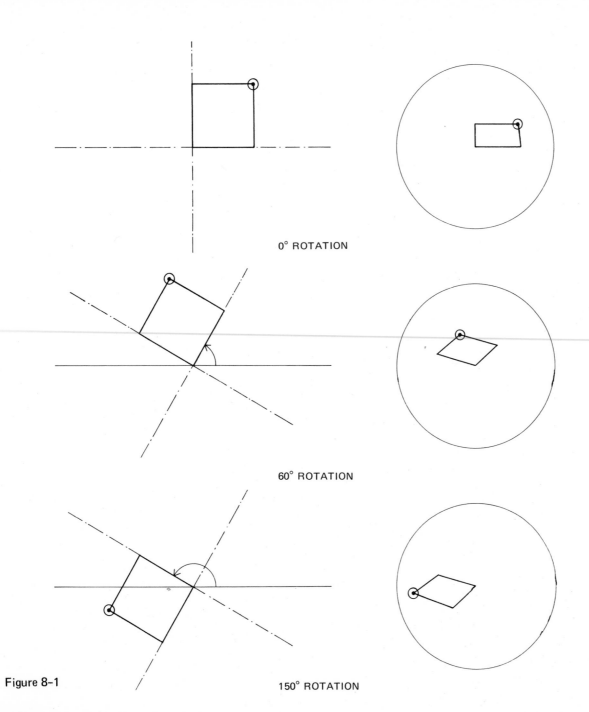

0° ROTATION

60° ROTATION

150° ROTATION

Figure 8-1

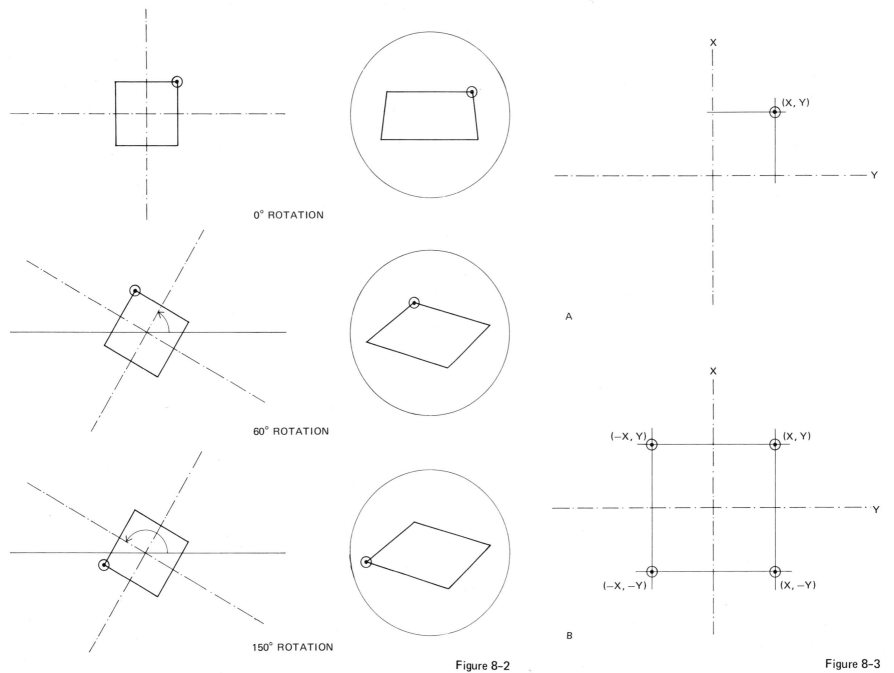

0° ROTATION

60° ROTATION

150° ROTATION

Figure 8-2

A

B

Figure 8-3

115

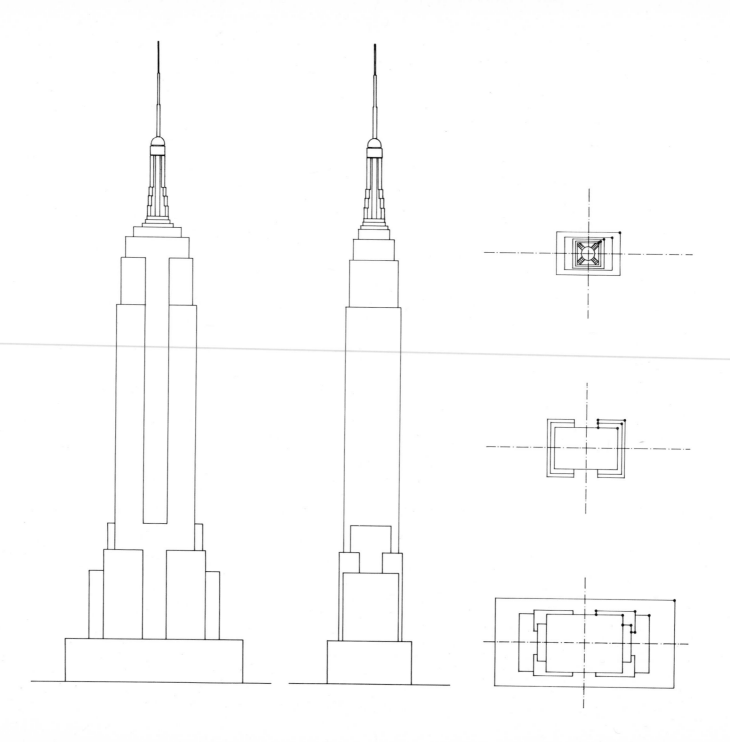

Figure 8-4

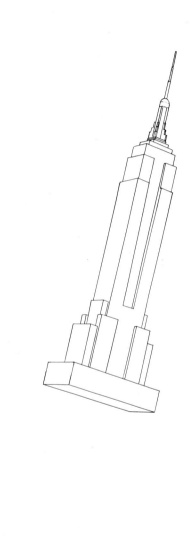

Figure 8–5

Figure 9-1

9 TURN AND SHIFT

In everything we have discussed thus far, the world has been viewed in terms of a single coordinate system. This is of course short-sighted. A family of points can be best depicted in a coordinate system when the numbers are simple and the organization is clear. If an object cannot be described in a relatively few number of points, then much effort might have to be expended just to identify the points. Take, for example, a humble house (Figure 9–2). With the origin at the center, this house may be described in the following way:

Xeq SQUARE for point (10, 20, 0)
 ″ ″ ″ ″ (10, 20, 9)
Xeq BASIC P for point (0,-20, 18)
 ″ ″ ″ ″ (0, 20, 18)

The structure is clear enough: the first pair of numbers represents the walls as defined by the corner points, and the second pair represents the location of the ridge line. But an identical house 14 feet to the right, 74 feet back, and rotated 26 degrees with respect to the first house must also have its coordinates defined in terms of the first house. Tedious computations would have to be made to determine the coordinates of each point of the second house as measured from the origin of the first house. This would also mean that the coordinates could not be symmetrical about the origin, and hence, the SQUARE program could not be used. Calculated individually, the coordinates, as measured from the origin, work out as follows:

1. (- 3.7554, 60.4078, 3)
2. (14.2205, 51.6404, 3)
3. (31.7554, 87.5922, 3)
4. (13.7794, 96.3596, 3)
5. (- 3.7554, 60.4078, 12)
6. (14.2205, 51.6404, 12)
7. (31.7554, 81.5922, 12)
8. (13.7794, 96.3596, 12)
9. (5.2326, 56.0241, 21)
10. (22.7674, 91.9759, 21)

Though this is not even an extreme case, it would be tiresome enough to merely enter the numbers into the calculator, let alone to also have the arduous task of computing each position (Figure 9–3).

The relationship between any two points in the first case is identical to the relationship between similar points in the second case. It is, however, necessary to compute the coordinates of the second case in terms of the first if we wish to plot the points of the two houses in the same view.

The actual numbers of the coordinates in the second case are only required in order to generate the numbers from which the image on the picture plane can be drawn. This computation could take place wholly inside the calculator since we are only interested in the projected result.

ELEVATION

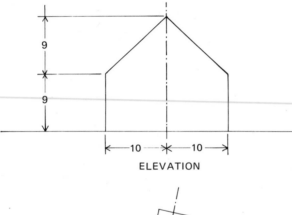

ELEVATION

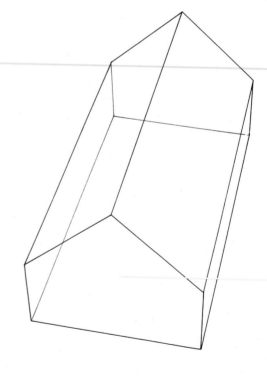

R-00	16
R-01	112
R-02	0
R-03	0
R-04	42
R-05	0
R-06	−12

Figure 9-2

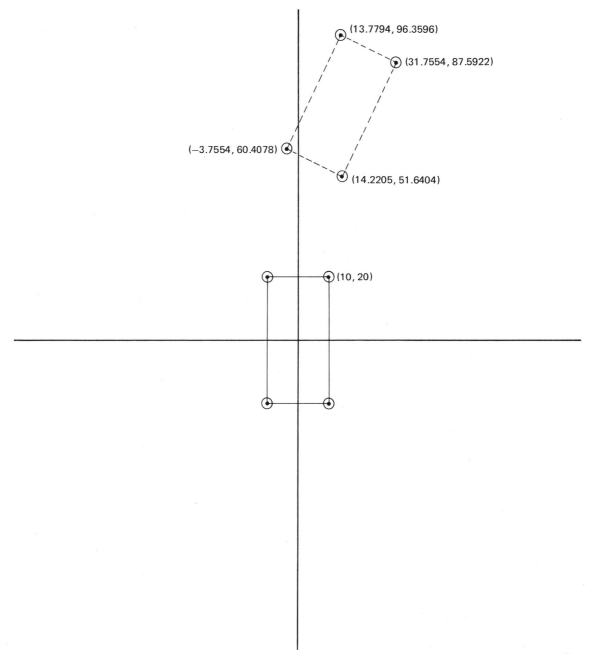

Figure 9-3

121

The points of the second house can be computed easily by the calculator by using two subroutines: TURN and SHIFT. We can think of this procedure as building a house at one site and moving it to another site. The new site is a specific distance away and may have a different orientation. In effect, the programs build a house, lift it from the foundation, turn it to its new orientation, and truck it to its new site. Each program does a simple task. TURN rotates a coordinate system to a new orientation. SHIFT moves the coordinate system to a new point. They can be used separately or together. When used together the order is important: TURN first and SHIFT second.

TURN Program.

1. Clear flag 04.
2. Xeq TURN.
3. Supply the angle of rotation in degrees about the three axes in the form x-rot, y-rot, and z-rot.

4. If SHIFT is also to be used, go on to SHIFT procedure.
5. If SHIFT is not being used, enter the coordinates of a point in the form: z enter y enter x. The program calculates the coordinates of the point in its new orientation. The new point is automatically entered into the stack in the proper order.
6. To plot this on the picture plane, Xeq BASIC P.
7. To plot subsequent points turned to this new orientation, enter the coordinates of the point, Xeq TURN, Xeq BASIC P.
8. When all points have been turned, clear flag 04.

SHIFT Program Procedure.

1. Clear Flag 03
2. Xeq SHIFT.
3. Supply the coordinates of the new origin, in the form (x, y, z).

4. Enter the coordinates of a point in the form: z enter y enter x. The program calculates the coordinates of the point at its new site. This is entered into the stack in the proper order.
5. Having transformed the coordinates, the BASIC P program will take the new point and find where it would appear on the picture plane.
6. To plot subsequent points which are only shifted to a new site, enter the coordinates, Xeq SHIFT, Xeq BASIC P.
7. To plot subsequent points of an object which is both turned and shifted, enter the coordinates, Xeq TURN, Xeq SHIFT, Xeq BASIC P.
8. When all points have been shifted, clear flag 03.

The following is an example of these procedures:

Xeq TURN and enter the following information into the proper registers:

$$x\text{-rotation} = 0.0000$$
$$y\text{-rotation} = 0.0000$$
$$z\text{-rotation} = -26.0000$$

The minus sign is because the rotation is counterclockwise as seen from the *negative* pole.

Xeq SHIFT and supply the new coordinates:

$$x = 14$$
$$y = 74$$
$$z = 3$$

Now that all the information has been entered, the calculator will reorient a point to the proper rotation and move it to the correct distance from the origin.

We would like to generate some of the points with the SQUARE program. The SQUARE program will automatically execute TURN and SHIFT if the flags are set. It is important to remember to clear the flags before using the SQUARE program for another procedure. Now all the points for the second house can be found by executing the program in the following way:

Xeq SQUARE for point (10, 20, 0)
″　　″　　″　　″　(10, 20, 9)
Xeq TURN Xeq SHIFT Xeq BASIC P for (0, -20, 18)
Xeq TURN Xeq SHIFT Xeq BASIC P for (0, 20, 18)

The projected view of the second house will result (Figures 9–4 to 9–10).

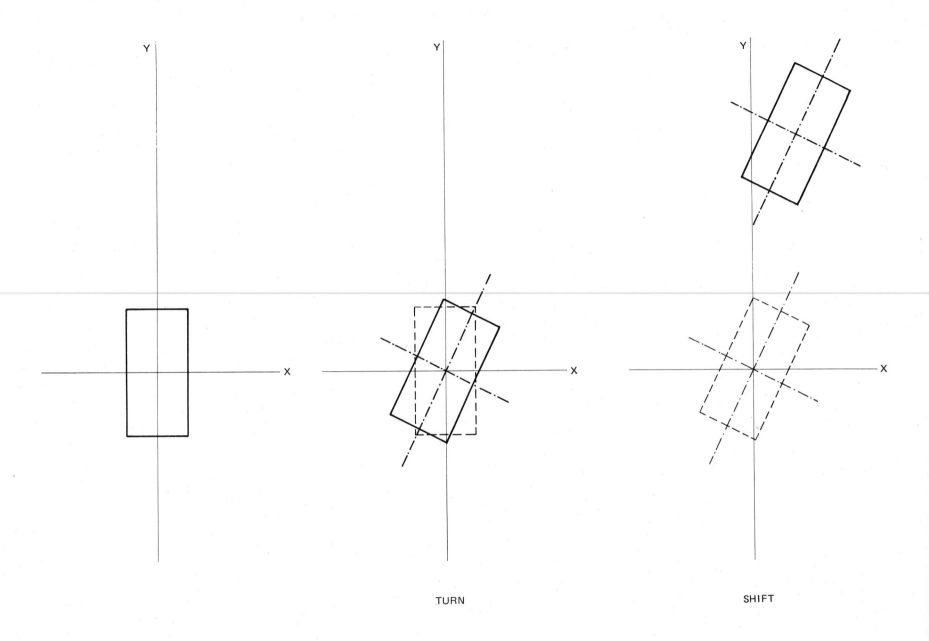

TURN

SHIFT

Figure 9-4

Figure 9-5

Figure 9-6

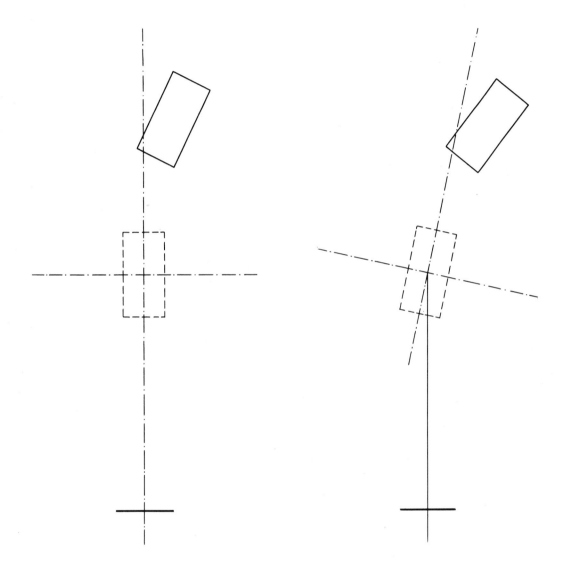

Figure 9-7 Figure 9-8

R-00	16
R-01	112
R-02	0
R-03	0
R-04	42
R-05	0
R-06	−12

Figure 9-9

R-00	16
R-01	112
R-02	0
R-03	0
R-04	42
R-05	0
R-06	−12

Figure 9-10

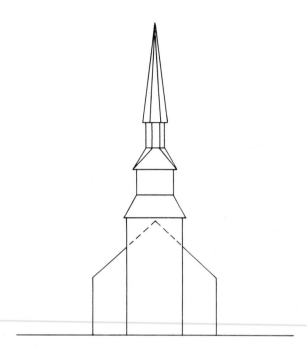

The TURN and SHIFT programs are very useful and can be adapted for many purposes. If you have a fairly complicated plan that is composed of essentially rectilinear components, it may be easier to subdivide the plan into rectangles, find the center and use the SHIFT and SQUARE program. It may be easier to use the SQUARE program several times than to identify all the points of all the components, because the SQUARE program requires only the center and one point to find the four points in the four quadrants, as opposed to finding all four points. If a number of different squares must be found for the same center, this method is much quicker.

If we were to add a belfry to the house, and the plan of the belfry at different elevations could be described as successive squares, you could use the SQUARE program when dealing with dimensions that relate just to the belfry and not to the house as a whole (Figures 9–11 and 9–12).

Figure 9–11

R-00	16
R-01	112
R-02	0
R-03	0
R-04	42
R-05	0
R-06	−12

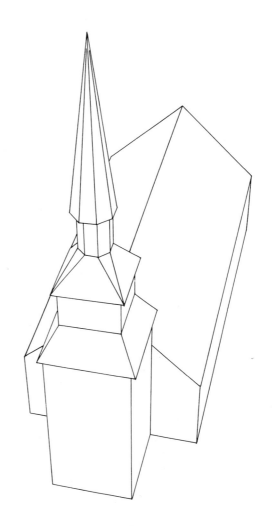

Figure 9–12

Using the TURN and SHIFT program to find the position of the second house is in a sense nesting one coordinate system within another. This can be extended so that many coordinate systems can be framed within one system—a development of houses, for example. It would only be a matter of finding the orientation and location of each house in relation to the first.

The TURN and SHIFT programs were used to construct the drawing of the western town (Figure 5–6). It is a relatively simple matter to depict similar repetitive building forms using this method, but if we were to compute the coordinates for every point of each building not in terms of the dimensions of the house but within the context of the coordinate system of the town, it would become virtually impossible to execute.

Another possibility is to have a coordinate system nested within a coordinate system nested within a coordinate system. For each additional nesting, a separate TURN and SHIFT program would have to be written using different memory registers and a mother program written to handle the sequence. Such a program might be:

MOM Program

Xeq TURN		1
"	"	2
"	"	3
Xeq SHIFT		1
"	"	2
"	"	3
Xeq Basic P		
End		

It may be best to explain this in a metaphorical way. Consider that the two houses we have been discussing are only little black squares on a large topographic map. Each house can be read as a position of longitude and latitude on the map. Each house is related to the other house and to the map by these coordinates.

If we could zoom in on these little black squares and see the houses at the next relevant scale, we would see the complexity of the plan. What was merely a little black square at the topographical map scale is now an assemblage of varied spaces, and what was just a point on a map coordinate is now a large defined area. For simplicity's sake, we will take the origin of the house as the same point as the map coordinate location. All the parts of the house relate to the origin and to the map as a whole.

If we zoom in still further, we see a chair in a room of the house. The chair can be described as a set of points that relate to a single point and in this case we define this point as the exact center of the seat. The orientation of the chair and the location of the reference point of the chair relate to the house as a whole.

If we zoom in still further, we see a 5¢ stamp on the seat of the chair. We define Washington's left eye as being the origin of the stamp. All of Washington's features and the perforations around the perimeter can all be related to his eye, and the eye in turn can be related to the center of the seat.

Now if we move back and look down at the topographical map, we can look at it from any distance or at any angle we choose. We can also turn the map around, with any point on the map acting as the center of the rotation. When we spin the map around, we are also spinning around Washington's nose. To plot the coordinates of Washington's nose in relation to the map is simpler than it may appear. The different coordinate systems are nested within each other in the following relationships:

Map to House TURN 1 — SHIFT 1
House to Chair TURN 2 — SHIFT 2
Chair to Stamp TURN 3 — SHIFT 3

The position of a postage stamp in relation to a map that is large enough to encompass a county are related by only three shifts in magnitude (using a common dimension, of course). We can plot the stamp as a map coordinate, while working with the stamp as simple dimensions around a local origin.

Computations that would be prohibitively complex become manageable with the programmable calculator. In any drawing, it is well worth spending time planning the maximum use of the calculator. Let the calculator make as many intermediate computations as possible. It will save time and effort and reduce the chance of error. As you gain facility in drawing with the aid of your calculator, you begin to stretch your thinking about drawings and attempt to execute ideas that would have once been beyond the realm of possibility.

Figure 10-1 Look at the black spot from a distance of 4″. The center circle will appear circular while the end circles will appear elliptical.

10 CIRCLES AND SPHERES

The basic perspective program takes a point in space and finds out where it would appear on a picture plane from an observer's point of view. Any shape can be seen in perspective as long as we can find points in space to describe it. When we want to make a drawing of a circle or a sphere, we must find a means of generating the points in space, given the location of the center and the length of the radius, and process these points through the basic perspective program. The resulting shape on the picture plane will be the true perspective view of a circle or a sphere in space.

When seen in perspective, a sphere always appears to be perfectly circular. On the other hand, a circle almost always appears to be an ellipse. The one exception for a circle is when we are looking at a circle that is in a plane parallel to the picture plane. Only then will a circle appear circular.

But for a sphere or a circle in a parallel plane to appear circular, it may have to be drawn as an ellipse. This apparent conundrum can be explained in the following way.

CIRCLE

Let us take the idea of the cone of vision literally, the apex of the cone being the eye of the observer. When the center of a circle is exactly on our line of sight and in a perpendicular plane, we have a right cone. Any circle in any plane that is not parallel to this circle must then be an oblique truncation of the cone. If the entire circle can be seen, then the oblique truncation will be an ellipse. If the circle is too large to be seen in its entirety, the truncation will be a parabola or a hyperbola.

Even in the case when the circles are in a plane parallel to the picture plane, only the circle whose center is at the center of the line of sight will appear to be perfectly circular (Figure 10–1). The eccentricity of the near circles may be so slight that it makes them appear to be circles, while the circles at the periphery will appear noticeably elliptical. Though the plane is parallel to the picture plane, any circle whose center is not at the center of the line of sight is in effect an oblique truncation of the cone. As it moves to the periphery, it has the effect of increasing the distance and rotating the circle (Figure 10–2).

The programs generate the points of a perspective view of a circle. We do not need to know the location of the foci or the eccentricity of the ellipse to be able to draw it. Though we do not need to know much about the ellipse, a few important factors need to be mentioned in order to apply the proper interpretation to the results.

If we inscribe a circle in a square, the circle will touch the square at four points, at the midpoint of each edge. The distance between op-

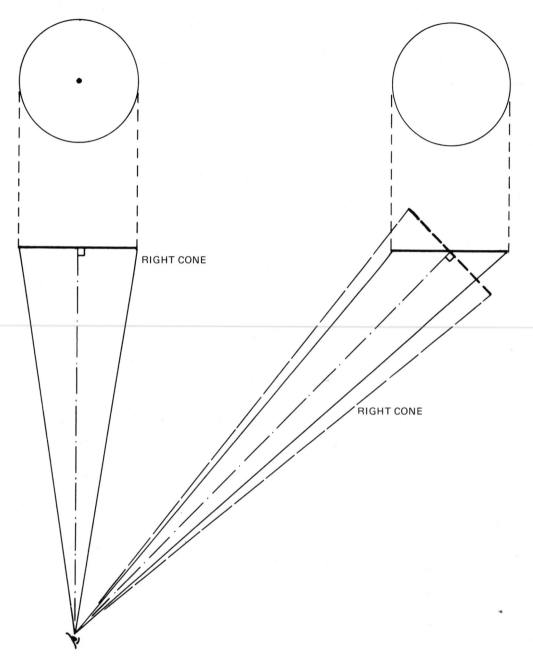

RIGHT CONE

RIGHT CONE

posite edges is the diameter of the circle (Figure 10–3). If we tilt both, we then see an ellipse inside a trapezoid (Figure 10–4). The midpoint where the circle touches the top and the bottom edge of the square corresponds to the midpoint where the ellipse touches the top and bottom edge of the trapezoid. The midpoint of the sides of the square does *not* fall at the midpoint of the sides of the trapezoid. The widest point of the ellipse is *not* at the diameter of the circle.

What then is the interpretation of the widest point of the ellipse? The only position in which we can see the entire diameter of the circle is one in which the circle is in a plane parallel to the picture plane. (See Figure 10–1.) To explain this we must return to the idea that we see

Figure 10-2 If the periferal circle is rotated to the right cone position, the circle will no longer appear as an ellipse but as a circle.

things as straight rays emanating from the eye. If we look at the circle edge on, as this line sweeps across the circle, this line is exactly tangent to the circle at two points (Figure 10-5). Notice that the points where the lines are tangent is not at the diameter of the circle. It cannot be at the diameter unless the two visual rays are parallel (Figure 10-6). If they are parallel, then the observer must be infinitely far away. Where the point is tangent must also be the point where the ellipse is widest; any wider sweep of the visual ray would no longer touch the circle. This does not correspond to the diameter of the circle. The widest point of the ellipse and the diameter relate directly to the distance of the observer.

Figure 10-3

R-00	16
R-01	8
R-02	0
R-03	0
R-04	30
R-05	0
R-06	0

Figure 10-4

Figure 10-5

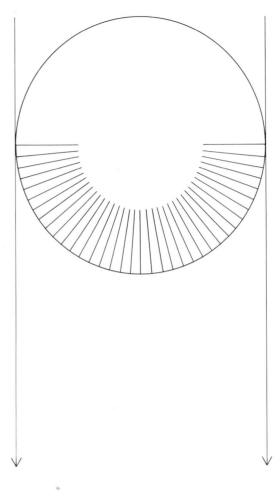

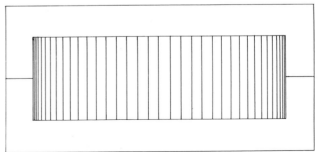

Figure 10-6

CYLINDER

A cylinder may be thought of as a pile of circles much like a stack of pancakes. Consider a row of cylinders, or unfluted columns, parallel to the picture plane. What has come to be known as Leonardo's paradox was his observation that for the columns to appear to be the same size on a flat picture plane, the farther away they are the wider they must be drawn. There is a big effect and a little effect that cause the physical change in the width of the image of the column on the picture plane (Figure 10-7). The little effect is that the farther away the column, the more width of the column can be seen (Figure 10-8). Such circles in the horizontal plane differ from circles in the vertical plane. An observer can see the diameter of a circle in the vertical plane (Figure 10-1), while in the horizontal plane the observer can see only the tangent point of the circle (Figure 10-7). As the circle is seen at ever greater distances, the observer can see ever greater widths of the circle. At greater distances the circle appears smaller, but you see more of it. The big effect is from progressively obliquer truncations of the visual cone, because of the flatness of the picture plane, as the columns recede to the periphery. If, however, the picture plane were circular, only the little effect would be observed, and the columns would reduce naturally in size as they receded toward the periphery (Figure 10-9).

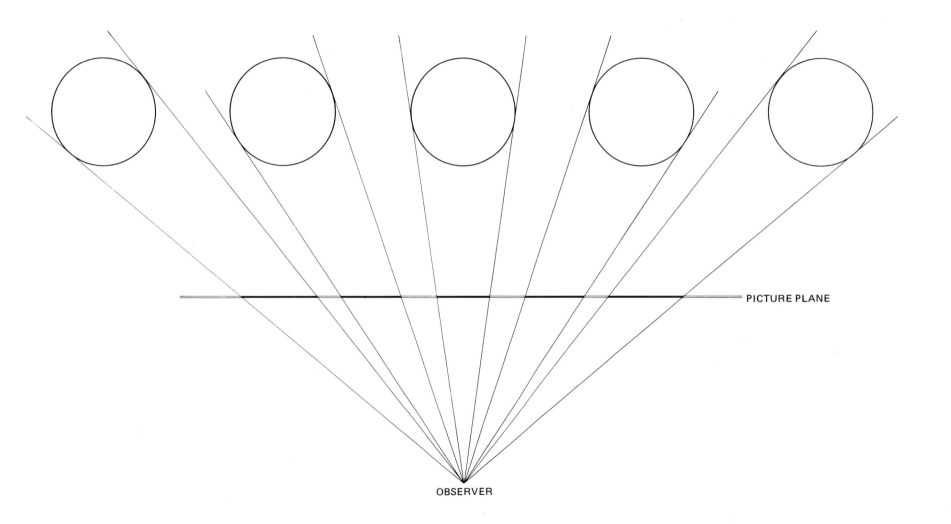

PICTURE PLANE

OBSERVER

Figure 10-7 Leonardo's paradox

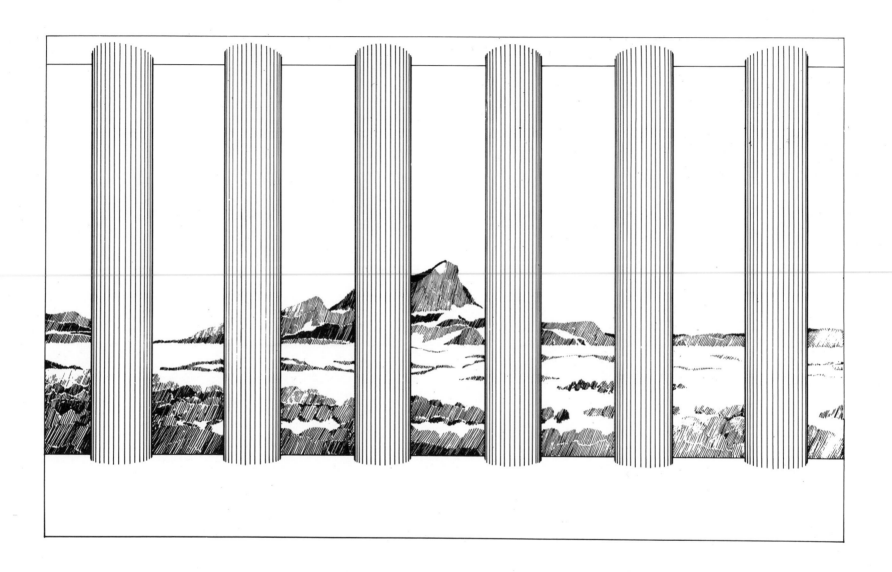

Figure 10-7a

140

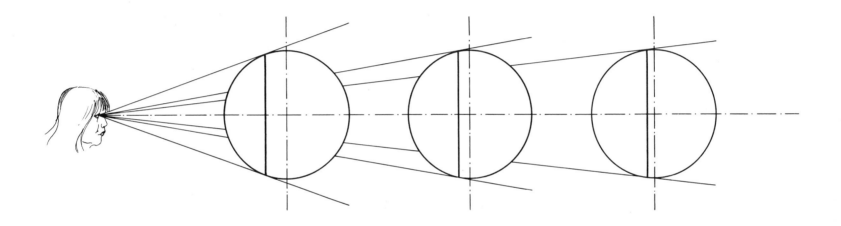

Figure 10-8

141

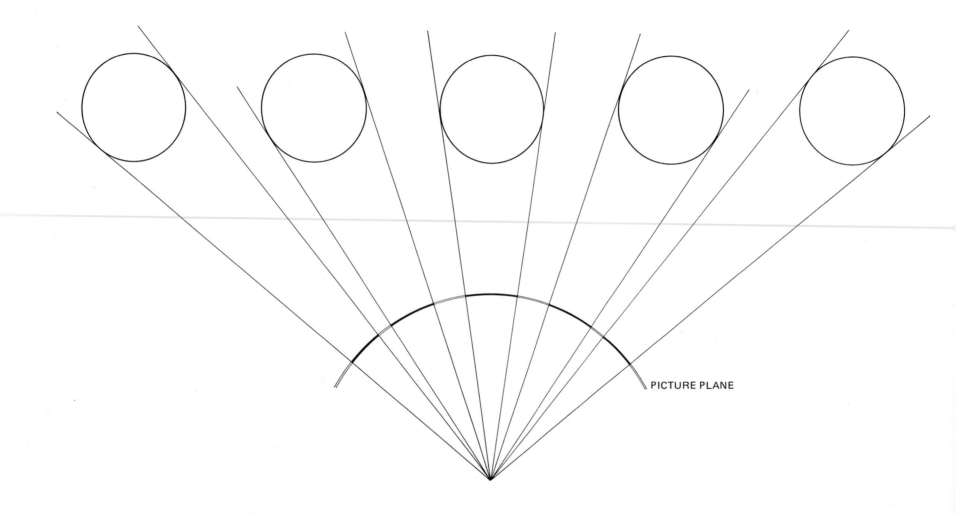

PICTURE PLANE

Figure 10-9

SPHERE

In Figure 10-10, the fingers holding the basketball are on one of the equatorial seams. Notice we cannot see the finger tips. The most that we can see of the sphere, as with the cylinder, is to the point of tangency. This does not reflect the actual diameter of the sphere. This is the reason why domes on buildings appear smaller outside than inside.

A sphere may be defined as all the points equidistant from a point. To establish the position of the sphere, we can fix the distance from our eye to the center of the sphere. When we look at a sphere, the boundary that we see is the point of tangency. A particular tangent line intersects the sphere, and at that point, the radius of the sphere is at right angles to the tangent line. Thus we have a right triangle with one side the radius of the sphere. The hypotenuse is the distance from the center of the sphere to the eye. From this triangle we find that the distance of the tangent line must also be constant. As the triangle is rotated about the hypotenuse, the tangent line must describe a right cone. Consequently, the sphere must always appear to be a circle.

However, only the sphere whose center coincides with the center of the line of sight can be drawn as a circle. If the center of the sphere is not at the center of the line of sight, then the plane of the circle of the right cone cannot be parallel to the picture plane. The picture plane is flat and cuts the right cone obliquely. An oblique truncation of the cone must be an ellipse. For a circle to appear circular from the observer's point of view, it must be drawn as a progressively more eccentric ellipse as the position of the sphere moves toward the periphery of the field of view (Figure 10-11).

But drawing a sphere (which always appears as a circle) as an ellipse, introduces a problem which might tempt you to hedge your bet. The farther away from the center of the line of sight, the more elliptical the drawing of the sphere must be to compensate for peripheral distortion. The more precisely this ellipse is drawn, the more precise must be the position of the eye with respect to the drawing for the eye to continue seeing the ellipse as a circle.

In an exaggerated example, if a drawing was constructed so that it was meant to be seen at a distance of 4 inches, but is seen instead at a distance of 16 inches, a sphere that was intended to be seen at the periphery of the field of view now may occupy an erroneous position at the center of the field of view. What was right at 4 inches is wrong at 16 inches. Since

Figure 10-10

you cannot easily dictate from what distance the drawing will be seen, it may be advantageous to draw the sphere as a circle regardless of its position in the field of view. This will insure that, though the circle is not correct at the designed distance, it will appear less noticeably distorted if seen at any other distance.

The shape of an ellipse informs the observer that the circle is not in a plane parallel to the picture plane. An ellipse may also be drawn to compensate for peripheral distortion. It is also true that an ellipse that results from a tilted plane has its eccentricity altered as its position moves toward the periphery. If we had to know the position of the foci in order to draw the ellipse, we would have to find a means of calculating the changing position of the foci owing to the tilt of the plane and the position in the field of view, which at best is a dismal job. Fortunately, this is not necessary—the calculator processes the position of the circle in space as if it were a camera obscura.

Figure 10-11 Look at the black spot from a distance of 4″.

DRAWING PERSPECTIVE CIRCLES

Unlike striking a neat circle with a compass, there is no readily available instrument that can draw all ellipses with the same ease. It is possible to draw a generally elliptical shape with two pins and a loop of string, but if you have ever tried to draw an ellipse of an exact prescribed size and eccentricity with just two pins and a loop of string, you will attest to the futility of such an enterprise. Even with a large collection of templates, finding an approximately correct ellipse is nearly impossible considering all the possible combinations of tilt and position that one circle could assume.

There are a number of scale devices which can be used to plot a series of points to draw an ellipse given the foci. But when we are drawing a perspective view of a circle, we may only know the position of the center and the length of the radius of that circle. Calculating the position of the foci for a circle tilted at a particular angle as seen from a particular distance would require far more laborious computation than anyone would ever attempt. Finding what a circle looks like in perspective is easy using the following programs.

Circle Programs

The circle programs generate as many coordinate points of a circle of a given radius as the draftsman requests. The BASIC P program then uses those coordinates to find where that point would appear on the picture plane. All the points are generated around the origin, in the xy-plane. This circle can be rotated, of course, by the TURN program and moved to the proper position in the field of view by the SHIFT program.

There are two versions of the CIRCLE program—the economy and the deluxe. They do essentially the same thing, but they call for different information. The following are the procedures for using these programs:

CIRCLE 1 (economy) Procedure.

1. Enter the proper information of BASIC P.
2. Xeq CIRCLE 1.
3. Supply the radius of the circle.
4. Supply the number of points desired.

Figure 10–12 illustrates the operation of this program. If the location of the circle is not at the origin in the xy-plane, locate the orientation and position of the circle by means of the TURN and SHIFT programs. When the flags are set for these programs, as with the SQUARE program, CIRCLE 1 will automatically execute TURN and SHIFT (Figure 10–13).

R-00	16.00
R-01	32.00
R-02	0.00
R-03	0.00
R-04	30.00
R-05	0.00
R-06	55.00

a

NUMBER OF POINTS? b

c

Figure 10-12a, b, c Circle 1 program.

TURN PROGRAM

X ROT	0
Y	0
Z	0

TURN PROGRAM

X ROT	90
Y	0
Z	0

d

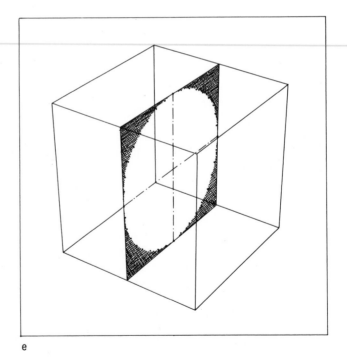

e

Figure 10-12d, e

148

X Rot	0
Y	90
Z	0

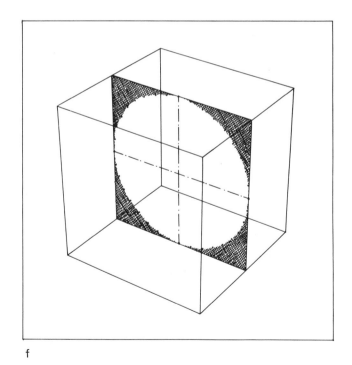

f

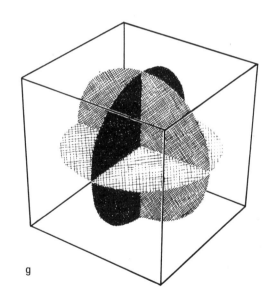

g

Figure 10–12f, g

FIRST POINT AND DIRECTION OF ADDITIONAL POINTS

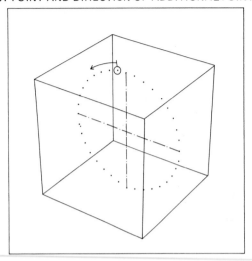

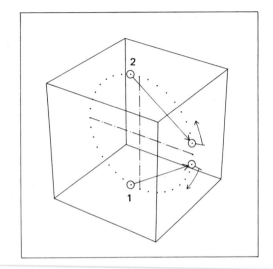

TURN PROGRAM

X ROT	0
Y	90
Z	0

TURN PROGRAM

X	0
Y	−90
Z	0

TURN PROGRAM 1

X	0
Y	−90.00
Z	−90.00

TURN PROGRAM 2

X	0
Y	90
Z	−90

Figure 10-13

CIRCLE 2 (deluxe) Procedure. Sometimes only a part of the circle is needed, so this is specified as the number of points and the angle between them. The radius is swept around the *xy*-plane and the starting point is the positive pole of the *x*-axis. Positive angles mean counterclockwise rotation, and negative numbers mean clockwise rotation. The first point may be any point on the circle and the location of this point is measured as an angle from the positive pole of the *x*-axis.

The procedure for using this program is as follows:

1. Enter the proper information of BASIC P.
2. Xeq CIRCLE 2.
3. Supply the radius of the circle.
4. Supply the number of points.
5. Supply the angle in degrees between points of the circle.
6. Supply the location of the first point as an angle from 0.0000 degrees.

If the center of the circle is not at the origin, locate the orientation and the position of the circle by means of the TURN and SHIFT programs. When the flags are set for these programs, as with CIRCLE 1, CIRCLE 2 will automatically execute TURN and SHIFT.

Drawing Perspective Spheres

The SPHERE program operates in a somewhat different way—the coordinates of the center of the sphere must be included. Given this point and the radius of the sphere, the program automatically computes the values required by the TURN and SHIFT programs, and uses TURN and SHIFT as integral subroutines.

SPHERE Program Procedure.

1. Enter the proper information of BASIC P.

2. Xeq SPHERE.
3. Supply the radius of the sphere.
4. Supply the number of points to be plotted.
5. Supply the coordinates of the center of the sphere.

The location of the sphere in the field of view will determine how eccentric the image of that sphere must be on the picture plane so that the observer will see the sphere as a perfect circle (Figure 10–14).

DRAWING THE LINES

There is a threshold at which straight line segments will be read as smooth curves. Knowing the exact location of the points of the curve will contribute greatly to the illusion that the straight lines are curves. The accuracy of a number produced by the calculator representing the location of a point in space on the picture plane far exceeds the accuracy attainable

151

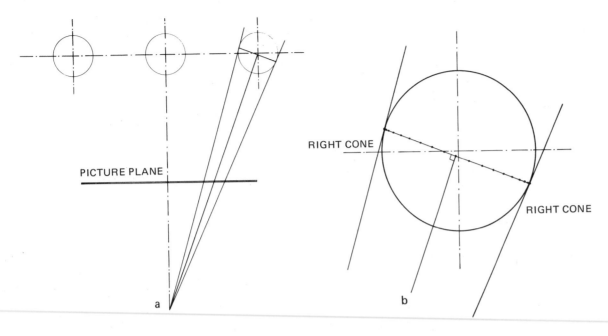

PICTURE PLANE

RIGHT CONE

RIGHT CONE

a

b

c

Figure 10-14 Look at the black spot from a distance of 4 inches.

with drafting tools. A draftsman rarely can draw with an accuracy greater than .01 inches. Indeed, one-sixtieth of an inch (0.0167 inches) is usually the smallest scale division. The location of a point on the picture plane normally has an accuracy of 0.00000001 inches when figured out by the calculator. The accuracy of the point as plotted by the draftsman is only limited to the draftsman's skill. Freehand lines may only be accurate to one-twentieth of an inch (0.05 inches).

It is important to consider the size of the circles. A very small circle may be more than adequately described in 6 or 8 points, while a very large circle may take many points—a point every 5 degrees would mean a total of 72 points which may be too many, yet a point every 10 degrees or a total of 36 points may be too few. Drawing a convincing curve with straight lines is abstracting the curve. Picking the right points is more art than science.

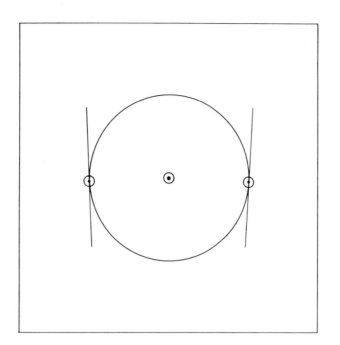

Selecting the number of points is a subjective matter. If you are a perfectionist by temperament, you probably will need fewer points than you think. If you are a free spirit, you may need more points than you think. Rather than detailing a method, it is much better to merely say that you should trust the judgment of your eye.

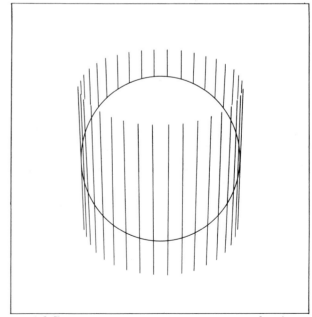

Figure 10-15 The sphere program, when used for two points, can be employed for calculating the tangent of a cylinder.

R-00	24
R-01	60
R-02	0
R-03	−5.25
R-04	0
R-05	0
R-06	55

PLAN

a

Figure 10–16a

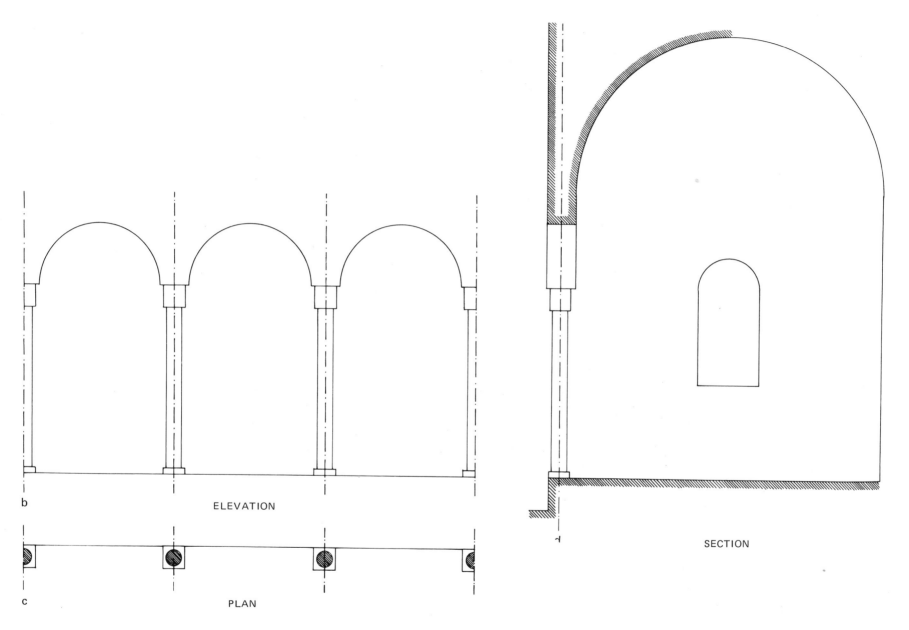

ELEVATION

PLAN

SECTION

Figure 10-16b, c, d

	TURN Program			SHIFT Program		
Arch	X Rot	Y Rot	Z Rot	Z	Y	X
1.	90°	0°	0°	12.0	±0.9	4.9
2.	90°	0°	0°	12.0	±0.9	14.7
3.	90°	0°	0°	12.0	±0.9	24.5
4.	90°	0°	0°	12.0	±0.9	−24.5
5.	90°	0°	0°	12.0	±0.9	−14.7
6.	90°	0°	0°	12.0	±0.9	−4.9
7.	0°	−90°	−90°	18.0	−10.9	40.0
8.	0°	−90°	−90°	12.0	−10.9	40.0
9.	0°	0°	0°	12.0	−10.9	41.0

BASIC P Program

R00	24.00
R01	60.00
R02	0.00
R03	−5.25
R04	0.00
R05	0.00
R06	55.00°

CIRCLE Program

Radius?	4.00
No/Pts?	36.00

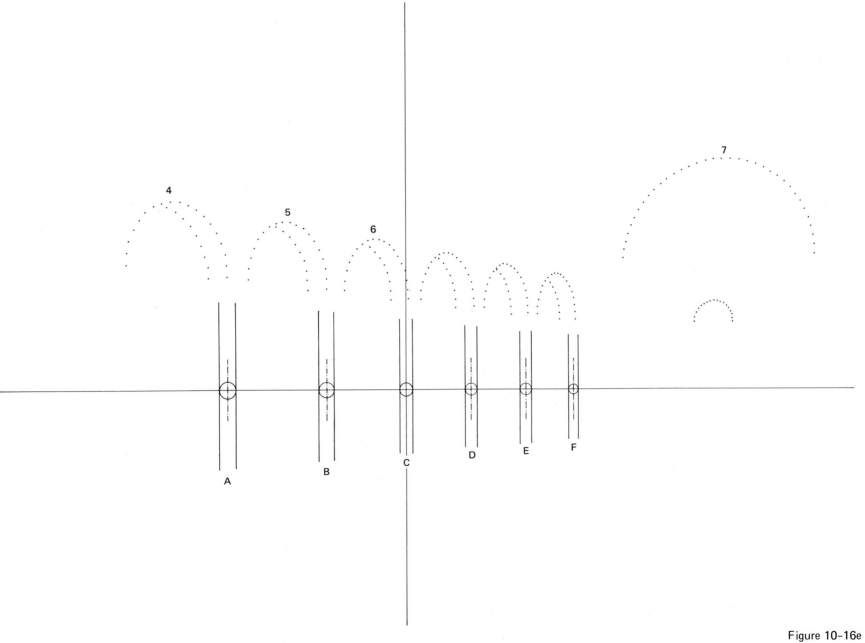

Figure 10-16e

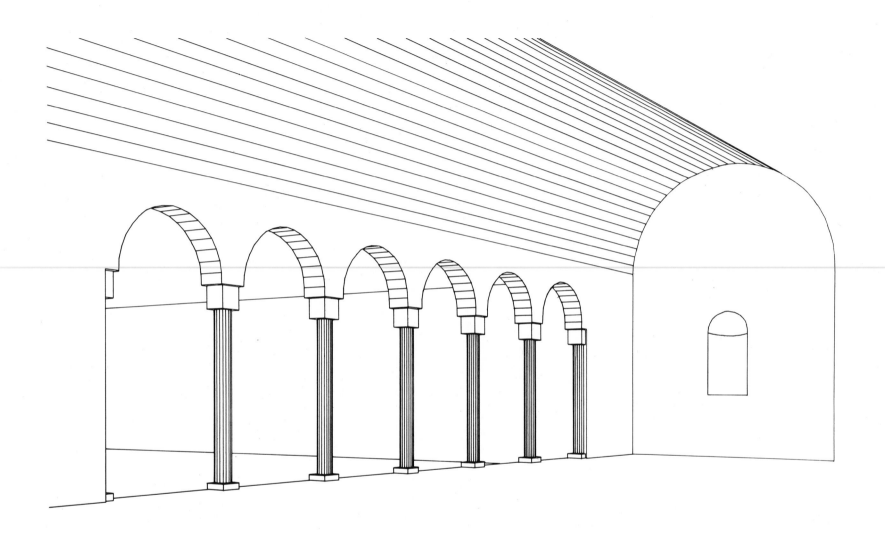

Figure 10-16f

CIRCLE EXAMPLE 2
SPIRAL STAIRCASE

a ELEVATION

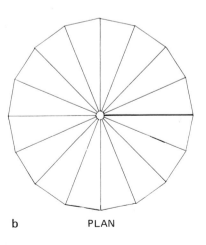

b PLAN

Figure 10-17a, b

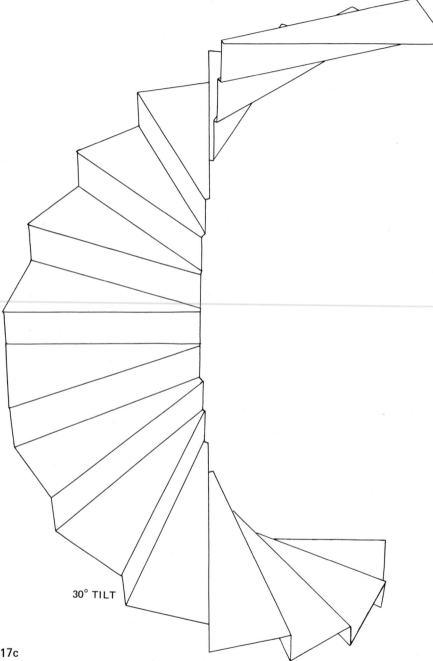

30° TILT

R-00	12
R-01	1.33
R-02	0
R-03	0
R-04	30
R-05	0
R-06	0

Figure 10-17c

R-00	12
R-01	1.33
R-02	0
R-03	0
R-04	60
R-05	0
R-06	0

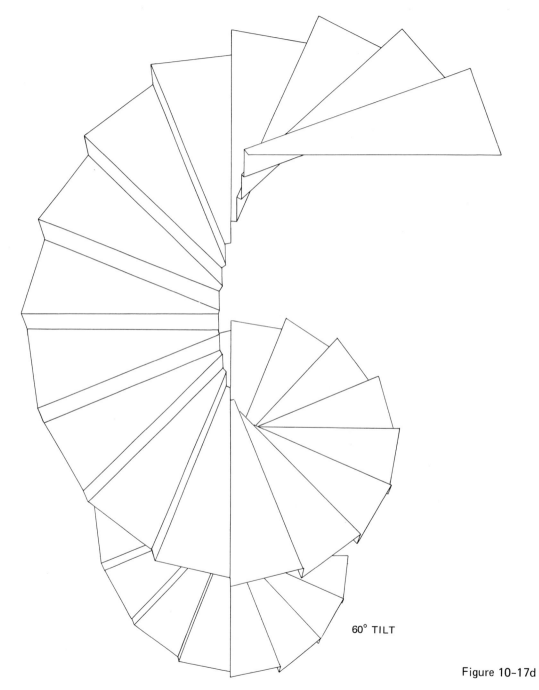

60° TILT

Figure 10-17d

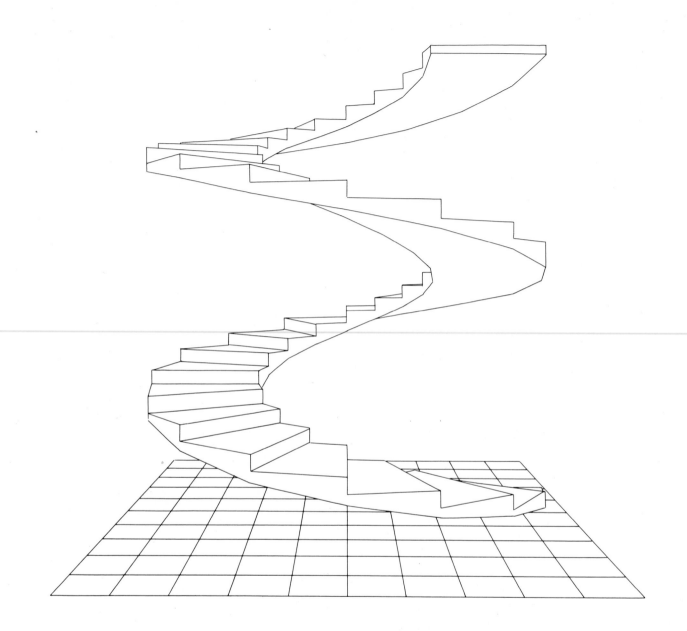

Figure 10-18

11 SHADOWS

The sun has always inspired cults—from the worshipers of Ra to the advocates of solar energy. Though *sun-worshipers* may now be a synonym for *nudists,* people still gather at Stonehenge to celebrate the sunrise at the summer solstice. In most civilian affairs, it may be sufficient to note that the days are longer in summer than in winter. But in architecture, it is often necessary to know with precision the effects of sunlight on buildings. On the practical side, it is important to gauge the penetration of sunlight into a building; on the aesthetic side, to be able to manipulate shadows to mold building forms.

As everyone knows, the sun rises in the east, climbs to its highest point at noon, and sets in the west. Every card-carrying sun worshiper realizes that this is a gross oversimplification. The sun rises south of east and sets south of west in the winter and rises north of east and sets north of west in the summer. The south-ernmost point where the sun rises and sets occurs at the winter solstice and the northernmost point occurs at the summer solstice (Figure 11-1). The position of the sunrise or sunset migrates through the seasons of the year between these two points crossing the due east and due west point twice a year, once on its northward journey at the vernal equinox and again on its southward journey at the autumnal equinox. The altitude at noon, the height the sun climbs in the sky as measured from the horizon, also varies with the daily change—the sun is at its highest at the summer solstice and lowest at the winter solstice (Figure 11-2).

This abstract description of the movement of the sun does not hint at the complexity of actually calculating the sun's position which is complicated by the fact that the earth's axis is tilted, its orbit is elliptical, and consequently, its velocity is always accelerating or decelerating. But when we make a drawing of a shadow, we only want to know its length and direction.

The general program for calculating the position of the sun in the northern hemisphere is called ALTAZIM. As the name suggests, the program calculates the altitude (the angle of the sun from the horizon to the center of the sun) and the azimuth (the angle of the sun from due south either eastward or westward).

The program is divided into three parts. The first part calculates the declination or relative position of the sun for a particular date. The second part calls for specifying the location where the shadow will be cast. The third part specifies the hour of the day. As has already been discussed, the position of the sun changes every day. The first part of the program spells out where the sun is located for a particular day. On any particular day, the angle that the sun strikes Singapore near the equator is different from the angle that it strikes Philadelphia, at 40° north latitude. The second part of

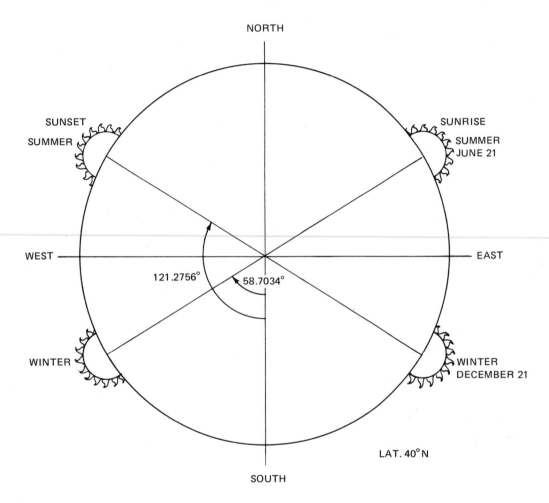

NORTH

SUNSET
SUMMER

SUNRISE

SUMMER
JUNE 21

WEST

EAST

121.2756°

58.7034°

WINTER

WINTER
DECEMBER 21

LAT. 40° N

SOUTH

the program takes this into account. The third part, taking the other two parts into consideration, calculates the altitude and azimuth for any hour of the day.

The first part requires the day be entered in the specific form *mm.ddyyyy* (*m* = digits for month; *d* = digits for day; *y* = digits for year). Thus March 5, 1984 becomes 3.051984. It is important not to leave any digits out, and also to include the year since it will be used to discriminate between leap years and non-leap years.

In the second part, the position where the shadow is to be cast is entered in terms of the longitude, latitude, and time zone. The longitude and latitude must be entered in the form *hh.mmss* (*h* = digits for hour; *m* = digits for minutes; *s* = digits for seconds). Eastern standard time is taken to be 5, being the fifth time zone from the Greenwich meridian; Central, 6; Mountain, 7; and Pacific, 8.

Figure 11-1

The third part asks for the time of day. This must be entered in the form *hh.mmss,* and it must be military time: 2 P.M. = 14.00.

The numbers that are produced by the program are the altitude and the azimuth of the sun.

The program has been separated into parts to make it possible to study variations of one aspect without having to recalculate the other two aspects each time. The ALTAZIM program has three flags that control the three aspects of the program. When the flags are clear, the calculator will execute all three parts of the program. Flag 00 controls the section of the program that relates to the date; flag 01, location; and flag 02, the time. If, for example, we were to calculate the position of the sun for successive hours on a particular day at a particular place, the location and the date would be fixed, but the hour would change. This can be done on the calculator by setting

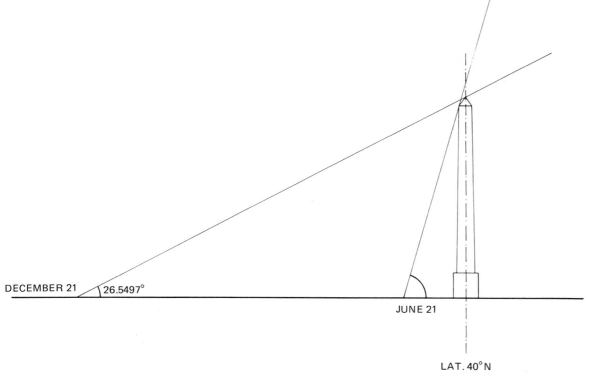

DECEMBER 21 26.5497°

JUNE 21

LAT. 40° N

Figure 11-2

flag 00 for the date and flag 01 for the location after the program has run through initially and the date and location have been established. With these flags set, only the time section of the program will be executed for any selection of hours. Any combination of date, location, and time can be employed by setting the corresponding flags.

For the obelisk in Figure 11–3, successive shadows are drawn in two-hour intervals —8.00, 10.00, 12.00, 14.00, 16.00 (8:00 A.M. through 4:00 P.M.)—in Philadelphia at 75°10′04″ longitude and 39°57′27″ latitude, on March 5, 1984.

To establish the position of the sun on March 5, 1984, in Philadelphia, at noon, the following procedure would be used.

ALTAZIM Program Procedure

1. Xeq ALTAZIM.

2. Supply the following information:

Date (mm.ddyyyy)	3.051984
Longitude (dd.mmss)	75.1004
Latitude (dd.mmss)	39.5727
Time Zone (5 = E.S.T.)	5
Hour (24hh.mmss)	12.0000

The program produces the following results:

Alt = 44.2422°
Azi = 4.1775°

There are a number of things that are illustrated by this result. From the altitude, it can be seen that the late winter sun is still quite low in the sky. The azimuth angle is over 4° at noon. Within this system, a positive azimuth means that the sun is east of the zenith, and a negative azimuth means that the sun is west of the zenith. Since the azimuth is positive (4.1775°), the sun has not yet reached its zenith, at which point the azimuth would be 0.0000°. It is still east of the zenith. This angular difference is the result of two factors: the equation of time and the number of degrees of longitude of Philadelphia from the standard meridian. The equation of time is the accumulated effect of the slight difference between 24 hours as measured by an accurate clock and the length of time it takes the sun to go from zenith to zenith. This is a consequence of the changing velocity of the earth as it makes its way along its elliptical orbit. The distance from the standard meridian can significantly affect the azimuth at noon. Since there are 24 hours in a day and there are 360° around the equator, the earth rotates 15° each hour. If 12:00 noon were to be defined strictly as the zenith of the sun, every position on the earth would have its own time zone. To avoid chaos and to avoid having to change one's

watch for any movement parallel to the equator, time zones one hour apart were established to regulate civilian affairs. Since the sun rotates 15° in an hour, the standard time zones are located in 15° intervals from Greenwich, England. Philadelphia, at longitude 75°10′04″, is nearly on the standard meridian at 75°00′00″, while Cincinnati, Ohio, which is in the same time zone is located at longitude 84°30′00″. The azimuth for noon on March 5, 1984, in Cincinnati would be 17.1002°.

S PT PROGRAM

The altitude and azimuth angles are used directly by the S PT program. The coordinates of a point in three dimensions processed by the program will produce two pairs of numbers. The first pair locates the position of that point on the picture plane, and the second pair locates on the picture plane the shadow of that point as would be cast by the sun in a particular position of altitude and azimuth on a horizontal plane.

The program calls for two additional pieces of information—the orientation of North and the elevation of the ground plane. If the x- and y-plane is thought of as the face of a compass, the positive x-pole is defined as the cardinal position North. If there is no rotation of any axes in the basic perspective program and the North position is defined as 0.0000, the shadow would be cast by the noon sun across the picture plane from left to right. If North is rotated 90.0000 degrees, the noon sun will cast a shadow directly away from the observer. If North is rotated 180.0000 degrees, the noon sun will cast a shadow from right to left. If North is rotated 270.0000 degrees, the noon sun will cast a shadow directly toward the observer. If we think of the coordinate system drawn on a map, the angle between North on the map and the direction of the positive pole must be supplied to the program.

The ground plane as used here is the elevation at which the ground intersects the coordinate system. If the ground plane is at $z = 0.0000$, then 0.0000 is entered into the program. If the coordinate system is raised above the ground and the ground plane intersects the coordinate system at $z = -1.0000$, then -1.0000 is entered into the program. Conversely, if the ground plane intersects the coordinate system at $z = 1.0000$, then 1.0000 is entered into the program.

S PT Program Procedure

1. Xeq ALTAZIM and supply the date, location and time to calculate the position of the sun.
2. Supply the information required by the BASIC P program.
3. Xeq S PT.
4. Supply the position of North.
5. Supply the elevation of the ground plane.

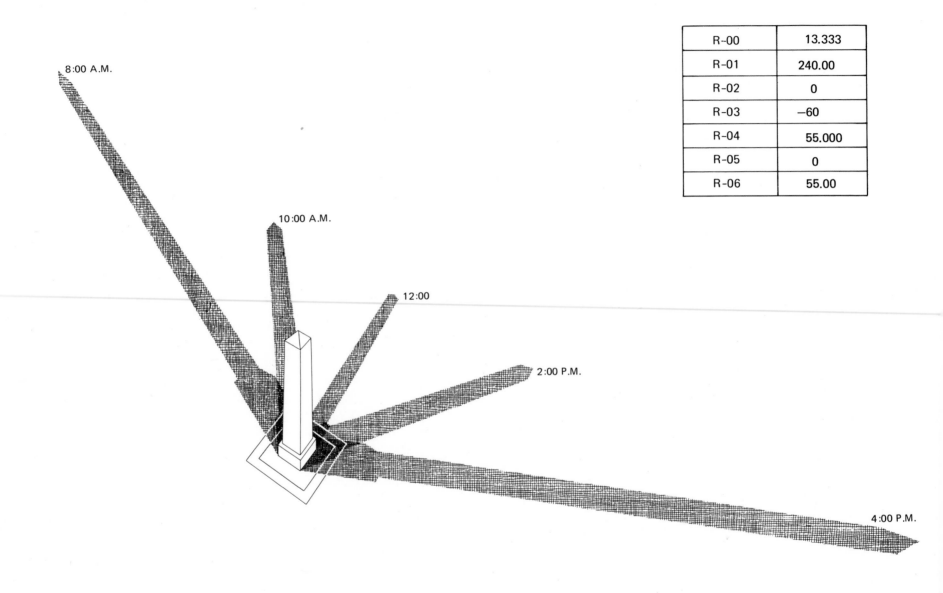

R-00	13.333
R-01	240.00
R-02	0
R-03	−60
R-04	55.000
R-05	0
R-06	55.00

8:00 A.M.

10:00 A.M.

12:00

2:00 P.M.

4:00 P.M.

Figure 11-3 Shadow of obelisk for March 5 in two hour intervals.

6. Enter the coordinates of a point (in the form z,y,x)

The program produces two pairs of numbers. Again, the first pair of numbers represents the location of the point on the picture plane. The second pair of numbers represents the location of the shadow of that point on the ground plane with regard to the position of the sun and to North (Figure 11–4).

There are two flags included in this program. Flag 03 is set when the preamble to the program has been completed, when the position of North and the elevation of the ground plane have been entered. The program will calculate successive shadow points without having to reenter the two numbers. Any new altitude and azimuth can be entered without altering the two numbers. If, however, a new North position or a new elevation is required, flag 03 must be cleared and the S PT procedure repeated.

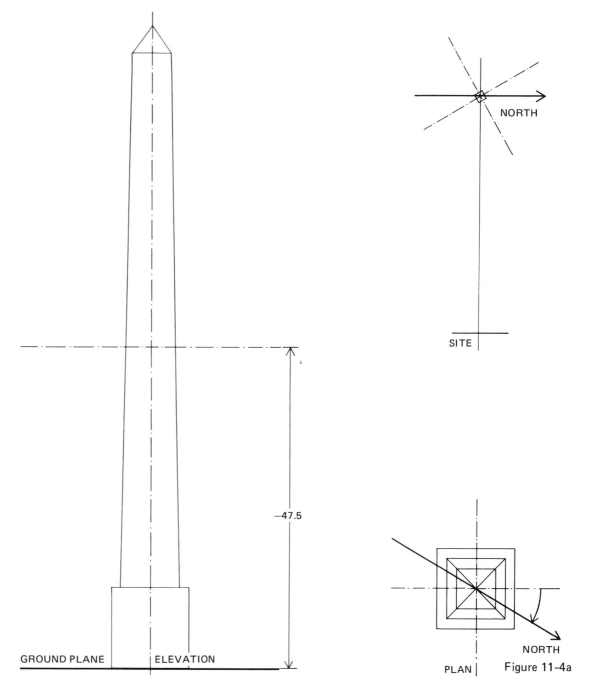

GROUND PLANE ELEVATION

–47.5

NORTH

SITE

PLAN Figure 11–4a

NORTH

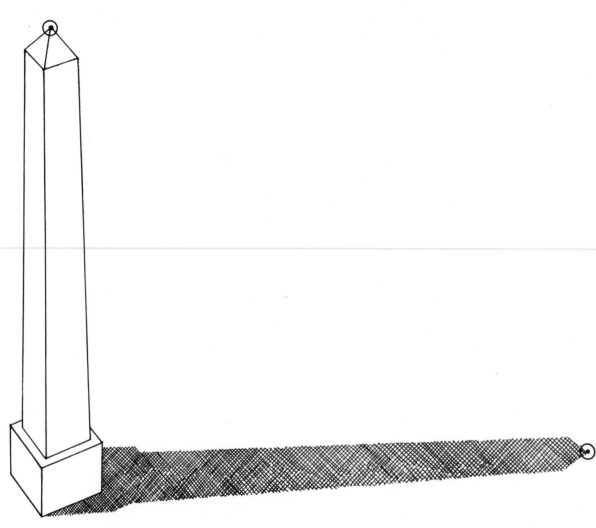

R–00	24
R–01	350
R–02	0
R–03	0
R–04	40
R–05	0
R–06	30

The second, flag 04, tells the calculator to skip over the section of the program that computes the initial point, and the program only computes the shadow point. This is useful when the position of the shadow at different times of the day are drawn of the same object.

Note: When using a smaller capacity calculator, the shadow can be drawn onto the rotated plan from the altitude and azimuth angles alone. Since the sun has not yet attained the zenith in Figure 11–5 and is still east of the zenith, the shadow it casts is measured as an angle west of north. The rays of the sun are all parallel, and consequently, the lines of the shadow are all parallel to the azimuth angle. The length of the shadow, *L,* is found by the relationship:

$$L = \frac{\text{Height}}{\tan (\text{Altitude})}$$

The length of the shadow can be found simply from the height.

Figure 11–4b

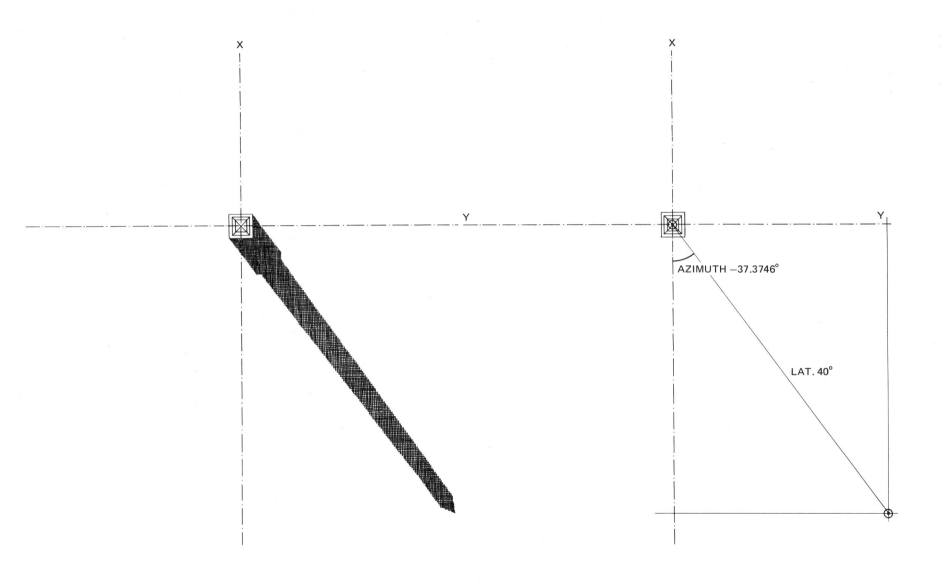

AZIMUTH −37.3746°

LAT. 40°

Figure 11-5 The shadow point is computable from the altitude and azimuth. The shadow point can then be processed through the basic P program.

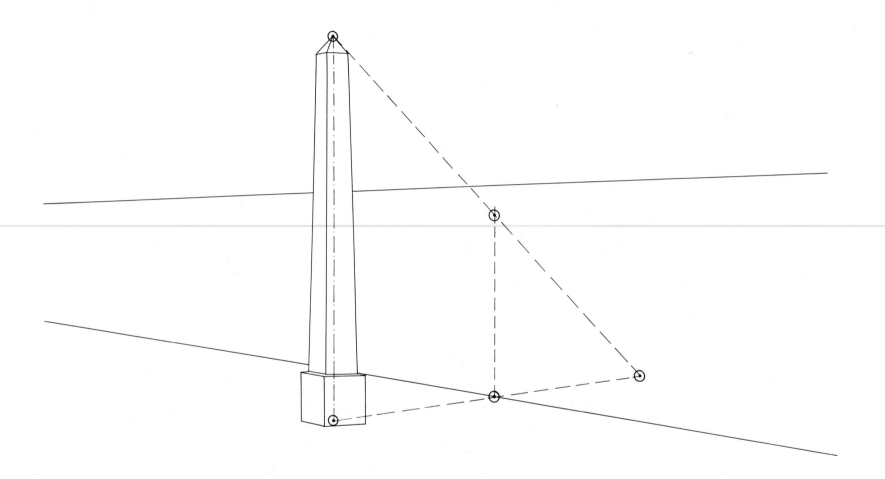

Figure 11-6a

R–00	24
R–01	350
R–02	0
R–03	0
R–04	0
R–05	0
R–06	30

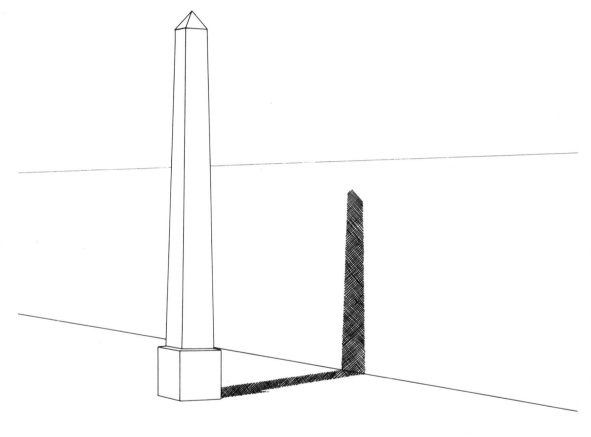

METHOD FOR DRAWING A SHADOW ON A VERTICAL PLANE

We have discussed shadows falling only on the horizontal plane. It is, of course, also possible to have shadows falling on the vertical plane. The problem with computing this is that there is no easy method to include all vertical planes without in effect creating a new program for each condition. It is the amount of effort that must be expended to define the position of the vertical plane that makes a universal method elusive. A simple graphic method in this case is expedient.

Imagine our obelisk with the sun shining on it. Using the S PT program, finding the position where the shadow of the obelisk will strike the ground is simple. But a wall intervenes. If we think of the point where the shadow strikes the ground as defining the hypotenuse of a right triangle with the ground as one side and the obelisk as the other, the wall cuts this

Figure 11-6b

R-00	24
R-01	56
R-02	0
R-03	−5.25
R-04	60.00
R-05	0
R-06	−60.0

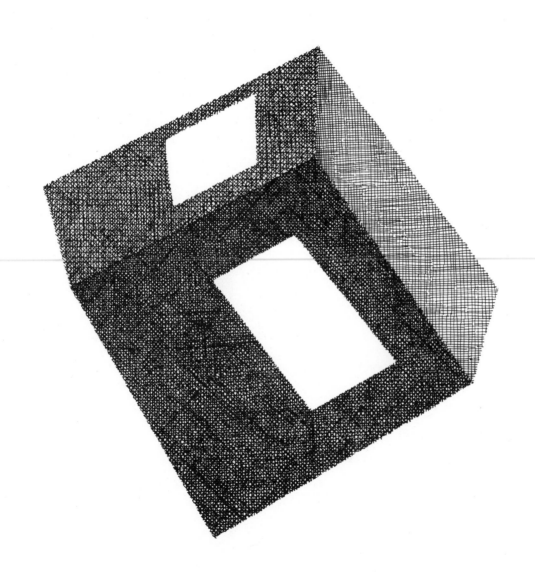

Figure 11-7a Light penetrating through a window at 12:00 noon, Feb. 12.

triangle, forming a smaller similar triangle. Finding the point where the sun ray strikes the wall becomes a matter of finding the similar triangle. Graphically, this is quite easy to do. We find the shadow point using the S PT program. Then we draw the triangle. Where the ground line intersects the wall plane defines the base of the similar triangle. Where the vertical line drawn parallel to the wall plane intersects the hypotenuse is the point where the shadow strikes the wall (Figure 11–6).

The shadow image may be thought of as the precise boundary between light and dark. The inverse of the shadow cast by an object is the sunlight penetrating through a window. The boundary in this case is described by the same means as a shadow cast by an object. The points representing the four corners of the window are needed to define the shape of the sunlight radiated through the window (Figure 11–7). The boundary is also an abstraction of a true shadow: the light from the sun emanates

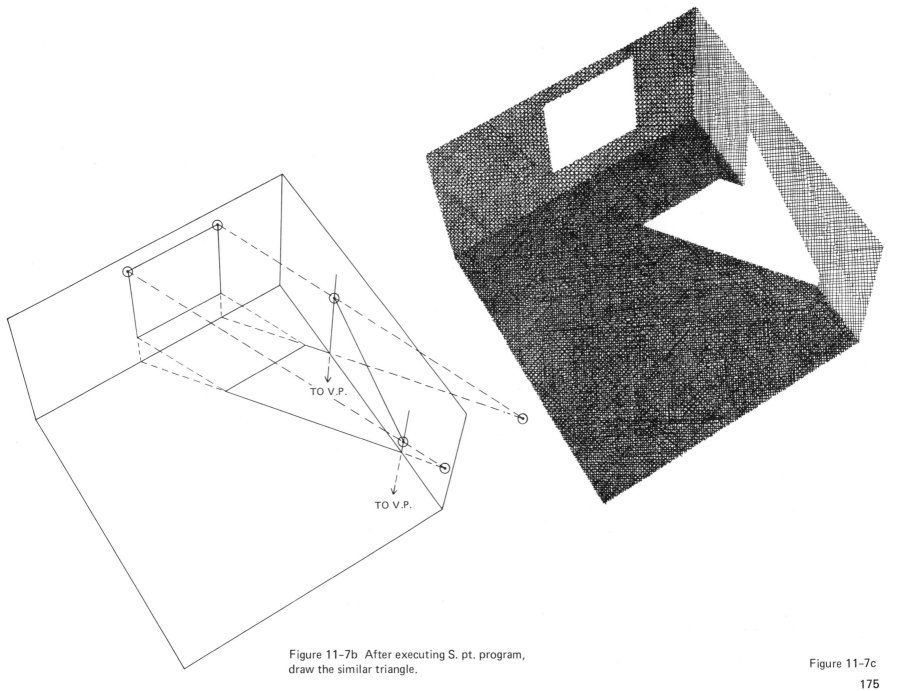

Figure 11–7b After executing S. pt. program,
draw the similar triangle.

Figure 11–7c

from a disk and not from a point source. The amount of light that comes from the sun varies across the disk from limb to limb, and consequently the shadow line is fuzzy and not crisp.

ANALEMMA

If place and hour of day are held constant and the altitude and azimuth are calculated for successive days, an analemma appears (Figure 11–8). The pinnacle of the obelisk at 12:00 noon marks points in two-day intervals. During the course of the year, the characteristic figure-eight shape of the analemma is described on the ground. The lines emanating from the base of the obelisk indicate the hour lines if the obelisk was the gnomon of a sundial. Some additional lines at the southern end of the circle have been added for graphic effect that indicate the hours that could not be crossed by shadow unless the obelisk was

north of the arctic circle. The ALTAZIM program mimics what happens in nature: the north-south movement results from the change in the solar declination, and the east-west movement shows that the sun is at times faster and at times slower than clock time. This dynamic results from the eccentricity of the earth's orbit around the sun and from the inclination of the earth's axis. The sun is more than 14 minutes slow on February 15 and more than 16 minutes fast on November 1. The figure eight is not symmetrical about the north-south line: the rate that the sun accumulates or loses time varies throughout the year. This results from the difference between the sun's zenith-to-zenith interval and 24 hours as measured by the clock at a particular position in the earth's orbit. This is the reason a sundial is never accurate. The ALTAZIM program calculates the true position of the sun with regard to true North for any date, place, and hour.

Figure 11-8 Noon analemma generated by an obelisk at lat 40°N. Each black spot represents position of the pinnacle at 12:00. The characteristic figure-eight shape of the analemma shows that the sun is sometimes "fast" and sometimes "slow" with respect to clock time.

12 A CUBE ON A SPHERE

The illumination of a sphere involves many complicated issues. There are several aspects to consider: the location of the line separating the illuminated hemisphere from the shaded hemisphere, the shadow cast by the sphere itself, and the shadow of an object falling on the sphere. Using the calculator, it is no more difficult to execute drawings with light falling on a sphere than to plot a cube. The versatility and brute force of the computing capabilities of the programmable calculator can handle even the most complex problems. Ideas that would have once been mind-boggling to attempt are manageable and can in fact be reduced to plotting points on the picture plane.

Since the sun is very far away, the light rays are essentially parallel; consequently, the perfect sphere will be divided into two equal parts—half light, half dark—and the dividing line will be a great circle. In the real world spheres are not perfect, the sun is not a point source but a disk, and there may be some defraction at the boundary, causing the line between the lit side and the shaded side to appear fuzzy.

If we imagine that the equatorial line is a disk in the *xy*-plane of the coordinate system, the shadow line would be that disk that was in the plane perpendicular to the rays of the sun. We know the position of the sun from the altitude and azimuth. The disk must be rotated so that it will be perpendicular to the sun. Any position may be found for the coordinate system, but the rotation must be done in steps, rotating about each axis.

The position of the sun is given as the altitude, (the angle from the horizon) and the azimuth (the angle from South). These angles must be taken through the equivalent steps of rotation about the axes of the coordinate system. The ROLPOL program automatically computes this rotation of the coordinate system from the altitude and azimuth and stores it for use in the EQ SHDW program and the SPH SH program.

Procedure for Drawing Equatorial Shadow and Sphere Shadow

1. Xeq ALTAZIM for a particular date, location, and hour. The result will be the altitude and azimuth.
2. Supply the necessary information for BASIC P.
3. Xeq ROLPOL.
4. Xeq EQ SHDW and supply the following information:
 a) Radius of the sphere.
 b) Height of the center of the sphere above the ground plane.
 c) Number of points around equator.
 d) Angle between points.
 e) Angle of first point.

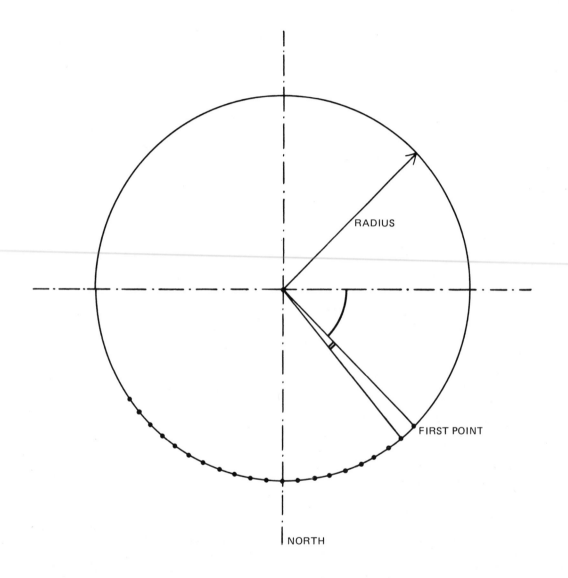

RADIUS

FIRST POINT

NORTH

Figure 12-1a

This program assumes that the center of the sphere is at the origin and the North orientation is 270° (the shadow will be cast toward the observer). (See Figure 12-1.)

The result will be two pairs of numbers. The first pair represents the location of a point on the equatorial line on the picture plane, and the second, the location of its shadow. When the points are plotted, the result is Figures 12-2 and 12-3. Since the center is at the origin, the image of it on the picture plane is, of course, a circle. The exact radius of this circle may be found by using the SPHERE program. The equatorial line can be seen to be an elongated ellipse. The shadow cast by the sphere is also an ellipse.

DRAWING A SHADOW CAST ON A SPHERE

Every point on the cube can be defined as (x, y, z). The sun ray that passes through this point at a particular altitude and azimuth will strike

the sphere at another point (x_s, y_s, z_s). This point must satisfy the equation of the sphere:

$$x_s^2 + y_s^2 + z_s^2 = r^2$$

where r is the radius of the sphere. The solution to this equation is found by using the SPH SH program. This program rotates the sphere and the cube so that the sun rays are falling vertically with respect to the coordinate system. In this position, in the xy-plane, the x and y values of the cube are coincident with the x_s and y_s values of the sphere. The z_s value of the sphere can be found in terms of x, y, and r, where r again is the radius of the sphere. When the value of the shadow point on the sphere (x_s, y_s, z_s) has been computed, the sphere and cube are rotated back to their original position, and the BASIC P section of the program will find the point on the picture plane. This works on the principle that the sun sees no shadows. This method can work for any curved surface

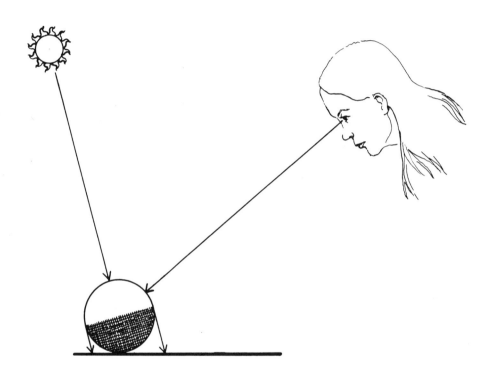

Figure 12-1b

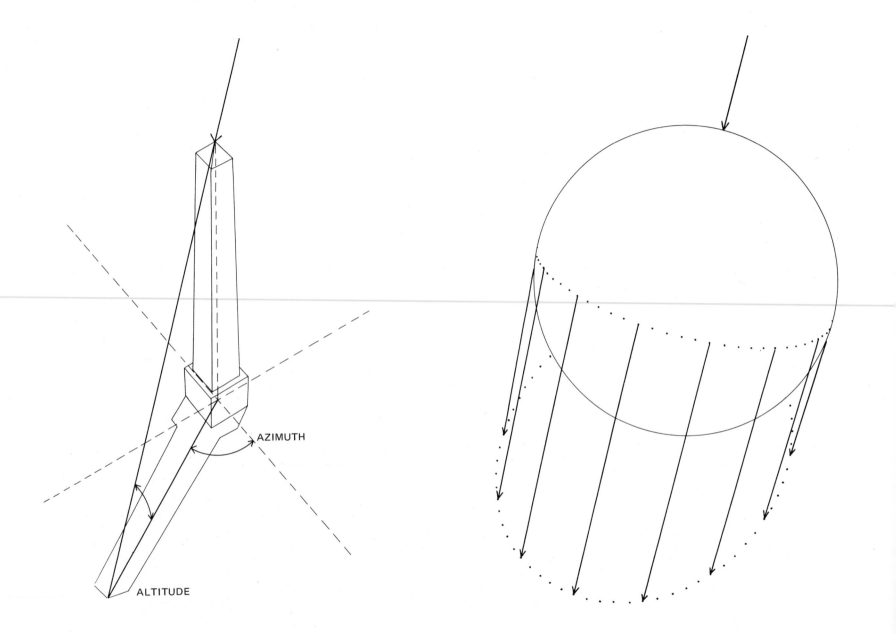

AZIMUTH

ALTITUDE

Figure 12-2

R-00	16
R-01	24
R-02	0
R-03	0
R-04	50
R-05	0
R-06	35

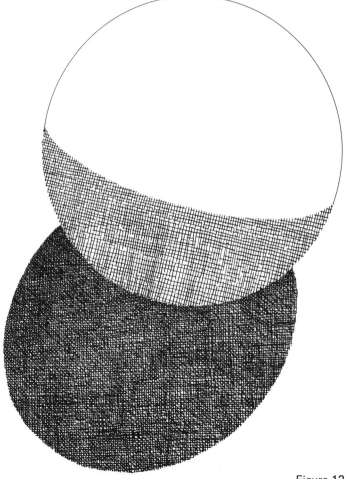

Figure 12-3

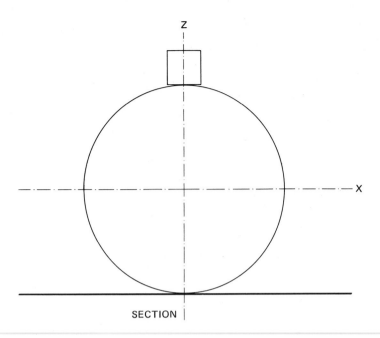

SECTION

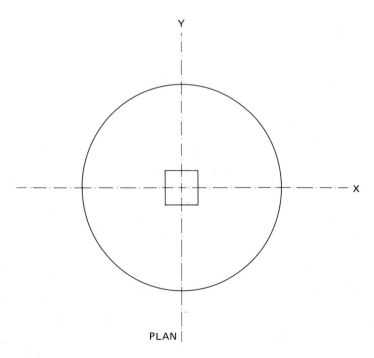

PLAN

Figure 12-4

that can be defined as an equation with *x, y,* and *z,* by substituting that equation in the program and solving for *z* in terms of *x* and *y.*

SPH SH Program Procedure.

1. Xeq EQ SHDW.
2. Xeq SQUARE to describe the cube.
3. Xeq SPH SH for points along the edge of the cube entered in the form z, y, x.

The relationship of the cube to the sphere may be found in Figure 12-4. When the SQUARE program has been executed and the cube drawn on the sphere, Figure 12-5 will result. Since the edges of the cube are straight lines, a cube can be drawn by finding its vertices and connecting them with lines. A shadow cast by a straight line on a sphere will be an arc, thus a number of points along a line are needed to describe the arc (Figure 12-6). The SPH SH program must be used for each

R-00	16
R-01	24
R-02	0
R-03	0
R-04	50
R-05	0
R-06	35

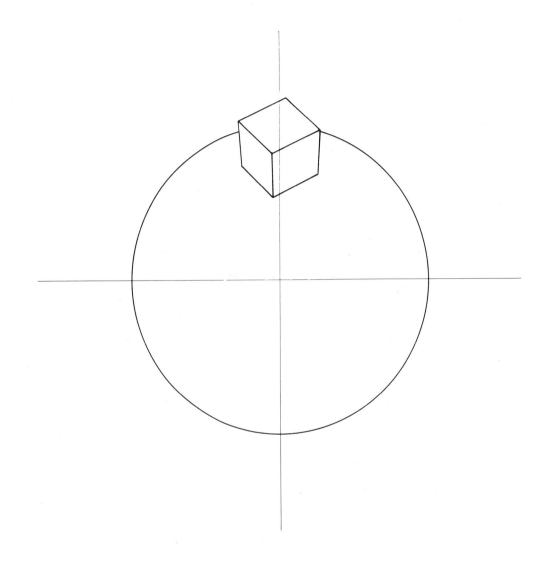

point on the edge of the cube that will cast a shadow. When these points are plotted, Figure 12-7 will result. When the lit and shaded hemispheres, the shadow of the sphere, and the shadow of the cube are drawn together, the result will be Figure 12-8.

The great advantage to being able to construct complex perspective drawings with facility and confidence in their numerical reality is the ability to actually work in three dimensions rather than to work with two-dimensional plans in which you can only deal with an idea in pieces and not as a whole. This expands your ability to see things, to know what they will look like, and to evaluate results.

Figure 12-5

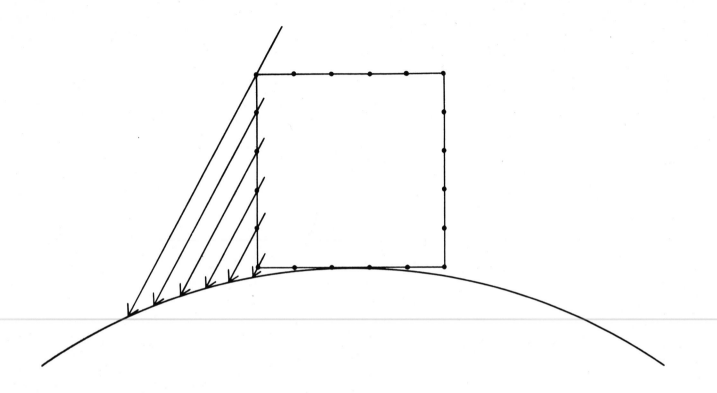

Figure 12–6

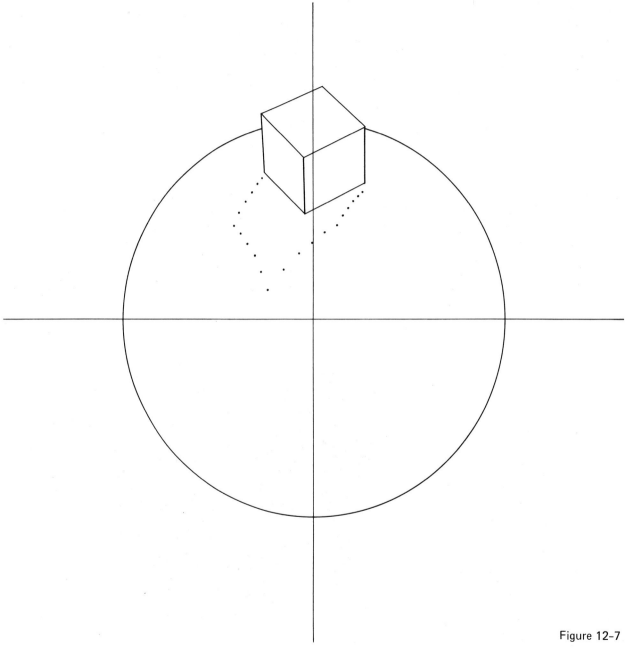

Figure 12-7

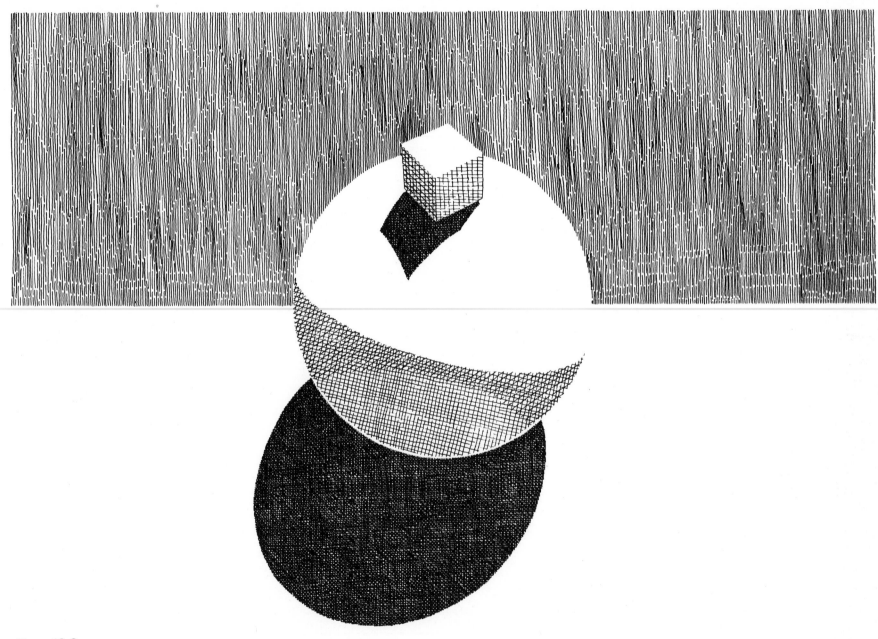

Figure 12-8

Appendix A
HEWLETT–PACKARD
PROGRAMS

BASIC P PROGRAM

```
01•LBL  BASIC P"        36 RCL 00
02 XEQ "BASIC"          37 X<>Y
03 XEQ "PRINT X"        38 /
04 END                  39 X<>Y
                        40 RCL 07
01•LBL "BASIC"          41 X<>Y
02 R-P                  42 R-P
03 X<>Y                 43 X<>Y
04 RCL 06               44 STO 07
05 +                    45 RDN
06 X<>Y                 46 *
07 P-R                  47 RCL 07
08 STO 07               48 X<>Y
09 RDN                  49 P-R
10 R-P                  50 END
11 X<>Y
12 RCL 04               01•LBL "PRINT X"
13 +                    02 "X="
14 X<>Y                 03 ARCL X
15 P-R                  04 AVIEW
16 X<>Y                 05 X<>Y
17 RCL 07               06 "Y="
18 X<>Y                 07 ARCL X
19 R-P                  08 AVIEW
20 X<>Y                 09 END
21 RCL 05
22 +
23 X<>Y
24 P-R
25 RCL 03
26 +
27 STO 07
28 RDN
29 RCL 02
30 +
31 X<>Y
32 RCL 01
33 +
34 RCL 00
35 +
```

NUMERICAL EXAMPLE

```
                10.00 STO 00
                20.00 STO 01
                30.00 STO 02
                40.00 STO 03
                50.00 STO 04
                60.00 STO 05
                70.00 STO 06

                 .006
                        PRREGX

R00=   10.00
R01=   20.00
R02=   30.00
R03=   40.00
R04=   50.00
R05=   60.00
R06=   70.00

                        FIX 8

        1.00000000 ENTER↑
        2.00000000 ENTER↑
        3.00000000
                XEQ "BASIC P"
X=10.30753911
Y=13.46711194
```

VP PROGRAM

```
01♦LBL "VP"          41 CHS               81♦LBL 07            121 -
02 CF 06             42 STO 26            82 TAN               122 X<>Y
03 CF 07             43 RCL 23            83 RCL 00            123 P-R
04 CF 08             44 XEQ 08            84 *                 124 XEQ 16
05 CF 09             45 FS? 10            85 RTN               125 RTN
06 CF 10             46 CHS               86♦LBL 08            126♦LBL 12
07 RCL 06            47 STO 27            87 X↑2               127 RCL 24
08 X=0?              48 SF 08             88 RCL 24            128 RCL 26
09 GTO 01            49♦LBL 03            89 X↑2               129 XEQ 16
10 XEQ 05            50 RCL 05            90 RCL 00            130 RCL 24
11 X<0?              51 X=0?              91 X↑2               131 RCL 27
12 SF 09             52 GTO 04            92 /                 132 XEQ 16
13 STO 22            53 FS? 08            93 1                 133 RCL 25
14 RCL 06            54 GTO 09            94 +                 134 0
15 90                55 FS? 07            95 *                 135 XEQ 16
16 -                 56 GTO 06            96 SQRT              136 RTN
17 XEQ 05            57 FS? 06            97 RTN               137♦LBL 13
18 X<0?              58 GTO 10            98♦LBL 09            138 RCL 24
19 SF 10             59♦LBL 04            99 RCL 24            139 0
20 STO 23            60 FS? 08            100 RCL 26           140 XEQ 16
21 SF 06             61 GTO 12            101 XEQ 11           141 RCL 25
22♦LBL 01            62 FS? 07            102 RCL 24           142 0
23 RCL 04            63 GTO 13            103 RCL 27           143 XEQ 16
24 X=0?              64 FS? 06            104 XEQ 11           144 RTN
25 GTO 03            65 GTO 15            105 RCL 25           145♦LBL 14
26 XEQ 07            66 GTO 14            106 0                146 0
27 STO 24            67♦LBL 05            107 XEQ 11           147 ENTER↑
28 RCL 04            68 TAN               108 RTN              148 XEQ 16
29 90                69 RCL 00            109♦LBL 10           149 RTN
30 -                 70 X<>Y              110 0                150♦LBL 15
31 XEQ 07            71 /                 111 RCL 22           151 0
32 STO 25            72 RTN               112 XEQ 11           152 RCL 22
33 SF 07             73♦LBL 06            113 0                153 XEQ 16
34 FS? 06            74 RCL 24            114 RCL 23           154 0
35 GTO 02            75 0                 115 XEQ 11           155 RCL 23
36 GTO 03            76 XEQ 11            116 RTN              156 XEQ 16
37♦LBL 02            77 RCL 25            117♦LBL 11           157 RTN
38 RCL 22            78 0                 118 R-P              158♦LBL 16
39 XEQ 08            79 XEQ 11            119 X<>Y             159 "V P"
40 FS? 09            80 RTN               120 RCL 05           160 AVIEW
```

```
161 XEQ "PRINT X"
162 END
```

NUMERICAL EXAMPLE

```
                .006
                        PRREGX

R00=   10.00
R01=   20.00
R02=   30.00
R03=   40.00
R04=   50.00
R05=   60.00
R06=   70.00

                        FIX 8
                        XEQ "VP"
V P
X=13.15207469
Y=1.05501026
V P
X=-11.05069157
Y=42.97543108
V P
X=-7.26681597
Y=-4.19549816
```

```
01*LBL "VAN PT"
02 FS? 02
03 GTO 01
04 "PT 1 ZYX?"
05 PROMPT
06 XEQ "BASIC"
07 STO 30
08 X<>Y
09 STO 31
10 "PT 2 ZYX?"
11 PROMPT
12 XEQ "BASIC"
13 STO 32
14 X<>Y
15 STO 33
16 "PT 3 ZYX?"
17 PROMPT
18 XEQ "BASIC"
19 STO 34
20 X<>Y
21 STO 35
22 "PT 4 ZYX?"
23 PROMPT
24 XEQ "BASIC"
25 STO 36
26 X<>Y
27 STO 37
28*LBL 01
29 RCL 30
30 RCL 32
31 -
32 RCL 31
33 RCL 33
34 -
35 X<>Y
36 /
37 STO 38
38 RCL 30
39 *
40 RCL 31
```

```
41 X<>Y
42 -
43 STO 39
44 RCL 34
45 RCL 36
46 -
47 RCL 35
48 RCL 37
49 -
50 X<>Y
51 /
52 STO 40
53 RCL 34
54 *
55 RCL 35
56 X<>Y
57 -
58 RCL 39
59 -
60 RCL 38
61 RCL 40
62 -
63 /
64 STO 42
65 RCL 38
66 *
67 RCL 39
68 +
69 STO 43
70 RCL 42
71 "X="
72 ARCL X
73 AVIEW
74 RDN
75 "Y="
76 ARCL X
77 AVIEW
78 .END.
```

NUMERICAL EXAMPLE

```
                .006
                        PRREGX

R00=   10.00
R01=   20.00
R02=   30.00
R03=   40.00
R04=   50.00
R05=   60.00
R06=   70.00

                        FIX 8

                XEQ "VAN PT"
PT 1 ZYX?
        0.00000000 ENTER↑
       10.00000000 ENTER↑
      -10.00000000     RUN
PT 2 ZYX?
        0.00000000 ENTER↑
       10.00000000 ENTER↑
       10.00000000     RUN
PT 3 ZYX?
        0.00000000 ENTER↑
      -10.00000000 ENTER↑
      -10.00000000     RUN
PT 4 ZYX?
        0.00000000 ENTER↑
      -10.00000000 ENTER↑
       10.00000000     RUN
X=13.15207472
Y=1.05501020
```

CR PROGRAM

		NUMERICAL EXAMPLE	

```
01*LBL "CR"        41 /
02 4               42 RCL 34
03 ENTER↑          43 *
04 3               44 STO 35
05 /               45 RCL 30
06 STO 34          46 *
07 "X=SF 01"       47 RCL 31
08 PROMPT          48 -
09 "NO/PTS?"       49 RCL 35
10 PROMPT          50 1
11 1               51 -
12 -               52 /
13 1 E3            53 FS? 01
14 /               54 GTO 04
15 STO 40          55*LBL 02
16 "PT 1 ZYX?"     56 "Y="
17 PROMPT          57 ARCL X
18 XEQ "BASIC P"   58 AVIEW
19 FS? 01          59*LBL 03
20 X<>Y            60 RCL 32
21 STO 30          61 RCL 31
22 "PT 2 ZYX?"     62 STO 30
23 PROMPT          63 RDN
24 XEQ "BASIC P"   64 STO 31
25 FS? 01          65 RDN
26 X<>Y            66 STO 32
27 STO 31          67 ISG 40
28 "PT 3 ZYX?"     68 GTO 01
29 PROMPT          69 RTN
30 XEQ "BASIC P"   70*LBL 04
31 FS? 01          71 "X="
32 X<>Y            72 ARCL X
33 STO 32          73 AVIEW
34*LBL 01          74 GTO 03
35 RCL 32          75 END
36 RCL 31
37 -
38 RCL 32
39 RCL 30
40 -
```

NUMERICAL EXAMPLE

```
                        .006                              FIX 8
                        PRREGX

R00=   10.00                                        XEQ "CR"
R01=   20.00              X=SF 01
R02=   30.00                                            RUN
R03=   40.00              NO/PTS?
R04=   50.00                     6.00000000         RUN
R05=   60.00              PT 1 ZYX?
R06=   70.00                     0.00000000 ENTER↑
                                 0.00000000 ENTER↑
                                 0.00000000     RUN
                          X=10.00000000
                          Y=13.33333334
                          PT 2 ZYX?
                                 0.00000000 ENTER↑
                                10.00000000 ENTER↑
                                 0.00000000     RUN
                          X=8.56269014
                          Y=15.35725162
                          PT 3 ZYX?
                                 0.00000000 ENTER↑
                                20.00000000 ENTER↑
                                 0.00000000     RUN
                          X=7.30911021
                          Y=17.12245436
                          Y=18.67556846
                          Y=20.05265136
                          Y=21.28202531
                          Y=22.38624601
                          Y=23.38349915
                          Y=24.28860984
```

SQUARE PROGRAM

```
01•LBL "SQUARE"
02 STO 12
03 RDN
04 STO 11
05 RDN
06 STO 10
07 RCL 10
08 RCL 11
09 CHS
10 RCL 12
11 CHS
12 XEQ 01
13 RCL 10
14 RCL 11
15 CHS
16 RCL 12
17 XEQ 01
18 RCL 10
19 RCL 11
20 RCL 12
21 XEQ 01
22 RCL 10
23 RCL 11
24 RCL 12
25 CHS
26 XEQ 01
27 RTN
28•LBL 01
29 FS? 04
30 XEQ "TURN"
31 FS? 03
32 XEQ "SHIFT"
33 XEQ "BASIC P"
34 END
```

NUMERICAL EXAMPLE

```
                       .006
                          PRREGX

             R00=  10.00
             R01=  20.00
             R02=  30.00
             R03=  40.00
             R04=  50.00
             R05=  60.00
             R06=  70.00

                          FIX 8

             0.00000000 ENTER↑
             1.00000000 ENTER↑
             2.00000000
                      XEQ "SQUARE"
         X=10.02870167
         Y=13.62438878
         X=10.27222513
         Y=12.64437819
         X=9.97390639
         Y=13.06872546
         X=9.70922982
         Y=14.06922283
```

CHAPTER 9
TURN PROGRAM

```
01♦LBL "TURN"
02 FS? 04
03 GTO 01
04 "X ROT?"
05 PROMPT
06 STO 15
07 "Y ROT?"
08 PROMPT
09 STO 16
10 "Z ROT?"
11 PROMPT
12 STO 17
13 SF 04
14 "Z,Y,X?"
15 PROMPT
16♦LBL 01
17 R-P
18 X<>Y
19 RCL 17
20 +
21 X<>Y
22 P-R
23 STO 07
24 RDN
25 R-P
26 X<>Y
27 RCL 15
28 +
29 X<>Y
30 P-R
31 X<> 07
32 X<>Y
33 R-P
34 X<>Y
35 RCL 16
36 +
37 X<>Y
38 P-R
39 X<>Y
40 RCL 07
41 X<>Y
42 END
```

NUMERICAL EXAMPLE

```
                    .006
                              PRREGX

              R00=  10.00
              R01=  20.00
              R02=  30.00
              R03=  40.00
              R04=  50.00
              R05=  60.00
              R06=  70.00

                              FIX 8

                      XEQ "TURN"
              X ROT?
                    10.00000000   RUN
              Y ROT?
                    20.00000000   RUN
              Z ROT?
                    30.00000000   RUN
              Z,Y,X?
                     1.00000000 ENTER↑
                     2.00000000 ENTER↑
                     3.00000000   RUN

                      XEQ "BASIC P"
              X=10.06174285
              Y=13.86935949
```

CHAPTER 9
SHIFT PROGAM

```
01♦LBL "SHIFT"
02 FS? 03
03 GTO 01
04 "NEW X?"
05 PROMPT
06 STO 30
07 "NEW Y?"
08 PROMPT
09 STO 31
10 "NEW Z?"
11 PROMPT
12 STO 32
13 SF 03
14 "Z,Y,X?"
15 PROMPT
16♦LBL 01
17 RCL 30
18 +
19 STO 07
20 RDN
21 RCL 31
22 +
23 X<>Y
24 RCL 32
25 +
26 X<>Y
27 RCL 07
28 END
```

NUMERICAL EXAMPLE
```
                    .006
                              PRREGX

              R00=  10.00
              R01=  20.00
              R02=  30.00
              R03=  40.00
              R04=  50.00
              R05=  60.00
              R06=  70.00
```

```
                              FIX 8
                      XEQ "SHIFT"
              NEW X?
                     1.00000000   RUN
              NEW Y?
                     2.00000000   RUN
              NEW Z?
                     3.00000000   RUN
              Z,Y,X?
                     1.00000000 ENTER↑
                     2.00000000 ENTER↑
                     3.00000000   RUN

                      XEQ "BASIC P"
              X=11.38970629
              Y=14.99097738

                    .006
                              PRREGX

              R00=  10.00
              R01=  20.00
              R02=  30.00
              R03=  40.00
              R04=  50.00
              R05=  60.00
              R06=  70.00

                              FIX 8

                     1.00000000 ENTER↑
                     2.00000000 ENTER↑
                     3.00000000
                      XEQ "TURN"
                      XEQ "SHIFT"
                      XEQ "BASIC P"
              X=11.14416207
              Y=15.42493539
```

196

CIRCLE 1 PROGRAM

```
01♦LBL "CIRCLE1"
02 FS? 01
03 GTO 01
04 "RADIUS?"
05 PROMPT
06 STO 08
07 "NO/PTS?"
08 PROMPT
09 ENTER↑
10 ENTER↑
11 1
12 -
13 1 E3
14 /
15 STO 40
16 RDN
17 360
18 X<>Y
19 /
20 STO 09
21 0
22 STO 14
23 SF 01
24♦LBL 01
25 RCL 09
26 ST+ 14
27 0
28 RCL 14
29 RCL 08
30 P-R
31 FS? 04
32 XEQ "TURN"
33 FS? 03
34 XEQ "SHIFT"
35 XEQ "BASIC P"
36 ISG 40
37 GTO 01
38 END
```

NUMERICAL EXAMPLE

```
                        .006
                            PRREGX

R00=  10.00
R01=  20.00
R02=  30.00
R03=  40.00
R04=  50.00
R05=  60.00
R06=  70.00

                            FIX 8

                    XEQ "CIRCLE1"
RADIUS?
         6.00000000    RUN
NO/PTS?
         3.00000000    RUN
X=8.98537861
Y=15.24640557
X=10.67795141
Y=12.90396048
X=10.33974253
Y=12.00992922
```

CIRCLE 2 PROGRAM

```
01♦LBL "CIRCLE2"
02 "RADIUS?"
03 PROMPT
04 STO 08
05 "NO/PTS?"
06 PROMPT
07 1
08 -
09 1 E3
10 /
11 STO 40
12 "PT-PT ANG?"
13 PROMPT
14 STO 09
15 "1ST PT ANG?"
16 PROMPT
17 STO 14
18♦LBL 01
19 0
20 RCL 14
21 RCL 08
22 P-R
23 FS? 04
24 XEQ "TURN"
25 FS? 03
26 XEQ "SHIFT"
27 XEQ "BASIC P"
28 RCL 09
29 ST+ 14
30 ISG 40
31 GTO 01
32 END
```

NUMERICAL EXAMPLE

```
                        .006
                            PRREGX

R00=  10.00
R01=  20.00
R02=  30.00
R03=  40.00
R04=  50.00
R05=  60.00
R06=  70.00

                            FIX 8

                    XEQ "CIRCLE2"
RADIUS?
         6.00000000    RUN
NO/PTS?
         3.00000000    RUN
PT-PT ANG?
        30.00000000    RUN
1ST PT ANG?
       -75.00000000    RUN
X=11.00384692
Y=11.67188629
X=10.87614055
Y=11.46443514
X=10.54950164
Y=11.73191077
```

SPHERE PROGRAM

01✦LBL "SPHERE"	41 X↑2	81 RCL 24	121 RDN
02 "RADIUS?"	42 RCL 23	82 X↑2	122 X<>Y
03 PROMPT	43 X↑2	83 -	123 R↑
04 STO 24	44 +	84 SQRT	124 XEQ "TURN"
05 "NO/PTS?"	45 SQRT	85 RCL 26	125 XEQ "SHIFT"
06 PROMPT	46 RCL 22	86 SIN	126 XEQ "BASIC P"
07 ENTER↑	47 X<>Y	87 *	127 ISG 40
08 ENTER↑	48 /	88 STO 08	128 GTO 01
09 1	49 ATAN	89 RCL 26	129 END
10 -	50 STO 15	90 TAN	
11 1 E3	51 RCL 04	91 /	
12 /	52 ST- 15	92 RCL 25	NUMERICAL EXAMPLE
13 STO 40	53 0	93 /	
14 RDN	54 STO 16	94 STO 27	.006
15 360	55 RCL 23	95 RCL 29	PRREGX
16 X<>Y	56 RCL 21	96 *	
17 /	57 +	97 RCL 02	R00= 10.00
18 STO 09	58 STO 28	98 -	R01= 20.00
19 0	59 X↑2	99 STO 30	R02= 30.00
20 STO 14	60 RCL 02	100 RCL 27	R03= 40.00
21 "CTR? Z,Y,X"	61 RCL 20	101 RCL 28	R04= 50.00
22 PROMPT	62 +	102 *	R05= 60.00
23 STO 20	63 STO 29	103 RCL 23	R06= 70.00
24 RDN	64 X↑2	104 -	
25 STO 21	65 +	105 STO 31	
26 RDN	66 RCL 03	106 RCL 27	FIX 8
27 STO 22	67 RCL 22	107 RCL 19	
28 RCL 00	68 +	108 *	XEQ "SPHERE"
29 RCL 01	69 STO 19	109 RCL 03	RADIUS?
30 +	70 X↑2	110 -	6.00000000 RUN
31 STO 23	71 +	111 STO 32	NO/PTS?
32 RCL 20	72 SQRT	112 SF 03	3.00000000 RUN
33 X<>Y	73 STO 25	113 SF 04	CTR? Z,Y,X
34 /	74 RCL 24	114✦LBL 01	4.00000000 ENTER↑
35 ATAN	75 X<>Y	115 RCL 09	5.00000000 ENTER↑
36 CHS	76 /	116 ST+ 14	6.00000000 RUN
37 STO 17	77 ASIN	117 0	X=11.09114041
38 RCL 06	78 STO 26	118 RCL 14	Y=16.59579339
39 ST- 17	79 RCL 25	119 RCL 08	X=9.03507625
40 RCL 20	80 X↑2	120 P-R	Y=12.04182006
			X=13.96646820
			Y=15.31490946

```
01♦LBL "ALTAZIM"        27 STO 26           67 STO 51          31 SF 06
02 FC? 00               28 ISG 25           68 +               32 ST+ 18
03 XEQ 01               29 GTO 01           69 X<>Y            33 12
04 FC? 01               30 RCL 26           70 P-R             34 *
05 XEQ "LOCAL"          31 2                71 STO 25          35 -
06 FC? 02               32 /                72 DEG             36 RCL 19
07 XEQ "HOUR"           33 TAN              73 XEQ "DECLINE"   37 *
08 XEQ "EQ 2"           34 1                74 STO 47          38 INT
09 RTN                  35 RCL 24           75 END             39 RCL 18
10♦LBL 01               36 +                                   40 RCL 20
11 XEQ "ORBIT"          37 1                                   41 *
12 XEQ "EQ TIME"        38 RCL 24           01♦LBL "DATE"       42 INT
13 END                  39 -                02 30.6001         43 +
                        40 /                03 STO 19          44 RCL 17
01♦LBL "ORBIT"          41 SQRT             04 365.25          45 +
02 XEQ "DATE"           42 *                05 STO 20          46 STO 22
03 RCL 21               43 ATAN             06 "DATE MM/DDYYYY?" 47 FS?C 06
04 .985609              44 2                07 PROMPT          48 GTO 01
05 *                    45 *                08 ENTER↑          49 GTO 02
06 PI                   46 STO 27           09 INT             50♦LBL 01
07 *                    47 149.6            10 STO 16          51 1
08 180                  48 STO 28           11 -               52 ST- 18
09 /                    49 ENTER↑           12 1 E2            53♦LBL 02
10 STO 23               50 1                13 *               54 14
11 .016726              51 ENTER↑           14 ENTER↑          55 RCL 19
12 STO 24               52 RCL 24           15 INT             56 *
13 6                    53 X↑2              16 STO 17          57 INT
14 1 E3                 54 -                17 -               58 RCL 18
15 /                    55 *                18 1 E4            59 RCL 20
16 STO 25               56 1                19 *               60 *
17 RCL 23               57 ENTER↑           20 STO 18          61 INT
18 STO 26               58 RCL 24           21 RCL 16          62 +
19 RAD                  59 RCL 27           22 1               63 1
20♦LBL 01               60 COS              23 +               64 +
21 RCL 26               61 *                24 ENTER↑          65 RCL 22
22 SIN                  62 +                25 1/X             66 X<>Y
23 RCL 24               63 /                26 .7              67 -
24 *                    64 STO 29           27 +               68 STO 21
25 RCL 23               65 RCL 27           28 CHS             69 END
26 +                    66 .1957908         29 INT
                                            30 X=0?
```

```
01♦LBL "DECLINE"        41 /                    37 +                    77 *
02 RCL 18               42 CHS                   38 STO 53               78 +
03 1 E2                 43 END                   39♦LBL 04               79 STO 53
04 /                                             40 RCL 23               80 GTO 04
05 FRC                                           41 RCL 51               81♦LBL 03
06 .004684              01♦LBL "EQ TIME"         42 +                    82 RCL 52
07 HR                   02 RAD                    43 RCL 53               83 SIN
08 *                    03 3                      44 -                    84 X↑2
09 CHS                  04 ENTER↑                 45 24                   85 RCL 22
10 23.270826           05 2                      46 *                    86 PI
11 HR                   06 /                      47 60                   87 *
12 +                    07 PI                     48 *                    88 180
13 STO 22              08 *                      49 2                    89 /
14 RCL 25              09 ST+ 51                 50 ENTER↑               90 SIN
15 X>0?                10 RCL 27                  51 PI                   91 X↑2
16 GTO 01             11 X<0?                    52 *                    92 *
17 GTO 02             12 XEQ 05                  53 /                    93 CHS
18♦LBL 01             13 RCL 51                  54 STO 48               94 1
19 RCL 22             14 +                       55 DEG                  95 +
20 RCL 25             15 2                       56 RTN                  96 SQRT
21 *                  16 ENTER↑                  57♦LBL 01               97 RCL 52
22 RCL 28             17 PI                      58 PI                   98 COS
23 ENTER↑             18 *                       59 -                    99 X<>Y
24 ENTER↑             19 X<>Y                     60 STO 52              100 /
25 RCL 24             20 X<=Y?                    61 XEQ 03             101 ACOS
26 *                  21 GTO 01                   62 PI                 102 STO 53
27 -                  22 3                        63 +                  103 RTN
28 /                  23 ENTER↑                   64 STO 53            104♦LBL 05
29 CHS                24 PI                       65 GTO 04            105 2
30 RTN                25 *                        66♦LBL 02            106 ENTER↑
31♦LBL 02             26 X<>Y                      67 2                107 PI
32 RCL 22             27 X<=Y?                     68 ENTER↑           108 *
33 RCL 25             28 GTO 02                    69 PI               109 +
34 *                  29 X<>Y                       70 *               110 RTN
35 RCL 28             30 -                         71 -                111 END
36 ENTER↑             31 STO 52                    72 STO 52
37 ENTER↑             32 XEQ 03                    73 XEQ 03           01♦LBL "LOCAL"
38 RCL 24             33 3                         74 2                02 "LONG? D/MMSS"
39 *                  34 ENTER↑                    75 ENTER↑           03 PROMPT
40 +                  35 PI                        76 PI               04 HR
                      36 *
```

```
05 STO 44        19 RCL 45        59 RCL 54
06 "LAT? D/MMSS"  20 SIN           60 -
07 PROMPT        21 RCL 47        61 FS?C 09
08 HR            22 SIN           62 CHS
09 STO 45        23 *             63 STO 54
10 "TI ZONE? EST=5"  24 RCL 45    64 "AZI="
11 PROMPT        25 COS           65 ARCL X
12 15            26 RCL 47        66 AVIEW
13 *            27 COS           67 END
14 RCL 44        28 RCL 46
15 X<>Y          29 COS
16 -            30 +
17 STO 49        31 *
18 END           32 *
                 33 ACOS
01*LBL "HOUR"    34 STO 50
02 "HR? 24H/MMSS" 35 RCL 47
03 PROMPT        36 SIN
04 HR            37 RCL 45
05 STO 43        38 SIN
06 END           39 RCL 50
                 40 COS
01*LBL "EQ 2"    41 *
02 RCL 43        42 -
03 12            43 RCL 45
04 -            44 COS
05 15            45 RCL 50
06 *            46 SIN
07 RCL 48        47 *
08 60            48 /
09 /            49 ACOS
10 15            50 STO 54
11 *            51 90
12 +            52 RCL 50
13 RCL 49        53 -
14 -            54 STO 50
15 X>0?          55 "ALT="
16 SF 09         56 ARCL X
17 ABS           57 AVIEW
18 STO 46        58 180
```

NUMERICAL EXAMPLE

```
              XEQ "ALTAZIM"
DATE MM/DDYYYY?
        6.16198200    RUN
LONG? D/MMSS
       75.00000000    RUN
LAT? D/MMSS
       40.00000000    RUN
TI ZONE? EST=5
        5.00000000    RUN
HR? 24H/MMSS
       11.00000000    RUN
ALT=69.02573964
AZI=41.97491200
```

```
                            SF 01
                            SF 02
                    XEQ "ALTAZIM"
DATE MM/DDYYYY?
       10.15198200    RUN
ALT=39.88542625
AZI=14.80376950

                            CF 02
                            SF 00
                            SF 01
                    XEQ "ALTAZIM"
HR? 24H/MMSS
       14.00000000    RUN
ALT=32.02209431
AZI=-40.08139560
```

CHAPTER 11
S PT PROGRAM

```
01♦LBL "S PT"              41 XEQ "BASIC P"
02 FS? 03                  42 END
03 GTO 01
04 "R/NORTH?"
05 PROMPT
06 STO 60
07 "GROUND?"          NUMERICAL EXAMPLE
08 PROMPT
09 STO 58                      XEQ "ALTAZIM"
10 SF 03              DATE MM/DDYYYY?
11 "Z Y X?"                 10.15198200    RUN
12 PROMPT             LONG? D/MMSS
13♦LBL 01                  75.00000000    RUN
14 STO 55             LAT? D/MMSS
15 RDN                     40.00000000    RUN
16 STO 56             TI ZONE? EST=5
17 RDN                      5.00000000    RUN
18 STO 57             HR? 24H/MMSS                    CF 03
19 FC? 04                  12.00000000    RUN          SF 04
20 GTO 02             ALT=40.90882890            XEQ "S PT"
21 RCL 56             AZI=-4.64333190        R/NORTH?
22 RCL 55                                      270.0000000    RUN
23 XEQ "BASIC P"             .00600000     GROUND?
24♦LBL 02                                        -6.00000000    RUN
25 RCL 58                            PRREGX     Z,Y,X?
26 ST- 57                                         0.00000000 ENTER↑
27 RCL 60             R00=  10.00000000           0.00000000 ENTER↑
28 RCL 54             R01=  20.00000000           0.00000000    RUN
29 +                  R02=  30.00000000     X=10.00000000
30 RCL 57             R03=  40.00000000     Y=13.33333334
31 RCL 50             R04=  50.00000000     X=8.51896541
32 TAN                R05=  60.00000000     Y=9.62579057
33 /                  R06=  70.00000000
34 P-R                      50.00000000
35 ST+ 55                            PRREGX        0.00000000 ENTER↑
36 RDN                                           10.00000000 ENTER↑
37 ST+ 56             R50=  40.90882890            0.00000000    RUN
38 RCL 58                   54.00000000     X=8.56269014
39 RCL 56                            PRREGX   Y=15.35725162
40 RCL 55             R54= -4.64333190     X=7.28757986
                                            Y=11.72425684
```

ROLPOL PROGRAM

```
01♦LBL "ROLPOL"
02 RCL 50
03 SIN
04 RCL 43
05 *
06 STO 30
07 RCL 50
08 COS
09 RCL 43
10 *
11 STO 31
12 RCL 54
13 X>0?
14 SF 05
15 ABS
16 90
17 X<>Y
18 X>Y?
19 XEQ 01
20 SIN
21 RCL 31
22 *
23 STO 32
24 RCL 30
25 X<>Y
26 /
27 ATAN
28 90
29 X<>Y
30 -
31 FS?C 05
32 CHS
33 STO 12
34 RCL 32
35 X↑2
36 RCL 30
37 X↑2
38 +
39 RCL 43
40 X↑2
41 X<>Y
42 -
43 SQRT
44 RCL 43
45 /
46 ACOS
47 90
48 X<>Y
49 -
50 FS?C 06
51 CHS
52 STO 13
53 RTN
54♦LBL 01
55 180
56 X<>Y
57 -
58 SF 06
59 END
```

EQ SHDW PROGRAM

```
01♦LBL "EQ SHDW"
02 "RADIUS?"
03 PROMPT
04 STO 18
05 "000 HT?"
06 PROMPT
07 STO 19
08 "NO/PTS?"
09 PROMPT
10 1
11 -
12 1 E3
13 /
14 STO 40
15 "ANGLE?"
16 PROMPT
17 STO 15
18 STO 20
19 "FIRST PT?"
20 PROMPT
21 ST+ 15
22♦LBL 01
23 RCL 20
24 ST- 15
25 0
26 ENTER↑
27 RCL 15
28 ENTER↑
29 RCL 18
30 P-R
31 STO 16
32 RDN
33 R-P
34 X<>Y
35 RCL 13
36 -
37 X<>Y
38 P-R
39 STO 17
40 RDN
41 RCL 16
42 R-P
43 X<>Y
44 RCL 12
45 -
46 X<>Y
47 P-R
48 X<>Y
49 RCL 19
50 +
51 X<>Y
52 RCL 17
53 X<>Y
54 XEQ "S PT"
55 ISG 40
56 GTO 01
57 END
```

CHAPTER 12
SPH SH PROGRAM

01◆LBL "SPH SH"	41 STO 3C	
02 STO 39	42 RDN	
03 RDN	43 RCL 41	CF 03
04 STO 41	44 R-P	SF 04
05 RDN	45 X<>Y	XEQ "S PT"
06 STO 42	46 RCL 13	R/NORTH?
07 RCL 41	47 -	270.0000000 RUN
08 R-P	48 X<>Y	GROUND?
09 X<>Y	49 P-R	-6.00000000 RUN
10 RCL 13	50 RCL 39	Z,Y,X?
11 +	51 XEQ "BASIC P"	XEQ "ROLPOL"
12 X<>Y	52 END	
13 P-R		XEQ "EQ SHDW"
14 STO 41		RADIUS?
15 RDN		6.00000000 RUN
16 RCL 39		000 HT?
17 R-P		6.00000000 RUN
18 X<>Y		NO/PTS?
19 RCL 12		2.00000000 RUN
20 +		ANGLE?
21 X<>Y		30.00000000 RUN
22 P-R		FIRST PT?
23 STO 39		-75.00000000 RUN
24 X↑2		X=15.45254140
25 RCL 18		Y=15.64946253
26 X↑2		X=9.05009435
27 X<>Y		Y=8.69459909
28 -		X=15.64422473
29 RCL 41		Y=16.89135131
30 X↑2		X=8.80596389
31 -		Y=9.14923205
32 SQRT		
33 STO 42		
34 RCL 39		
35 R-P		
36 X<>Y		8.00000000 ENTER↑
37 RCL 12		-1.00000000 ENTER↑
38 -		-1.00000000
39 X<>Y		XEQ "SPH SH"
40 P-R		X=13.27886650
		Y=16.26775760

NUMERICAL EXAMPLE

XEQ "ALTAZIM"
DATE MM/DDYYYY?
6.16198200 RUN
LONG? D/MMSS
75.00000000 RUN
LAT? D/MMSS
40.00000000 RUN
TI ZONE? EST=5
5.00000000 RUN
HR? 24H/MMSS
12.00000000 RUN
ALT=73.34950311
AZI=0.36764310

.00600000
PRREGX

R00= 10.00000000
R01= 20.00000000
R02= 30.00000000
R03= 40.00000000
R04= 50.00000000
R05= 60.00000000
R06= 70.00000000
50.00000000
PRREGX

R50= 73.34950311
54.00000000
PRREGX

R54= 0.36764310

Appendix B
TEXAS INSTRUMENTS PROGRAMS

General Purpose Card of Frequently Used Programs

Consolidated programs require three sides of two magnetic cards.

Partition of Calculator:
4 Press 2nd OP 17 Display 639.39

Organization of Magnetic Card:

Basic Perspective Programs				
T & S TURN	SHIFT	CIRCLE 1		VP
z	y	x	BASIC	SQUARE

Flags Used in Programs:

TURN	Flag	4
SHIFT	"	3
VP	Flags	5, 6, 7, 8, 9

BASIC P Program

000	76	LBL	040	37	P/R	080	43	RCL	
001	11	A	041	32	X⇄T	081	07	07	
002	42	STO	042	48	EXC	082	95	=	
003	10	10	043	07	07	083	32	X⇄T	
004	91	R/S	044	22	INV	084	37	P/R	
005	76	LBL	045	37	P/R	085	32	X⇄T	
006	12	B	046	85	+	086	91	R/S	
007	42	STO	047	43	RCL	087	32	X⇄T	
008	11	11	048	05	05	088	91	R/S	
009	91	R/S	049	95	=	089	92	RTN	
010	76	LBL	050	37	P/R				
011	13	C	051	85	+				
012	42	STO	052	43	RCL				
013	12	12	053	02	02				
014	91	R/S	054	95	=				
015	76	LBL	055	32	X⇄T				
016	14	D	056	85	+				
017	43	RCL	057	43	RCL				
018	12	12	058	03	03				
019	32	X⇄T	059	95	=				
020	43	RCL	060	48	EXC				
021	11	11	061	07	07				
022	22	INV	062	85	+				
023	37	P/R	063	43	RCL				
024	85	+	064	00	00				
025	43	RCL	065	85	+				
026	06	06	066	43	RCL				
027	95	=	067	01	01				
028	37	P/R	068	95	=				
029	32	X⇄T	069	35	1/X				
030	42	STO	070	65	×				
031	07	07	071	43	RCL				
032	43	RCL	072	00	00				
033	10	10	073	95	=				
034	22	INV	074	48	EXC				
035	37	P/R	075	07	07				
036	85	+	076	22	INV				
037	43	RCL	077	37	P/R				
038	04	04	078	32	X⇄T				
039	95	=	079	65	×				

Instructions for Printer

086	99	PRT
087	32	X⇄T
088	99	PRT
089	98	ADV
090	92	RTN

Organization of Magnetic Card:

BASIC Perspective Program

z	y	x	BASIC

Store in Memory Registers:

10	Press	STO 00	Display	10.
20	"	STO 01	"	20.
30	"	STO 02	"	30.
40	"	STO 03	"	40.
50	"	STO 04	"	50.
60	"	STO 05	"	60.
70	"	STO 06	"	70.

Contents of Memory Registers:

R-00	10.00
R-01	20.00
R-02	30.00
R-03	40.00
R-04	50.00
R-05	60.00
R-06	70.00

Enter:

1	Press A	Display	1.
2	" B	"	2.
3	" C	"	3.
	Press D		

Calculator Computes:

X		Display 10.30753911
Y	Press R/S	Display 13.46711194

VP Program

090	76	LBL	130	85	+	170	76	LBL	
091	10	E'	131	42	STO	171	33	X²	
092	29	CP	132	28	28	172	42	STO	
093	43	RCL	133	43	RCL	173	31	31	
094	06	06	134	04	04	174	86	STF	
095	67	EQ	135	75	-	175	09	09	
096	25	CLR	136	09	9	176	76	LBL	
097	71	SBR	137	00	0	177	45	YX	
098	65	×	138	95	=	178	43	RCL	
099	22	INV	139	71	SBR	179	05	05	
100	77	GE	140	85	+	180	67	EQ	
101	29	CP	141	42	STO	181	55	÷	
102	76	LBL	142	29	29	182	87	IFF	
103	24	CE	143	86	STF	183	09	09	
104	42	STO	144	08	08	184	30	TAN	
105	26	26	145	87	IFF	185	87	IFF	
106	43	RCL	146	07	07	186	08	08	
107	06	06	147	35	1/X	187	75	-	
108	75	-	148	61	GTO	188	87	IFF	
109	09	9	149	45	YX	189	07	07	
110	00	0	150	76	LBL	190	49	PRD	
111	95	=	151	35	1/X	191	76	LBL	
112	71	SBR	152	43	RCL	192	55	÷	
113	65	×	153	26	26	193	87	IFF	
114	22	INV	154	71	SBR	194	09	09	
115	77	GE	155	95	=	195	60	DEG	
116	39	COS	156	87	IFF	196	87	IFF	
117	76	LBL	157	05	05	197	08	08	
118	34	ГX	158	28	LOG	198	70	RAD	
119	42	STO	159	76	LBL	199	87	IFF	
120	27	27	160	23	LNX	200	07	07	
121	86	STF	161	42	STO	201	90	LST	
122	07	07	162	30	30	202	61	GTO	
123	76	LBL	163	43	RCL	203	80	GRD	
124	25	CLR	164	27	27	204	76	LBL	
125	43	RCL	165	71	SBR	205	29	CP	
126	04	04	166	95	=	206	86	STF	
127	67	EQ	167	87	IFF	207	05	05	
128	45	YX	168	06	06	208	61	GTO	
129	71	SBR	169	38	SIN	209	24	CE	

210	76	LBL	250	65	×
211	28	LOG	251	43	RCL
212	94	+/-	252	00	00
213	61	GTO	253	95	=
214	23	LNX	254	92	RTN
215	76	LBL	255	76	LBL
216	38	SIN	256	95	=
217	94	+/-	257	33	X²
218	61	GTO	258	65	×
219	33	X²	259	53	(
220	76	LBL	260	53	(
221	39	COS	261	43	RCL
222	86	STF	262	28	28
223	06	06	263	33	X²
224	61	GTO	264	55	÷
225	34	ГX	265	43	RCL
226	76	LBL	266	00	00
227	65	×	267	33	X²
228	30	TAN	268	54)
229	35	1/X	269	85	+
230	65	×	270	01	1
231	43	RCL	271	54)
232	00	00	272	95	=
233	95	=	273	34	ГX
234	92	RTN	274	92	RTN
235	76	LBL	275	76	LBL
236	75	-	276	30	TAN
237	43	RCL	277	43	RCL
238	28	28	278	30	30
239	71	SBR	279	32	X:T
240	50	I×I	280	43	RCL
241	29	CP	281	28	28
242	43	RCL	282	71	SBR
243	29	29	283	50	I×I
244	71	SBR	284	43	RCL
245	50	I×I	285	31	31
246	92	RTN	286	32	X:T
247	76	LBL	287	43	RCL
248	85	+	288	28	28
249	30	TAN	289	71	SBR

290	50	I×I
291	29	CP
292	43	RCL
293	29	29
294	71	SBR
295	50	I×I
296	92	RTN
297	76	LBL
298	49	PRD
299	43	RCL
300	26	26
301	32	X!T
302	00	0
303	71	SBR
304	50	I×I
305	43	RCL
306	27	27
307	32	X!T
308	00	0
309	71	SBR
310	50	I×I
311	92	RTN
312	76	LBL
313	50	I×I
314	22	INV
315	37	P/R
316	75	−
317	43	RCL
318	05	05
319	95	=
320	37	P/R
321	32	X!T
322	91	R/S
323	32	X!T
324	91	R/S
325	92	RTN
326	76	LBL
327	60	DEG
328	43	RCL
329	30	30

330	91	R/S
331	43	RCL
332	28	28
333	91	R/S
334	43	RCL
335	31	31
336	91	R/S
337	43	RCL
338	28	28
339	91	R/S
340	00	0
341	91	R/S
342	43	RCL
343	29	29
344	91	R/S
345	92	RTN
346	76	LBL
347	70	RAD
348	00	0
349	91	R/S
350	43	RCL
351	28	28
352	91	R/S
353	00	0
354	91	R/S
355	43	RCL
356	29	29
357	91	R/S
358	92	RTN
359	76	LBL
360	80	GRD
361	00	0
362	91	R/S
363	00	0
364	91	R/S
365	92	RTN
366	76	LBL
367	90	LST
368	43	RCL
369	26	26

370	91	R/S
371	00	0
372	91	R/S
373	43	RCL
374	27	27
375	91	R/S
376	00	0
377	91	R/S
378	92	RTN

Organization of Magnetic Card:

		VP Program	
			VP
z	y	x	BASIC

Contents of Memory Registers:

R-00	10.00
R-01	20.00
R-02	30.00
R-03	40.00
R-04	50.00
R-05	60.00
R-06	70.00

Execute Program:

Press E′ (2nd E)

VP 1X			Display	13.15207469	
	Y	Press	R/S	″	1.05501026
VP 2X		″	R/S	″	−11.05069156
	Y	″	R/S	″	42.97543110
VP 3X		″	R/S	″	−7.26681597
	Y	″	R/S	″	−4.19549815

Clear Flags:

Press RST

000	76	LBL	040	37	P/R	080	43	RCL	120	17	B'	160	54)
001	11	A	041	32	X!T	081	07	07	121	00	0	161	55	÷
002	42	STO	042	48	EXC	082	95	=	122	91	R/S	162	53	(
003	10	10	043	07	07	083	32	X!T	123	76	LBL	163	43	RCL
004	91	R/S	044	22	INV	084	37	P/R	124	17	B'	164	34	34
005	76	LBL	045	37	P/R	085	32	X!T	125	53	(165	75	-
006	12	B	046	85	+	086	92	RTN	126	43	RCL	166	43	RCL
007	42	STO	047	43	RCL	087	76	LBL	127	31	31	167	36	36
008	11	11	048	05	05	088	15	E	128	75	-	168	54)
009	91	R/S	049	95	=	089	87	IFF	129	43	RCL	169	95	=
010	76	LBL	050	37	P/R	090	02	02	130	33	33	170	42	STO
011	13	C	051	85	+	091	16	A'	131	54)	171	40	40
012	42	STO	052	43	RCL	092	03	3	132	55	÷	172	65	×
013	12	12	053	02	02	093	00	0	133	53	(173	43	RCL
014	91	R/S	054	95	=	094	42	STO	134	43	RCL	174	34	34
015	76	LBL	055	32	X!T	095	08	08	135	30	30	175	95	=
016	14	D	056	85	+	096	86	STF	136	75	-	176	94	+/-
017	43	RCL	057	43	RCL	097	02	02	137	43	RCL	177	85	+
018	12	12	058	03	03	098	00	0	138	32	32	178	43	RCL
019	32	X!T	059	95	=	099	91	R/S	139	54)	179	35	35
020	43	RCL	060	48	EXC	100	76	LBL	140	95	=	180	75	-
021	11	11	061	07	07	101	16	A'	141	42	STO	181	43	RCL
022	22	INV	062	85	+	102	14	D	142	38	38	182	39	39
023	37	P/R	063	43	RCL	103	72	ST*	143	65	×	183	95	=
024	85	+	064	00	00	104	08	08	144	43	RCL	184	55	÷
025	43	RCL	065	85	+	105	01	1	145	30	30	185	53	(
026	06	06	066	43	RCL	106	44	SUM	146	95	=	186	43	RCL
027	95	=	067	01	01	107	08	08	147	94	+/-	187	38	38
028	37	P/R	068	95	=	108	32	X!T	148	85	+	188	75	-
029	32	X!T	069	35	1/X	109	72	ST*	149	43	RCL	189	43	RCL
030	42	STO	070	65	×	110	08	08	150	31	31	190	40	40
031	07	07	071	43	RCL	111	01	1	151	95	=	191	54)
032	43	RCL	072	00	00	112	44	SUM	152	42	STO	192	95	=
033	10	10	073	95	=	113	08	08	153	39	39	193	42	STO
034	22	INV	074	48	EXC	114	43	RCL	154	53	(194	42	42
035	37	P/R	075	07	07	115	08	08	155	43	RCL	195	65	×
036	85	+	076	22	INV	116	32	X!T	156	35	35	196	43	RCL
037	43	RCL	077	37	P/R	117	03	3	157	75	-	197	38	38
038	04	04	078	32	X!T	118	08	8	158	43	RCL	198	95	=
039	95	=	079	65	×	119	67	EQ	159	37	37	199	85	+

```
200   43  RCL
201   39   39
202   95   =
203   32  X!T
204   43  RCL
205   42   42
206   91  R/S
207   32  X!T
208   91  R/S
209   92  RTN
```

Organization of Magnetic Card:

VAN PT Program				
sub	sub			
z	y	x	BASIC	VAN PT

Numerical Example:

Contents of Memory Registers:

R-00	10.00
R-01	20.00
R-02	30.00
R-03	40.00
R-04	50.00
R-05	60.00
R-06	70.00

Clear Flags:

Press RST

Execute Program:

Press E Display 0

Enter First Point

z	0	Press A	Display	0.
y	10	" B	"	10.
x	-10	" C	"	$-10.$
		Press E	Display	0.

Enter Second Point

z	0	Press A	Display	0.
y	10	" B	"	10.
x	10	" C	"	10.
		Press E	Display	0.

Enter Third Point

z	0	Press A	Display	0.
y	-10	" B	"	$-10.$
x	-10	" C	"	$-10.$
		Press E	Display	0.

Enter Fourth Point

z	0	Press A	Display	0.
y	-10	" B	"	$-10.$
x	10	" C	"	10.
		Press E		

Calculator Computes:

VP X Display 13.15207469
 Y Press R/S Display 1.05501026

Clear Flags:

Press RST

CR Program

000	76	LBL	040	37	P/R	080	43	RCL	120	17	B'	160	42	STO
001	11	A	041	32	X:T	081	07	07	121	72	ST*	161	36	36
002	42	STO	042	48	EXC	082	95	=	122	08	08	162	53	(
003	10	10	043	07	07	083	32	X:T	123	42	STO	163	53	(
004	91	R/S	044	22	INV	084	37	P/R	124	37	37	164	43	RCL
005	76	LBL	045	37	P/R	085	61	GTO	125	01	1	165	36	36
006	12	B	046	85	+	086	37	P/R	126	44	SUM	166	65	×
007	42	STO	047	43	RCL	087	76	LBL	127	08	08	167	43	RCL
008	11	11	048	05	05	088	15	E	128	03	3	168	33	33
009	91	R/S	049	95	=	089	87	IFF	129	07	7	169	54)
010	76	LBL	050	37	P/R	090	00	00	130	32	X:T	170	75	-
011	13	C	051	85	+	091	16	A'	131	43	RCL	171	43	RCL
012	42	STO	052	43	RCL	092	04	4	132	08	08	172	34	34
013	12	12	053	02	02	093	55	÷	133	67	EQ	173	54)
014	91	R/S	054	95	=	094	03	3	134	18	C'	174	55	÷
015	76	LBL	055	32	X:T	095	95	=	135	43	RCL	175	53	(
016	14	D	056	85	+	096	42	STO	136	37	37	176	43	RCL
017	43	RCL	057	43	RCL	097	32	32	137	91	R/S	177	36	36
018	12	12	058	03	03	098	03	3	138	76	LBL	178	75	-
019	32	X:T	059	95	=	099	03	3	139	18	C'	179	01	1
020	43	RCL	060	48	EXC	100	42	STO	140	53	(180	54)
021	11	11	061	07	07	101	08	08	141	43	RCL	181	95	=
022	22	INV	062	85	+	102	00	0	142	35	35	182	91	R/S
023	37	P/R	063	43	RCL	103	91	R/S	143	75	-	183	48	EXC
024	85	+	064	00	00	104	42	STO	144	43	RCL	184	35	35
025	43	RCL	065	85	+	105	09	09	145	34	34	185	48	EXC
026	06	06	066	43	RCL	106	86	STF	146	54)	186	34	34
027	95	=	067	01	01	107	00	00	147	55	÷	187	48	EXC
028	37	P/R	068	95	=	108	00	0	148	53	(188	33	33
029	32	X:T	069	35	1/X	109	91	R/S	149	43	RCL	189	97	DSZ
030	42	STO	070	65	×	110	76	LBL	150	35	35	190	09	09
031	07	07	071	43	RCL	111	16	A'	151	75	-	191	18	C'
032	43	RCL	072	00	00	112	71	SBR	152	43	RCL	192	22	INV
033	10	10	073	95	=	113	14	D	153	33	33	193	86	STF
034	22	INV	074	48	EXC	114	76	LBL	154	54)	194	01	01
035	37	P/R	075	07	07	115	37	P/R	155	95	=	195	00	0
036	85	+	076	22	INV	116	87	IFF	156	65	×	196	92	RTN
037	43	RCL	077	37	P/R	117	01	01	157	43	RCL	197	76	LBL
038	04	04	078	32	X:T	118	32	X:T	158	32	32	198	32	X:T
039	95	=	079	65	×	119	76	LBL	159	95	=	199	32	X:T

```
200   61 GTO
201   17 B'
```

Organization of Magnetic Card:

CR Program				
sub	sub	sub		
z	y	x	BASIC	CR

Contents of Memory Registers:

R-00	10.00
R-01	20.00
R-02	30.00
R-03	40.00
R-04	50.00
R-05	60.00
R-06	70.00

Clear Flags:

Press RST

If X Value is Desired:

Press St flg 1

Execute Program:

Press E Display 0

Enter Number of Subsequent Points:

6 Press R/S Display 0

Enter First Point (0, 0, 0):

z	0	Press	A	Display	0.
y	0	"	B	"	0.
x	0	"	C	"	0.

Press D

1st Pt Y Display 13.33333333

Enter Second Point (0, 10, 0):

z	0	Press	A	Display	0.
y	10		B	"	10.
x	0	"	C	"	0.

Press D

2nd Pt Y Display 15.35725162

Enter Third Point (0, 20, 0):

z	0	Press	A	Display	0.
y	20	"	B	"	20.
x	0	"	C	"	0.

Press D

3rd Pt Y Display 17.12245436

Subsequent Points:

4th	Pt Y	Press	R/S	Display	18.67556847
5th	Pt Y	"	"	"	20.05265139
6th	Pt Y	"	"	"	21.28202535
7th	Pt Y	"	"	"	22.38624606
8th	Pt Y	"	"	"	23.38349920
9th	Pt Y	"	"	"	24.28860987

SQUARE Program

379	76	LBL	419	92	RTN	
380	15	E	420	76	LBL	
381	43	RCL	421	43	RCL	
382	10	10	422	43	RCL	
383	42	STO	423	13	13	
384	13	13	424	42	STO	
385	43	RCL	425	10	10	
386	11	11	426	43	RCL	
387	42	STO	427	14	14	
388	14	14	428	42	STO	
389	43	RCL	429	11	11	
390	12	12	430	43	RCL	
391	42	STO	431	15	15	
392	15	15	432	42	STO	
393	71	SBR	433	12	12	
394	43	RCL	434	92	RTN	
395	01	1	435	76	LBL	
396	94	+/-	436	16	A'	
397	49	PRD	437	87	IFF	
398	11	11	438	04	04	
399	49	PRD	439	17	B'	
400	12	12	440	87	IFF	
401	16	A'	441	03	03	
402	71	SBR	442	18	C'	
403	43	RCL	443	14	D	
404	01	1	444	92	RTN	
405	94	+/-				
406	49	PRD				
407	11	11				
408	16	A'				
409	71	SBR				
410	43	RCL				
411	16	A'				
412	71	SBR				
413	43	RCL				
414	01	1				
415	94	+/-				
416	49	PRD				
417	12	12				
418	16	A'				

Organization of Magnetic Card:

			SQUARE Program	
				VP
z	y	x	BASIC	SQUARE

Numerical Example:

Contents of Memory Registers:

R-00	10.00
R-01	20.00
R-02	30.00
R-03	40.00
R-04	50.00
R-05	60.00
R-06	70.00

Execute Program:

z	0		Press A	Display	0.
y	1		" B	"	1.
x	2		" C	"	2.
			Press E		

Calculator Computes:

1st Pt X			Display	10.02870167
Y	Press R/S		"	13.62438878
2nd Pt X	"	"	"	10.27222513
Y	"	"	"	12.64437819
3rd Pt X	"	"	"	9.97390639
Y	"	"	"	13.06872546
4th Pt X	"	"	"	9.70922981
Y	"	"	"	14.06922283

TURN Program

445	76	LBL		485	22	INV
446	17	B'		486	37	P/R
447	87	IFF		487	85	+
448	04	04		488	43	RCL
449	42	STO		489	16	16
450	00	0		490	95	=
451	91	R/S		491	37	P/R
452	42	STO		492	32	X!T
453	16	16		493	48	EXC
454	00	0		494	07	07
455	91	R/S		495	22	INV
456	42	STO		496	37	P/R
457	17	17		497	85	+
458	00	0		498	43	RCL
459	91	R/S		499	17	17
460	42	STO		500	95	=
461	18	18		501	37	P/R
462	86	STF		502	42	STO
463	04	04		503	12	12
464	00	0		504	43	RCL
465	92	RTN		505	07	07
466	76	LBL		506	42	STO
467	42	STO		507	11	11
468	43	RCL		508	32	X!T
469	12	12		509	42	STO
470	32	X!T		510	10	10
471	43	RCL		511	87	IFF
472	11	11		512	03	03
473	22	INV		513	18	C'
474	37	P/R		514	14	D
475	85	+		515	92	RTN
476	43	RCL				
477	18	18				
478	95	=				
479	37	P/R				
480	32	X!T				
481	42	STO				
482	07	07				
483	43	RCL				
484	10	10				

Organization of Magnetic Card:

TURN Program				
TURN			VP	
z	y	x	BASIC	SQUARE

Numerical Example:

Contents of Memory Registers:

R-00	10.00
R-01	20.00
R-02	30.00
R-03	40.00
R-04	50.00
R-05	60.00
R-06	70.00

Clear Flags:

Press RST

Execute Program: ·

Press B' (2nd B) Display 0

Enter X Axis Rotation:

10 Press R/S Display 0

Enter Y Axis Rotation:

20 Press R/S Display 0

Enter Z Axis Rotation:

30 Press R/S Display 0

Enter Coordinates of a Point:

z	1	Press A	Display	1.
y	2	" B	"	2.
x	3	" C	"	3.

Press B' (2nd B)

Calculator Computes:

X		Display 10.06174284
Y	Press R/S	" 13.86935949

SHIFT Program

516	76	LBL
517	18	C'
518	87	IFF
519	03	03
520	47	CMS
521	00	0
522	91	R/S
523	42	STO
524	19	19
525	00	0
526	91	R/S
527	42	STO
528	20	20
529	00	0
530	91	R/S
531	42	STO
532	21	21
533	86	STF
534	03	03
535	00	0
536	92	RTN
537	76	LBL
538	47	CMS
539	43	RCL
540	19	19
541	44	SUM
542	12	12
543	43	RCL
544	20	20
545	44	SUM
546	11	11
547	43	RCL
548	21	21
549	44	SUM
550	10	10
551	14	D
552	92	RTN

Organization of Magnetic Card:

SHIFT Program				
TURN	SHIFT			VP
z	y	x	BASIC	SQUARE

Numerical Example:

Contents of Memory Registers:

R-00 10.00
R-01 20.00
R-02 30.00
R-03 40.00
R-04 50.00
R-05 60.00
R-06 70.00

Clear Flags:

 Press RST

Execute Program:

 Press C' (2nd C) Display 0

Enter X Coordinate Shift:

 1 Press R/S Display 0

Enter Y Coordinate Shift:

 2 Press R/S Display 0

Enter Z Coordinate Shift:

 3 Press R/S Display 0

Enter Coordinates of a Point:

z 1 Press A Display 1.
y 2 " B " 2.
x 3 " C " 3.
 Press C' (2nd C)

Calculator Computes:

 X Display 11.38970629
 Y Press R/S " 14.99097738

TURN and SHIFT Programs

Organization of Magnetic Card:

TURN and SHIFT Programs				
T & S	TURN	SHIFT		VP
z	y	x	BASIC	SQUARE

Numerical Example:

Contents of Memory Registers:

R-00 10.00
R-01 20.00
R-02 30.00
R-03 40.00
R-04 50.00
R-05 60.00
R-06 70.00

Assume that TURN and SHIFT have been executed and flags 3 & 4 are set.

Execute Program:

Enter Coordinates of a Point:

z 1 Press A Display 1.
y 2 " B " 2.
x 3 " C " 3.
 Press A' (2nd A)

Calculator Computes:

 X Display 11.14416206
 Y Press R/S " 15.42493539

CIRCLE 1 Program

553	76	LBL	593	71	SBR	
554	19	D'	594	16	A'	
555	00	0	595	97	DSZ	
556	91	R/S	596	09	09	
557	42	STO	597	89	π	
558	22	22	598	92	RTN	
559	00	0				
560	91	R/S				
561	42	STO				
562	09	09				
563	35	1/X				
564	65	×				
565	03	3				
566	06	6				
567	00	0				
568	95	=				
569	42	STO				
570	23	23				
571	00	0				
572	42	STO				
573	24	24				
574	42	STO				
575	10	10				
576	76	LBL				
577	89	π				
578	43	RCL				
579	23	23				
580	44	SUM				
581	24	24				
582	43	RCL				
583	22	22				
584	32	X!T				
585	43	RCL				
586	24	24				
587	37	P/R				
588	42	STO				
589	11	11				
590	32	X!T				
591	42	STO				
592	12	12				

Organization of Magnetic Card:

CIRCLE 1 Program				
T & S	TURN	SHIFT	CIRCLE 1	VP
z	y	x	BASIC	SQUARE

Contents of Memory Registers:

R-00	10.00
R-01	20.00
R-02	30.00
R-03	40.00
R-04	50.00
R-05	60.00
R-06	70.00

(Execute TURN and SHIFT if required, otherwise clear flags)

Numerical Example:

Execute Program:

 Press D' (2nd D) Display 0

Enter Radius of Circle:

6 Press R/S Display 0

Enter Number of Points:

3 Press R/S

Calculator Computes:

1st Pt X			Display	8.98537861
Y	Press	R/S	"	15.24640557
2nd Pt X	"	"	"	10.67795141
Y	"	"	"	12.90396048
3rd Pt X	"	"	"	10.33974253
Y	"	"	"	12.00992922

CIRCLE 2 Program

553	76	LBL
554	19	D'
555	00	0
556	91	R/S
557	42	STO
558	22	22
559	00	0
560	91	R/S
561	42	STO
562	09	09
563	00	0
564	91	R/S
565	42	STO
566	23	23
567	94	+/-
568	42	STO
569	24	24
570	00	0
571	91	R/S
572	44	SUM
573	24	24
574	00	0
575	42	STO
576	10	10
577	76	LBL
578	89	π
579	43	RCL
580	23	23
581	44	SUM
582	24	24
583	43	RCL
584	22	22
585	32	X⇄T
586	43	RCL
587	24	24
588	37	P/R
589	42	STO
590	11	11
591	32	X⇄T
592	42	STO

593	12	12
594	71	SBR
595	16	A'
596	97	DSZ
597	09	09
598	89	π
599	92	RTN

Organization of Magnetic Card:

CIRCLE 2 Program				
T & S	TURN	SHIFT	CIRCLE 2	VP
z	y	x	BASIC	SQUARE

Numerical Example:

Contents of Memory Registers:

R-00	10.00
R-01	20.00
R-02	30.00
R-03	40.00
R-04	50.00
R-05	60.00
R-06	70.00

(Execute TURN and SHIFT if required, otherwise clear flags)

Execute Program:

	Press D' (2nd D)	Display 0

Enter Radius of Circle:

6	Press R/S	Display 0

Enter Number of Points:

3	Press R/S	Display 0

Enter Angle Between Points:

30	Press R/S	Display 0

Enter Angle of First Point:

−75	Press R/S	

Calculator Computes

1st Pt X			Display	11.00384692
Y	Press	R/S	"	11.67188629
2nd Pt X	"	"	"	10.87614054
Y	"	"	"	11.46443514
3rd Pt X	"	"	"	10.54950165
Y	"	"	"	11.73191077

SPHERE Program

000	76	LBL	040	37	P/R	080	43	RCL	120	37	P/R	160	43	RCL
001	11	A	041	32	X¦T	081	07	07	121	85	+	161	21	21
002	42	STO	042	48	EXC	082	95	=	122	43	RCL	162	44	SUM
003	10	10	043	07	07	083	32	X¦T	123	16	16	163	10	10
004	91	R/S	044	22	INV	084	37	P/R	124	95	=	164	14	D
005	76	LBL	045	37	P/R	085	32	X¦T	125	37	P/R	165	92	RTN
006	12	B	046	85	+	086	91	R/S	126	32	X¦T	166	76	LBL
007	42	STO	047	43	RCL	087	32	X¦T	127	48	EXC	167	15	E
008	11	11	048	05	05	088	91	R/S	128	07	07	168	00	0
009	91	R/S	049	95	=	089	92	RTN	129	22	INV	169	42	STO
010	76	LBL	050	37	P/R	090	76	LBL	130	37	P/R	170	31	31
011	13	C	051	85	+	091	16	A"	131	85	+	171	91	R/S
012	42	STO	052	43	RCL	092	87	IFF	132	43	RCL	172	42	STO
013	12	12	053	02	02	093	04	04	133	17	17	173	24	24
014	91	R/S	054	95	=	094	17	B"	134	95	=	174	00	0
015	76	LBL	055	32	X¦T	095	87	IFF	135	37	P/R	175	91	R/S
016	14	D	056	85	+	096	03	03	136	42	STO	176	42	STO
017	43	RCL	057	43	RCL	097	18	C"	137	12	12	177	09	09
018	12	12	058	03	03	098	14	D	138	43	RCL	178	35	1/X
019	32	X¦T	059	95	=	099	92	RTN	139	07	07	179	65	×
020	43	RCL	060	48	EXC	100	76	LBL	140	42	STO	180	03	3
021	11	11	061	07	07	101	17	B"	141	11	11	181	06	6
022	22	INV	062	85	+	102	43	RCL	142	32	X¦T	182	00	0
023	37	P/R	063	43	RCL	103	12	12	143	42	STO	183	95	=
024	85	+	064	00	00	104	32	X¦T	144	10	10	184	42	STO
025	43	RCL	065	85	+	105	43	RCL	145	87	IFF	185	08	08
026	06	06	066	43	RCL	106	11	11	146	03	03	186	00	0
027	95	=	067	01	01	107	22	INV	147	18	C"	187	91	R/S
028	37	P/R	068	95	=	108	37	P/R	148	14	D	188	42	STO
029	32	X¦T	069	35	1/X	109	85	+	149	92	RTN	189	15	15
030	42	STO	070	65	×	110	43	RCL	150	76	LBL	190	91	R/S
031	07	07	071	43	RCL	111	18	18	151	18	C"	191	42	STO
032	43	RCL	072	00	00	112	95	=	152	43	RCL	192	14	14
033	10	10	073	95	=	113	37	P/R	153	19	19	193	91	R/S
034	22	INV	074	48	EXC	114	32	X¦T	154	44	SUM	194	42	STO
035	37	P/R	075	07	07	115	42	STO	155	12	12	195	13	13
036	85	+	076	22	INV	116	07	07	156	43	RCL	196	43	RCL
037	43	RCL	077	37	P/R	117	43	RCL	157	20	20	197	00	00
038	04	04	078	32	X¦T	118	10	10	158	44	SUM	198	85	+
039	95	=	079	65	×	119	22	INV	159	11	11	199	43	RCL

200	01	01		240	44	SUM		280	35	1/X		320	43	RCL
201	95	=		241	16	16		281	65	×		321	02	02
202	42	STO		242	00	0		282	43	RCL		322	95	=
203	23	23		243	42	STO		283	24	24		323	42	STO
204	35	1/X		244	17	17		284	95	=		324	19	19
205	65	×		245	43	RCL		285	22	INV		325	43	RCL
206	43	RCL		246	23	23		286	38	SIN		326	27	27
207	13	13		247	85	+		287	42	STO		327	65	×
208	95	=		248	43	RCL		288	26	26		328	43	RCL
209	22	INV		249	14	14		289	43	RCL		329	28	28
210	30	TAN		250	95	=		290	25	25		330	75	-
211	94	+/-		251	42	STO		291	33	X²		331	43	RCL
212	42	STO		252	28	28		292	75	-		332	23	23
213	18	18		253	33	X²		293	43	RCL		333	95	=
214	43	RCL		254	85	+		294	24	24		334	42	STO
215	06	06		255	53	(295	33	X²		335	20	20
216	22	INV		256	43	RCL		296	95	=		336	43	RCL
217	44	SUM		257	02	02		297	34	√X		337	27	27
218	18	18		258	85	+		298	65	×		338	65	×
219	43	RCL		259	43	RCL		299	43	RCL		339	43	RCL
220	13	13		260	13	13		300	26	26		340	22	22
221	33	X²		261	54)		301	38	SIN		341	75	-
222	85	+		262	42	STO		302	95	=		342	43	RCL
223	43	RCL		263	29	29		303	42	STO		343	03	03
224	23	23		264	33	X²		304	30	30		344	95	=
225	33	X²		265	85	+		305	55	÷		345	42	STO
226	95	=		266	53	(306	43	RCL		346	21	21
227	34	√X		267	43	RCL		307	26	26		347	86	STF
228	35	1/X		268	03	03		308	30	TAN		348	03	03
229	65	×		269	85	+		309	95	=		349	86	STF
230	43	RCL		270	43	RCL		310	55	÷		350	04	04
231	15	15		271	15	15		311	43	RCL		351	76	LBL
232	95	=		272	54)		312	25	25		352	10	E'
233	22	INV		273	42	STO		313	95	=		353	43	RCL
234	30	TAN		274	22	22		314	42	STO		354	30	30
235	42	STO		275	33	X²		315	27	27		355	32	X↕T
236	16	16		276	95	=		316	65	×		356	43	RCL
237	43	RCL		277	34	√X		317	43	RCL		357	08	08
238	04	04		278	42	STO		318	29	29		358	44	SUM
239	22	INV		279	25	25		319	75	-		359	31	31

360	43	RCL
361	31	31
362	37	P/R
363	42	STO
364	10	10
365	32	X↕T
366	42	STO
367	12	12
368	00	0
369	42	STO
370	11	11
371	16	A'
372	97	DSZ
373	09	09
374	10	E'
375	92	RTN

Organization of Magnetic Card:

SPHERE Program		
T&S TURN SHIFT		
z y	x	BASIC SPHERE

Numerical Example:

Contents of Memory Registers:

R-00 10.00
R-01 20.00
R-02 30.00
R-03 40.00
R-04 50.00
R-05 60.00
R-06 70.00

Clear Flags:

 Press RST

Execute Program:

 Press E Display 0

Enter Radius of Sphere:

6 Press R/S Display 0

Enter Number of Points:

3 Press R/S Display 0

Enter Coordinates of Center of Sphere:

z 4 Press R/S Display 4.
y 5 " " " 5.
x 6 " "

Calculator Computes:

1st Pt X			Display	11.09114041
Y	Press	R/S	"	16.59579338
2nd Pt X	"	"	"	9.03076251
Y	"	"	"	12.04182006
3rd Pt X	"	"	"	13.96646820
Y	"	"	"	15.31490945

ALTAZIM Program

000	76	LBL	040	24	CE	080	95	=
001	11	A	041	54)	081	65	×
002	87	IFF	042	59	INT	082	43	RCL
003	00	00	043	42	STO	083	19	19
004	12	B	044	17	17	084	95	=
005	03	3	045	95	=	085	59	INT
006	00	0	046	65	×	086	85	+
007	93	.	047	01	1	087	53	(
008	06	6	048	52	EE	088	43	RCL
009	00	0	049	04	4	089	18	18
010	00	0	050	95	=	090	65	×
011	01	1	051	42	STO	091	43	RCL
012	42	STO	052	18	18	092	20	20
013	19	19	053	25	CLR	093	54)
014	03	3	054	43	RCL	094	59	INT
015	06	6	055	16	16	095	85	+
016	05	5	056	85	+	096	43	RCL
017	93	.	057	01	1	097	17	17
018	02	2	058	95	=	098	95	=
019	05	5	059	42	STO	099	42	STO
020	42	STO	060	07	07	100	22	22
021	20	20	061	35	1/X	101	87	IFF
022	29	CP	062	85	+	102	06	06
023	00	0	063	93	.	103	98	ADV
024	91	R/S	064	07	7	104	61	GTO
025	75	-	065	95	=	105	99	PRT
026	53	(066	59	INT	106	76	LBL
027	24	CE	067	67	EQ	107	98	ADV
028	54)	068	96	WRT	108	01	1
029	59	INT	069	76	LBL	109	22	INV
030	42	STO	070	97	DSZ	110	44	SUM
031	16	16	071	22	INV	111	18	18
032	95	=	072	44	SUM	112	22	INV
033	65	×	073	18	18	113	86	STF
034	01	1	074	65	×	114	06	06
035	52	EE	075	01	1	115	76	LBL
036	02	2	076	02	2	116	99	PRT
037	95	=	077	85	+	117	53	(
038	75	-	078	43	RCL	118	53	(
039	53	(079	07	07	119	01	1

120	04	4	160	09	9	200	24	24	240	95	=	280	09	9

120	04	4		160	09	9		200	24	24		240	95	=		280	09	9
121	65	×		161	08	8		201	85	+		241	42	STO		281	00	0
122	43	RCL		162	05	5		202	43	RCL		242	27	27		282	08	8
123	19	19		163	06	6		203	23	23		243	53	(283	42	STO
124	54)		164	00	0		204	95	=		244	01	1		284	01	01
125	59	INT		165	09	9		205	42	STO		245	65	×		285	95	=
126	85	+		166	65	×		206	26	26		246	53	(286	37	P/R
127	53	(167	89	π		207	97	DSZ		247	01	1		287	32	X⨭T
128	43	RCL		168	54)		208	09	09		248	75	-		288	42	STO
129	18	18		169	55	÷		209	86	STF		249	43	RCL		289	25	25
130	65	×		170	01	1		210	53	(250	24	24		290	60	DEG
131	43	RCL		171	08	8		211	53	(251	33	X²		291	43	RCL
132	20	20		172	00	0		212	43	RCL		252	54)		292	18	18
133	54)		173	95	=		213	26	26		253	54)		293	55	÷
134	59	INT		174	42	STO		214	55	÷		254	55	÷		294	01	1
135	85	+		175	23	23		215	02	2		255	53	(295	00	0
136	01	1		176	93	.		216	54)		256	53	(296	00	0
137	54)		177	00	0		217	30	TAN		257	01	1		297	95	=
138	94	+/-		178	01	1		218	65	×		258	85	+		298	22	INV
139	85	+		179	06	6		219	53	(259	53	(299	59	INT
140	43	RCL		180	07	7		220	53	(260	43	RCL		300	65	×
141	22	22		181	02	2		221	01	1		261	24	24		301	93	.
142	95	=		182	06	6		222	85	+		262	65	×		302	00	0
143	42	STO		183	42	STO		223	43	RCL		263	43	RCL		303	00	0
144	21	21		184	24	24		224	24	24		264	27	27		304	04	4
145	61	GTO		185	06	6		225	54)		265	39	COS		305	06	6
146	16	A'		186	42	STO		226	55	÷		266	54)		306	08	8
147	76	LBL		187	09	09		227	53	(267	54)		307	04	4
148	96	WRT		188	43	RCL		228	01	1		268	95	=		308	88	DMS
149	86	STF		189	23	23		229	75	-		269	42	STO		309	95	=
150	06	06		190	42	STO		230	43	RCL		270	29	29		310	94	+/-
151	61	GTO		191	26	26		231	24	24		271	32	X⨭T		311	85	+
152	97	DSZ		192	70	RAD		232	54)		272	43	RCL		312	02	2
153	76	LBL		193	76	LBL		233	54)		273	27	27		313	03	3
154	16	A'		194	86	STF		234	34	√X		274	85	+		314	93	.
155	53	(195	43	RCL		235	54)		275	93	.		315	02	2
156	43	RCL		196	26	26		236	22	INV		276	01	1		316	07	7
157	21	21		197	38	SIN		237	30	TAN		277	09	9		317	00	0
158	65	×		198	65	×		238	65	×		278	05	5		318	08	8
159	93	.		199	43	RCL		239	02	2		279	07	7		319	02	2

```
320  06   6        360  55   ÷        400  32  X¦T        440  43  RCL        480  77  GE
321  88   DMS      361  53   (        401  02   2         441  03   03        481  32  X¦T
322  95   =        362  01   1        402  65   ×         442  54   )         482  75   -
323  42   STO      363  75   -        403  89   π         443  65   ×         483  53   (
324  22   22       364  43   RCL      404  95   =         444  02   2         484  02   2
325  29   CP       365  24   24       405  77   GE        445  04   4         485  65   ×
326  43   RCL      366  54   )        406  76   LBL       446  65   ×         486  89   π
327  25   25       367  95   =        407  03   3         447  06   6         487  54   )
328  77   GE       368  94   +/-      408  65   ×         448  00   0         488  95   =
329  87   IFF      369  61   GTO      409  89   π         449  54   )         489  42  STO
330  53   (        370  18   C'       410  95   =         450  55   ÷         490  02   02
331  43   RCL      371  76   LBL      411  77   GE        451  53   (         491  71  SBR
332  22   22       372  18   C'       412  77   GE        452  02   2         492  78  Σ+
333  65   ×        373  42   STO      413  94   +/-       453  65   ×         493  85   +
334  43   RCL      374  05   05       414  85   +         454  89   π         494  53   (
335  25   25       375  76   LBL      415  32   X¦T       455  54   )         495  02   2
336  54   )        376  19   D'       416  95   =         456  95   =         496  65   ×
337  55   ÷        377  29   CP       417  42   STO       457  42   STO       497  89   π
338  53   (        378  70   RAD      418  02   02        458  06   06        498  54   )
339  01   1        379  53   (        419  71   SBR       459  60   DEG       499  95   =
340  85   +        380  03   3        420  78   Σ+        460  61   GTO       500  42  STO
341  53   (        381  55   ÷        421  85   +         461  12   B         501  03   03
342  01   1        382  02   2        422  53   (         462  76   LBL       502  61  GTO
343  65   ×        383  54   )        423  03   3         463  76   LBL       503  79   x̄
344  43   RCL      384  65   ×        424  65   ×         464  32   X¦T       504  76  LBL
345  24   24       385  89   π        425  89   π         465  75   -         505  78  Σ+
346  54   )        386  95   =        426  54   )         466  89   π         506  53   (
347. 95   =        387  44   SUM      427  95   =         467  95   =         507  43  RCL
348  94   +/-      388  01   01       428  42   STO       468  42   STO       508  02   02
349  61   GTO      389  43   RCL      429  03   03        469  02   02        509  38  SIN
350  18   C'       390  27   27       430  76   LBL       470  71   SBR       510  33  x²
351  76   LBL      391  22   INV      431  79   x̄         471  78   Σ+        511  65   ×
352  87   IFF      392  77   GE       432  53   (         472  85   +         512  53   (
353  53   (        393  66   PAU      433  53   (         473  89   π         513  53   (
354  43   RCL      394  76   LBL      434  43   RCL       474  95   =         514  43  RCL
355  22   22       395  67   EQ       435  23   23        475  42   STO       515  22   22
356  65   ×        396  85   +        436  85   +         476  03   03        516  65   ×
357  43   RCL      397  43   RCL      437  43   RCL       477  61   GTO       517  89   π
358  25   25       398  01   01       438  01   01        478  79   x̄         518  54   )
359  54   )        399  95   =        439  75   -         479  76   LBL       519  55   ÷
```

520	01	1	560	00	0	600	75	-	640	04	04	680	43	RCL
521	08	8	561	91	R/S	601	01	1	641	39	COS	681	28	28
522	00	0	562	88	DMS	602	02	2	642	95	=	682	95	=
523	54)	563	42	STO	603	54)	643	22	INV	683	42	STO
524	38	SIN	564	13	13	604	65	×	644	39	COS	684	28	28
525	33	X²	565	00	0	605	01	1	645	42	STO	685	91	R/S
526	54)	566	91	R/S	606	05	5	646	28	28	686	01	1
527	94	+/-	567	88	DMS	607	85	+	647	53	(687	08	8
528	85	+	568	42	STO	608	43	RCL	648	43	RCL	688	00	0
529	01	1	569	14	14	609	06	06	649	05	05	689	75	-
530	95	=	570	00	0	610	55	÷	650	38	SIN	690	43	RCL
531	34	⌐X	571	91	R/S	611	04	4	651	75	-	691	29	29
532	35	1/X	572	65	×	612	75	-	652	53	(692	95	=
533	65	×	573	01	1	613	43	RCL	653	43	RCL	693	87	IFF
534	43	RCL	574	05	5	614	15	15	654	14	14	694	09	09
535	02	02	575	95	=	615	95	=	655	38	SIN	695	69	OP
536	39	COS	576	94	+/-	616	77	GE	656	65	×	696	76	LBL
537	95	=	577	85	+	617	58	FIX	657	43	RCL	697	59	INT
538	22	INV	578	43	RCL	618	76	LBL	658	28	28	698	42	STO
539	39	COS	579	13	13	619	57	ENG	659	39	COS	699	29	29
540	42	STO	580	95	=	620	50	I×I	660	54)	700	92	RTN
541	03	03	581	42	STO	621	42	STO	661	54)	701	76	LBL
542	92	RTN	582	15	15	622	04	04	662	55	÷	702	58	FIX
543	76	LBL	583	76	LBL	623	43	RCL	663	53	(703	86	STF
544	66	PAU	584	13	C	624	14	14	664	43	RCL	704	09	09
545	85	+	585	87	IFF	625	38	SIN	665	14	14	705	61	GTO
546	53	(586	02	02	626	65	×	666	39	COS	706	57	ENG
547	02	2	587	14	D	627	43	RCL	667	65	×	707	76	LBL
548	65	×	588	00	0	628	05	05	668	43	RCL	708	69	OP
549	89	π	589	91	R/S	629	38	SIN	669	28	28	709	94	+/-
550	54)	590	88	DMS	630	85	+	670	38	SIN	710	22	INV
551	95	=	591	42	STO	631	43	RCL	671	54)	711	86	STF
552	61	GTO	592	12	12	632	14	14	672	95	=	712	09	09
553	67	EQ	593	76	LBL	633	39	COS	673	22	INV	713	61	GTO
554	92	RTN	594	14	D	634	65	×	674	39	COS	714	59	INT
555	76	LBL	595	60	DEG	635	43	RCL	675	42	STO			
556	12	B	596	29	CP	636	05	05	676	29	29			
557	87	IFF	597	53	(637	39	COS	677	09	9			
558	01	01	598	43	RCL	638	65	×	678	00	0			
559	13	C	599	12	12	639	43	RCL	679	75	-			

The ALTAZIM Program requires three sides of two magnetic cards.

Partition of Calculator:

3 Press 2nd OP 17 Display 719.29

Clear Flags (see note 3):

Press RST

Execute Program:

Press A Display 0

Enter Date (June 16, 1982):

6.161982 Press R/S Display 0

Enter Location (Philadelphia):

Longitude (dd.mmss)
75.0000 Press R/S Display 0

Latitude (dd.mmss)
40.0000 Press R/S Display 0

Time Zone (Eastern Standard Time = 5)
5 Press R/S Display 0

Enter Time (11:00 A.M.):

Hour (24hh.mmss)
11.0000 Press R/S

Calculator Computes:

Altitude Display 69.025739
Azimuth Press R/S Display 41.974911

Note:

1. Altitude and azimuth are in decimal degrees and not degrees-minutes-seconds. The altitude is stored in R-28 and the azimuth in R-29.
2. Positive value of azimuth means that the sun is east of South and negative value means that the sun is west of South.
3. There are three flags that control the three aspects of this program:

 Set Flag 0 — Calculator skips *Date* section of program.
 Set Flag 1 — Calculator skips *Location* section of program.
 Set Flag 2 — Calculator skips *Time* section of program.

Set Flags 1 and 2 (same location and time):

Press A Display 0

Enter *Date* (October 15, 1982):

10.151982 Press R/S

Calculator Computes:

Altitude Display 39.885426
Azimuth Press R/S Display 14.803769

Clear Flags: Press R/S

Now Set Flags 0 and 1 (10/15/82, Philadelphia):
Press A Display 0

Enter *Time* (2:00 p.m.):

Hour (24hh.mmss)
14.0000 Press R/S

Calculator Computes:

Altitude Display 32.022094
Azimuth Press R/S Display −40.081395

S PT Program

000	76	LBL	040	37	P/R	080	43	RCL	120	37	P/R	160	43	RCL
001	11	A	041	32	X:T	081	07	07	121	85	+	161	21	21
002	42	STO	042	48	EXC	082	95	=	122	43	RCL	162	44	SUM
003	10	10	043	07	07	083	32	X:T	123	16	16	163	10	10
004	91	R/S	044	22	INV	084	37	P/R	124	95	=	164	14	D
005	76	LBL	045	37	P/R	085	32	X:T	125	37	P/R	165	92	RTN
006	12	B	046	85	+	086	91	R/S	126	32	X:T	166	76	LBL
007	42	STO	047	43	RCL	087	32	X:T	127	48	EXC	167	15	E
008	11	11	048	05	05	088	91	R/S	128	07	07	168	87	IFF
009	91	R/S	049	95	=	089	92	RTN	129	22	INV	169	05	05
010	76	LBL	050	37	P/R	090	76	LBL	130	37	P/R	170	19	D"
011	13	C	051	85	+	091	16	A"	131	85	+	171	00	0
012	42	STO	052	43	RCL	092	87	IFF	132	43	RCL	172	91	R/S
013	12	12	053	02	02	093	04	04	133	17	17	173	42	STO
014	91	R/S	054	95	=	094	17	B"	134	95	=	174	26	26
015	76	LBL	055	32	X:T	095	87	IFF	135	37	P/R	175	00	0
016	14	D	056	85	+	096	03	03	136	42	STO	176	91	R/S
017	43	RCL	057	43	RCL	097	18	C"	137	12	12	177	42	STO
018	12	12	058	03	03	098	14	D	138	43	RCL	178	27	27
019	32	X:T	059	95	=	099	92	RTN	139	07	07	179	86	STF
020	43	RCL	060	48	EXC	100	76	LBL	140	42	STO	180	05	05
021	11	11	061	07	07	101	17	B"	141	11	11	181	00	0
022	22	INV	062	85	+	102	43	RCL	142	32	X:T	182	91	R/S
023	37	P/R	063	43	RCL	103	12	12	143	42	STO	183	76	LBL
024	85	+	064	00	00	104	32	X:T	144	10	10	184	19	D"
025	43	RCL	065	85	+	105	43	RCL	145	87	IFF	185	87	IFF
026	06	06	066	43	RCL	106	11	11	146	03	03	186	06	06
027	95	=	067	01	01	107	22	INV	147	18	C"	187	10	E"
028	37	P/R	068	95	=	108	37	P/R	148	14	D	188	14	D
029	32	X:T	069	35	1/X	109	85	+	149	92	RTN	189	76	LBL
030	42	STO	070	65	×	110	43	RCL	150	76	LBL	190	10	E"
031	07	07	071	43	RCL	111	18	18	151	18	C"	191	43	RCL
032	43	RCL	072	00	00	112	95	=	152	43	RCL	192	27	27
033	10	10	073	95	=	113	37	P/R	153	19	19	193	22	INV
034	22	INV	074	48	EXC	114	32	X:T	154	44	SUM	194	44	SUM
035	37	P/R	075	07	07	115	42	STO	155	12	12	195	10	10
036	85	+	076	22	INV	116	07	07	156	43	RCL	196	43	RCL
037	43	RCL	077	37	P/R	117	43	RCL	157	20	20	197	10	10
038	04	04	078	32	X:T	118	10	10	158	44	SUM	198	55	÷
039	95	=	079	65	×	119	22	INV	159	11	11	199	43	RCL

```
200   28   28
201   30   TAN
202   95   =
203   32   X!T
204   43   RCL
205   26   26
206   85   +
207   43   RCL
208   29   29
209   95   =
210   37   P/R
211   44   SUM
212   11   11
213   32   X!T
214   44   SUM
215   12   12
216   43   RCL
217   27   27
218   42   STD
219   10   10
220   14   D
221   92   RTN
```

Organization of Magnetic Card:

		S PT Program		
T & S	TURN	SHIFT	sub	sub
z	y	x	BASIC	S PT

Numerical Example:

Execute ALTAZIM for *Date*—10.151982
Locátion—Long.
75.00, Lat. 40.00, TZ
5
Time—12:00 noon

Contents of Memory Registers:

R-00	10.00	
R-01	20.00	
R-02	30.00	
R-03	40.00	
R-04	50.00	
R-05	60.00	
R-06	70.00	
R-28	40.908828	Altitude
R-29	−4.643332	Azimuth

If Flag 6 is set, the program will calculate only the shadow.

If Flag 6 is clear, the program will calculate the location of a point and then the shadow of that point.

Execute Program:

Press E Display 0

Enter Orientation of North:

270 Press R/S Display 0

Enter Location of Ground Plane:

−6 Press R/S Display 0

Enter Coordinates of a Point:

z 0 Press A Display 0.
y 0 " B " 0.
x 0 " C " 0.
 Press E

Calculator Computes:

X of PT Display 10.00000000
Y of Pt Press R/S " 13.33333333
Shadow X of Pt " " " 8.51896540
Shadow Y of Pt " " " 9.62579057

Subsequent Point:

z 0 Press A Display 0.
y 10 Press B Display 10.
z 0 Press C Display 0.
 Press E

Calculator Computes:

X of Pt Display 8.562690133
Y of Pt Press R/S " 15.357251620
Shadow X of Pt " " " 7.287579858
Shadow Y of PT " " " 11.724256850

ROLPOL, EQ SHDW, and SPH SH Programs

000	76	LBL	040	37	P/R	080	43	RCL	120	43	RCL	160	29	29
001	11	A	041	32	X:T	081	07	07	121	10	10	161	77	GE
002	42	STO	042	48	EXC	082	95	=	122	55	÷	162	96	WRT
003	10	10	043	07	07	083	32	X:T	123	43	RCL	163	76	LBL
004	91	R/S	044	22	INV	084	37	P/R	124	28	28	164	97	DSZ
005	76	LBL	045	37	P/R	085	32	X:T	125	30	TAN	165	50	IxI
006	12	B	046	85	+	086	91	R/S	126	95	=	166	32	X:T
007	42	STO	047	43	RCL	087	32	X:T	127	32	X:T	167	09	9
008	11	11	048	05	05	088	91	R/S	128	43	RCL	168	00	0
009	91	R/S	049	95	=	089	92	RTN	129	26	26	169	32	X:T
010	76	LBL	050	37	P/R	090	76	LBL	130	85	+	170	77	GE
011	13	C	051	85	+	091	15	E	131	43	RCL	171	98	ADV
012	42	STO	052	43	RCL	092	87	IFF	132	29	29	172	76	LBL
013	12	12	053	02	02	093	05	05	133	95	=	173	99	PRT
014	91	R/S	054	95	=	094	19	D'	134	37	P/R	174	38	SIN
015	76	LBL	055	32	X:T	095	00	0	135	44	SUM	175	65	x
016	14	D	056	85	+	096	91	R/S	136	11	11	176	43	RCL
017	43	RCL	057	43	RCL	097	42	STO	137	32	X:T	177	31	31
018	12	12	058	03	03	098	26	26	138	44	SUM	178	95	=
019	32	X:T	059	95	=	099	00	0	139	12	12	179	42	STO
020	43	RCL	060	48	EXC	100	91	R/S	140	43	RCL	180	32	32
021	11	11	061	07	07	101	42	STO	141	27	27	181	35	1/X
022	22	INV	062	85	+	102	27	27	142	42	STO	182	65	x
023	37	P/R	063	43	RCL	103	86	STF	143	10	10	183	43	RCL
024	85	+	064	00	00	104	05	05	144	14	D	184	30	30
025	43	RCL	065	85	+	105	00	0	145	92	RTN	185	95	=
026	06	06	066	43	RCL	106	91	R/S	146	76	LBL	186	22	INV
027	95	=	067	01	01	107	76	LBL	147	16	A'	187	30	TAN
028	37	P/R	068	95	=	108	19	D'	148	29	CP	188	94	+/-
029	32	X:T	069	35	1/X	109	87	IFF	149	43	RCL	189	85	+
030	42	STO	070	65	x	110	06	06	150	28	28	190	09	9
031	07	07	071	43	RCL	111	10	E'	151	38	SIN	191	00	0
032	43	RCL	072	00	00	112	14	D	152	42	STO	192	95	=
033	10	10	073	95	=	113	76	LBL	153	30	30	193	87	IFF
034	22	INV	074	48	EXC	114	10	E'	154	43	RCL	194	07	07
035	37	P/R	075	07	07	115	43	RCL	155	28	28	195	90	LST
036	85	+	076	22	INV	116	27	27	156	39	COS	196	76	LBL
037	43	RCL	077	37	P/R	117	22	INV	157	42	STO	197	86	STF
038	04	04	078	32	X:T	118	44	SUM	158	31	31	198	42	STO
039	95	=	079	65	x	119	10	10	159	43	RCL	199	33	33

```
200  43 RCL      240  08   8       280  09  09      320  32 X!T      360  12  12
201  32  32      241  00   0       281  00   0      321  22 INV      361  32 X!T
202  33 X²       242  95   =       282  91 R/S      322  37 P/R      362  22 INV
203  85  +       243  86 STF       283  42 STO      323  75  -       363  37 P/R
204  43 RCL      244  08  08       284  15  15      324  43 RCL      364  85  +
205  30  30      245  61 GTO       285  42 STO      325  33  33      365  43 RCL
206  33 X²       246  99 PRT       286  20  20      326  95   =      366  33  33
207  95  =       247  76 LBL       287  00   0      327  37 P/R      367  95   =
208  94 +/-      248  90 LST       288  91 R/S      328  85  +       368  37 P/R
209  85  +       249  94 +/-       289  44 SUM      329  43 RCL      369  32 X!T
210  01   1      250  22 INV       290  15  15      330  19  19      370  42 STO
211  95   =      251  86 STF       291  76 LBL      331  95   =      371  12  12
212  34 ГX       252  07  07       292  88 DMS      332  42 STO      372  33 X²
213  22 INV      253  61 GTO       293  43 RCL      333  10  10      373  94 +/-
214  39 COS      254  86 STF       294  20  20      334  32 X!T      374  85  +
215  94 +/-      255  76 LBL       295  22 INV      335  42 STO      375  43 RCL
216  85  +       256  87 IFF       296  44 SUM      336  12  12      376  18  18
217  09   9      257  94 +/-       297  15  15      337  15  E       377  33 X²
218  00   0      258  22 INV       298  43 RCL      338  97 DSZ      378  75  -
219  95   =      259  86 STF       299  18  18      339  09  09      379  43 RCL
220  87 IFF      260  08  08       300  32 X!T      340  88 DMS      380  11  11
221  08  08      261  42 STO       301  43 RCL      341  92 RTN      381  33 X²
222  87 IFF      262  34  34       302  15  15      342  76 LBL      382  95   =
223  42 STO      263  22 INV       303  37 P/R      343  18 C'       383  34 ГX
224  34  34      264  86 STF       304  32 X!T      344  43 RCL      384  42 STO
225  22 INV      265  07  07       305  42 STO      345  11  11      385  10  10
226  86 STF      266  92 RTN       306  16  16      346  32 X!T      386  32 X!T
227  07  07      267  76 LBL       307  00   0      347  43 RCL      387  43 RCL
228  92 RTN      268  17 B'        308  22 INV      348  10  10      388  12  12
229  76 LBL      269  00   0       309  37 P/R      349  22 INV      389  32 X!T
230  96 WRT      270  91 R/S       310  75  -       350  37 P/R      390  22 INV
231  86 STF      271  42 STO       311  43 RCL      351  85  +       391  37 P/R
232  07  07      272  18  18       312  34  34      352  43 RCL      392  75  -
233  61 GTO      273  00   0       313  95   =      353  34  34      393  43 RCL
234  97 DSZ      274  91 R/S       314  37 P/R      354  95   =      394  33  33
235  76 LBL      275  42 STO       315  32 X!T      355  37 P/R      395  95   =
236  98 ADV      276  19  19       316  42 STO      356  32 X!T      396  37 P/R
237  94 +/-      277  00   0       317  11  11      357  42 STO      397  32 X!T
238  85  +       278  91 R/S       318  43 RCL      358  11  11      398  42 STO
239  01   1      279  42 STO       319  16  16      359  43 RCL      399  12  12
```

```
400  43 RCL
401  11  11
402  32 X:T
403  22 INV
404  37 P/R
405  75  -
406  43 RCL
407  34  34
408  95  =
409  37 P/R
410  42 STD
411  10  10
412  32 X:T
413  42 STD
414  11  11
415  14  D
416  92 RTN
```

Organization of Magnetic Card:

Cube on Sphere					
ROLPOL	EQ SHDW	SPH SH	sub		sub
z	y	x		BASIC S PT	

Numerical Example:

Execute ALTAZIM for *Date*—6.161982

Location—Long. 75.00, Lat. 40.00, TZ 5

Time—12:00 noon

Contents of Memory Registers:

R-00	10.00	
R-01	20.00	
R-02	30.00	
R-03	40.00	
R-04	50.00	
R-05	60.00	
R-06	70.00	
R-28	73.349503	Altitude
R-29	0.367643	Azimuth

Execute S PT for *North*—270

Ground— -6

Execute ROLPOL:

Press A' (2nd A) Display 16.650144

Execute EQ SHDW:

Press B' (2nd B) Display 0

Enter Radius of Sphere:

6 Press R/S Display 0

Enter Height of Center:

6 Press R/S Display 0

Enter Number of Points:

2 Press R/S Display 0

Enter Angle Between Points:

30 Press R/S Display 0

Enter Angle of First Point:

-75 Press R/S

Calculator Computes:

Point on Sphere	X		Display	15.452541	
	Y	Press R/S	"	15.649462	
Shadow	X	"	"	"	9.050094
	Y	"	"	"	8.694599
Second Point	X	"	"	"	15.644224
	Y	"	"	"	16.891351
Shadow	X	"	"	"	8.805963
	Y	"	"	"	9.149232

Execute SPH SH:

Enter Coordinates of a Point above the Sphere:

z	8	Press A	Display 8.
y	-1	Press B	Display -1.
x	-1	Press C	Display -1.
		Press C' (2nd C)	

Calculator Computes:

Shadow of Pt

on Sphere	X		Display 13.27886650
	Y	Press R/S	Display 16.26775760

INDEX